THE EYE IN THE WIND

Edward Gage

THE EYE IN THE WIND

Scottish Painting Since 1945

COLLINS
St. Jame's Place, London
1977

For Henry, Anthea, Caroline
and other people of tomorrow

First published 1977
©Edward Gage 1977

ISBN 0 00 211 194 2

Set in Baskerville

Made and Printed by
Partridge & Love
Wick, Nr. Bristol.

CONTENTS

ACKNOWLEDGEMENTS

Although writing a book like this is a lonely occupation, it cannot be done entirely without the help of other men and women. In this respect my particular thanks are due first, and last in fact, to Bill Buchanan for his encouragement at the outset of the venture and his comments on the final stages; to the artists themselves who kindly sent me information and photographs or answered my questions; to Bill Jackson of Aitken Dott, the photographer, Tom Scott, and all the galleries and collectors who gave advice about illustrations and made available examples in their possession; to Nino Stewart for typing a screed of biographical data; and to my wife, Valerie, for all her patient help in matters of research. Not least, of course, I am indebted to the Scottish Arts Council, whose financial assistance was designed to bring costs down and thereby make the book available to many more readers than would otherwise have been possible.

LIST OF PLATES

The title, "The Eye in the Wind", is not a quotation but a phrase that just came, by chance, to mind like an appropriate gift. When I examined it, I realised that the wind was the one element of weather which always seemed to be active in Scotland; the eye is the receiver of the visual image; the eye in the wind is both the eye of the Scottish painter and my own eye – because the wind is the agency of change and winnows the wheat from the chaff. Lastly, the word 'window' derives from the Old Norse word, *vindauga*, which is a combination of the word for wind and the word for eye (literally an 'eye of the wind' – i.e. an opening for the air to enter); and a painting, of course, is a window into a man's mind.

PREFACE

The principal aim of this book is to provide some guide to contemporary painting in Scotland and to the work of expatriate Scots, a number of whom figure on the international scene. Any contemporary study must be made on the move, as it were, and its author walks a treacherous and shifting ground; a closely guarded prisoner of his own period, denied the perspective of time and facing a situation that is constantly changing as he appraises it. Yet, despite these inescapable weaknesses, current accounts have a genuine historical as well as present value and ought to be written if for that reason alone.

More than anything else, sheer necessity was the spur to this essay. For too long I had found myself at a loss when asked by those interested where they might see collected examples of contemporary Scottish painting – or find a book on the subject. At least I can try to answer the second part of their request. That the non-existence of such publications was not common to all small nations, I discovered when visiting Denmark several years ago as one of an international group of art critics visiting the country at the invitation of the Ministry of Culture.

So in one sense this book is an unabashed exercise in public relations, mainly provoked by my feelings of duty and frustration; but it is not propaganda and I trust it will be seen to have different merits. It is not intended to be a work of art-historical scholarship. I am neither historian nor scholar, but painter and reviewer. Maybe the fluid and imprecise profile of contemporary art is more clearly apprehensible to a man on the field of battle than to a detached historian who must, perforce, stay his pen until the outcome of the struggle becomes a little more certain. In these circumstances the reader may reasonably doubt my ability to be unwaveringly objective at every point, because my own romantic nature presumes strong subjective feelings. I like to imagine, however, that those classically ordered, intellectual and critical portions of me have generated a fair measure of objectivity to complement a taste which is reasonably catholic.

The book endeavours to demonstrate something of the evolution of Scottish painting since 1945, principally using the work of fifty-two artists. Its form resolved itself almost organically through this approach. It begins with a brief historical survey of events "Before 1945" followed by a general background to other "Matters Cultural". These are designed as an introduction for the benefit of those who, perhaps, know nothing or little about artistic developments in Scotland. In the main text ("Since 1945"), I have set critical appreciations of the selected artists within a chronological framework and have filled the interstices with facts, incidents, cross-references and other names which will, I hope, help to illuminate the shape of

Scottish painting as it has emerged over the last thirty years or so, its complexity, diversity, and expansion.

Some attempt has been made to outline groupings, tendencies and influencies, but this book could never hope to be entirely comprehensive. Choices and omissions have had to be made and I would not expect informed readers to find them all agreeable. Many painters there are whose exclusion I regret and those who are included are meant to form an introductory or indicative collection rather than any definitive list of the "Top 52 Artists". In making the final selection I have tried to reach an acceptable balance that will acknowledge singular contributions and, at the same time, embrace the widest possible range of activity. For each artist thus chosen, there is also to be found in the book a reproduction of a work and a biographical note; in this the artists are listed alphabetically.

One

BEFORE 1945

Though Scotland may not always have been so rich in matters of visual expression as it now appears to be, there are formative characteristics which it would be foolish to ignore, even in a study that is limited to the contemporary scene in only one of the plastic arts. We stand on a mountain of human experience and – the present depending, as it must do, upon the past – I have to probe for a moment or two into the cultural deposits beneath our feet in order to examine generally both art and architecture. Painting itself has most often been only a rather slender aspect of the whole corpus of Scottish art and an appraisal of the entire visual heritage is of fundamental importance.

It would be tidy and neatly chauvinistic if we were to discover a series of powerful native traits emerging in the dawn of time and continuing to thrive over the centuries. The most we shall find, however, is a recognisable flavour; the arts do not exist in a vacuum but are constantly open to outside influences – even in a country that is set, geographically, so far away from the early mainstreams of European culture. To trace the evolution of its art and architecture, is to realise just how much a part of the continent of Europe Scotland has always been. At first, and for many centuries, cultural traffic was very positively one way, but in the eighteenth century several native painters and architects began to exert influences of their own well beyond its borders.

The Scot has always been an inveterate traveller; often, and especially in earlier days, simply setting off in search of knowledge that was not available to him at home. Characteristically, however, he has remained remarkably independent in his outlook and has always been particularly anxious never to be mistaken for his English neighbour. It comes as no surprise, therefore, to find him occasionally leap-frogging across the Channel, propelled, for example, by the affinities he feels with developments in France. The bonds of the Auld Alliance are not restricted to political affairs.

But the national temperament is also moulded by the physical nature of the land and the rigours of its climate. Scotland offers a tremendous variety of landscape within its comparatively small compass – a physical encouragement, perhaps, towards a wide freedom of choice and independence of spirit – yet it remains dominated by its Northerly position; by its rugged coasts and mountains and deep glens; by its surfeit of wind and rain and its long, dark winters. For these reasons another facet of the artistic nature is unashamedly Romantic; sometimes excessively so, in that expressionistic vein which is the hallmark of Northern races who may not build intellectual castles in the sun and are for ever trapped in brooding atmospheres, fantasies, self-analyses or pyrotechnical displays of emotion.

The Scottish heritage begins with the colonisation of the country, first by late Stone age tribes and then by Bronze and Iron Age Celts. Their unmistakable traces are most readily visible in the standing stones, the chambered cairns and those fortified towers called 'brochs' which are dotted all over the Highlands and Islands. Nor was the land entirely unaffected – despite Hadrian's exclusive barrier – by the Roman occupation of Britain; but as no villas or towns have ever been uncovered, evidence of this is confined to sites and remains of forts, camps, signal stations, roads, bridges and two great walls – one the Antonine and the other named after Hadrian.

A more peaceful invasion from Rome – by its Church – began in the fifth century with the spread of Christianity mainly through the Celtic filter of Ireland. This overlaid the results of various Norse, Pictish and other immigrations and is the period of symbol stones, carved monoliths, stone crosses and the magnificent Book of Kells, at least part of which was executed on Scottish soil. Everywhere here we find that type of linear decoration, exceedingly rich and intricate but nonetheless, expressive, which derives from more ancient vocabularies of pattern-making – the Celtic among them – where geometric and organic figures combine in a semi-abstraction of complex, interlacing strap-work.

The symbolic and linear qualities of such designs are clearly recalled in Alan Davie's paintings today. It is, perhaps, to this early physical enjoyment in the creation of richly wrought surfaces that we may trace the hedonistic indulgences of *belle peinture* in twentieth century Scottish painting, where succulent pigment and sumptuous colour are a chief delight.

After this Irish Romanesque interlude, and following on the heels of the Conquest, Norman influence reached up from the South and inspired a flurry of building that produced motte-and-bailey castles, shell keeps, churches and the splendid monasteries and cathedrals – some standing even now, others in ruins since the Reformation – which are to be found from the Borders to the Orkneys. For the ensuing four hundred years, Scottish architecture generally reflected the Norman and Gothic styles as they evolved in England.

Relatively impoverished and frequently riven by strife, the country was far from being a hothouse favourable to the arts. It was also lightly populated and situated at the bumpy north end of a severed limb of Europe – some distance from Florence – so that the Renaissance arrived late and second-hand for the most part, by way of Germany, Holland and France.

One whisper of the phenomenon did conform to the rhythm of the Continental timetable and caught the sympathetic ear of regal patronage. The proliferation of building in the reign of James V is unique. By his marriage in 1537, James revived the Franco-Scottish alliance and French master-masons were engaged in works for the Crown at the castles of Falkirk and Stirling. But though the facades of these places are, in fact, the earliest Renaissance essays to be found in Britain, they had no widespread effect on later architecture of the sixteenth century.

This was a period when trade began to develop in the East coast burghs with the Baltic and Low countries; and when the plainer, vernacular type of building we call "Scottish Baronial" arose at the demand of the landowners. While predominantly French in its derivation, this style embraces Netherlandish characteristics as well as the traditional form of the Scots "peel" tower. Its main ingredients are

emphatic verticality and a profusion of corbelled turrets, crow-stepped gables and decorated dormer windows. There was, of course, a revival of the style in the Victorian era.

The lengthy innings of this highly individual but patently medieval fashion was interrupted by the second and definitive advent of the Renaissance. Now it came with a Netherlandish flavour through the work of William Wallace, architect of Heriot's Hospital (begun in 1628), and his successors. Having drifted apart, Scottish and English architecture once more began to move in concert and some measure of unity was achieved when Sir William Bruce introduced the classical concepts of Christopher Wren towards the end of the seventeenth century.

In that century too came the real emergence of Scottish painting. It is instructive to observe how portrait painters – including George Jamesone, who is the first of any magnitude – were usually influenced by Flemish portraiture, the work of Rubens or Van Dyck in particular, while still-life painters kept a sharp eye on Dutch masters of that genre.

Travel and the Grand Tour centred on Italy became the passport for all would-be creative or cultured gentlemen in the eighteenth century. By then, Scotland was overtly cosmopolitan and not only impressing the world with the quality of her philosophers. It lent an architect, Charles Cameron, to the Russian court; and it actually inaugurated a new form of design and decoration that was a major contribution to the evolution of architecture. The "Adam" style was the elegant neo-classical brain-child of Robert Adam, whose later elevations for Charlotte Square set the seal on James Craig's plans for the New Town of Edinburgh.

In the 1740s, the portrait painter Allan Ramsay took his place as Scotland's first artist of international stature. Like others before him he was fresh from a period of study in Rome, which was then the Mecca of art. Some Scottish painters had even established themselves there, but most were content to serve an apprenticeship. Thus Alexander Nasmyth, the father of landscape painting in Scotland, brought back the picturesque manner of Claude.

With the dawn of the Victorian era, late Georgian architecture gave way to a spate of fresh revivals – classical, gothic and baronial – and only in Thomas Telford's forthright bridges do we find any hint of future developments. By then too the country was relatively prosperous and capable of supporting its own arts; a satisfactory academy and school of art were now in full operation, so the desire to travel for educational purposes was considerably diminished. Nevertheless, Raeburn visited Italy – returning with few visible after-effects – Wilkie wandered ubiquitously, and William Dyce met the German Nazarenes in Rome. Though Dyce's precise and limpid style could be said to anticipate that of the Pre-Raphaelites, the Brotherhood was to be virtually ignored North of the Border. Their love of detail – along with their narrative and sentimental genre – is, however, to be found in the early work of the artist whom we must now consider.

It is in a more invigorating aesthetic climate, therefore, that we encounter Scotland's first great modern painter. The later work of William McTaggart (1835–1910), who was the son of a crofter from Machrihanish and grandfather of Sir William MacTaggart (b1903), is something of a phenomenon. At the same time as Impressionism was flourishing, yet without any contact with affairs in France, he reacted instinctively to light and colour, adopting a high-keyed palette. His con-

clusions, therefore, are singularly akin to those reached by the Impressionist painters; participants in a revolutionary movement which solved the final problems of translating the visible world into pigment – the recording of transitory effects of light in brush strokes of pure colour. There are – as in science, of course – several classic instances in art history of simultaneous development without any previous interaction; cultures tend to follow tracks that are parallel.

But to some extent it is the *difference* between McTaggart and his French contemporaries that now seems important. He was a Northerner and not merely concerned – as the French often exclusively were – with recording the fleeting fall of light, but with capturing and making palpable the moods of weather, the atmospheres of place. This he did, especially in the later years of his life, through a scudding tumult of pigment that comes closer to an Expressionist than an Impressionist mode of behaviour. The wind blows strongly through such paintings, where his well-charged brush flickers and scampers across the canvas miraculously to suggest an infinity of space; and to fuse clouds, trees and people in a perpetual flow or bobbing torrent of energy. In such circumstances one readily forgives the sentimental knots of little children which sometimes dance into his gustier visions as being the lightweight reflections, the saccharine complements of emotions that are otherwise profound and passionate. Often they are so merged with rock or grassy bank that it seems their author was also embarrassed by their presence but had not the heart to banish them entirely.

In 1862, the Royal Glasgow Institute of the Fine Arts was founded "to promote a taste for art generally" and its annual exhibitions (in the McLellan Galleries) still take place.

Glasgow prospered as a result of the Industrial Revolution and towards the turn of the century was bustling with creative activity. Links with French painting were forged by the influential art dealer Alex Reid (1854–1928) – the Reid of Reid and Lefèvre – and from the 1880s a lively group of painters, which has come to be known as the Glasgow Boys, was active. With the natural and healthy reflexes of youth, the Boys were furious with the Royal Scottish Academy in Edinburgh, which they felt deliberately excluded any art not made in the city; and they were scornful of the romantic or picturesque landscapes as well as the sentimental subject pictures being painted by their elders. These latter were dubbed "The Gluepots", a nickname coined from the extreme stickiness of the medium that was used and amusingly echoed in a picture, painted before 1885, by Alexander Davidson entitled "The Broken Doll". In it, a grandfather, while mending a toy for his wee girl, utters the memorable words quoted in the sub-title – "A' doot it'll need the Gluepot".

Quick to realise the significance of artists like Courbet, Corot, and Whistler, these Glasgow painters hardly seemed to notice the conclusions McTaggart had already reached and came to appreciate Impressionism by way of the fresh air of Barbizon and the Japanese reflections observed by Whistler on the River Thames at night. There were 23 members of the group. The principal figures were W. Y. Macgregor (1855–1923), who was based in Glasgow; Sir James Guthrie (1859–1930), who lived at Cockburnspath on the Berwickshire coast – an area the Boys had adopted as their local Barbizon; Sir John Lavery (1856–1941), who spent much time in France; and E. A. Hornel (1864–1933), who worked in Kirkcudbright but visited Japan in the company of George Henry (1858?–1943). The group sported

other distinguished figures such as Sir D. Y. Cameron (1865–1945), Joseph Crowhall (1861–1913), E. A. Walton (1860–1922), and Arthur Melville (1833–1904). These boys were no trivial parish-pumpers but a cosmopolitan band whose work was hailed and recognised across Europe and America.

But it was an architect who became Scotland's first international figure of modern times and by his example changed the whole course of architectural history. The man was Charles Rennie Mackintosh (1868–1928) and his masterpiece, the Glasgow School of Art (1897–1910), was later recognised by Walter Gropius, founder of the Bauhaus, as the "beginning of the Breakthrough". Reacting against the over-elaboration and concealment of function prevalent in Victorian architecture, Mackintosh began to simplify, and in a paper given to the Glasgow Institute when he was 25, declared that "Old architecture lived because it had a purpose; modern architecture, to be real, must not be an envelope without contents".

As a result his buildings tended to be uncomplicated and functional in a way that established the language of modern architecture. Yet, paradoxically, his inspiration was lodged in tradition; not the *lingua franca* of Classical and Gothic which was then so popular, but in that of the Scottish Vernacular with its plain, towering walls and complex summits. It is from this source that Mackintosh's buildings drew their strength.

He was also known for his highly individual and romantic designs for interiors, furniture, artifacts and decorations which practitioners of the international style of *Art Nouveau* viewed as a valuable contribution to their cause; dubbing it the 'Glasgow Style'. In this aspect of his work he turned to even older traditions and adapted Celtic and Pictish forms to his own purposes; but while he acknowledged their relationship with *Art Nouveau*, he regarded his conclusions as independent of that movement.

Though very much a prophet without honour at home, he was the darling of the Vienna Secession – the radical Austrian movement embracing symbolism and Art Nouveau which was founded in 1897 and presided over by Gustav Klimt. Nevertheless, he died a frustrated spirit. By 1914 he had ceased to practise and he spent the last years of his life mostly at Port Vendres, in the Pyrennées Orientales, where he painted landscapes in watercolour.

By the second decade of the 20th century, Scottish painting was dominated by several younger artists who re-affirmed the significance of Impressionism as it had appeared in Scotland, both in McTaggart's instinctive, home-grown version with its vivid handling, its *plein air* touch, and in the more colourful French varieties imported through the continental tastes of the Glasgow Boys. Between 1910 and 1931, these new men quite naturally and logically became the Scottish response – at a reasonable distance in time and space – to the catalytic discoveries made by the Post-Impressionists (expecially Cézanne), the Fauves and the Cubists.

The painters in question were, first and foremost, S. J. Peploe (1871–1935), George Leslie Hunter (1879–1931) and F. C. B. Cadell (1883–1937); and, as an infusion of intense colour with rich pigment was the characteristic most common to all their work, they are referred to as the "Scottish Colourists". The work of J. D. Fergusson (1874–1961) is usually associated with them but he is not generally regarded as a member of the group. The triumvirate cohered and was particularly active between 1910 and 1914.

Though he was not averse to an occasional dash of Fauvist intensity, there is usually less of Cézanne and nothing at all of Cubism in Cadell's broadly simplified and sensuous summations of atmospheric landscapes, elegant portraits or fashionable interiors. He was, in the best sense, a natural painter for whom the language flowed easily and there is a style and bravura in parts of his approach which link him with an English contemporary, Sir William Nicholson. It was Nicholson who, in company with James Pryde (1866–1941), the frequently neglected and moodily theatrical painter from St. Andrews, founded modern British poster design under the signature of the "Beggarstaff Brothers".

As painting evolves and changes over the years, so does our view of the past look different. Among the Colourists, Cadell has probably the most to say at this particular moment. His landscapes can be miracles of inventive colour, his inhabited rooms are mysteriously understated and some of his descriptions of unpeopled apartments contain elements – hard edges, concise design, bold coloration and frank effects of patterning – that speak directly to several recent manners of painting.

Cadell was an East-coast man and, like Peploe, was born in Edinburgh; Fergusson hailed from Leith, but he studied in Paris and Munich, finally spending as many as ten years on the continent. Geographically speaking, Hunter, therefore, was the group's odd man out as he came from Rothesay and travel took him much further West than the Clyde, to California, where he worked as an illustrator; a career he followed until 1914. The great earthquake in San Francisco destroyed his first one-man show even before it opened and he returned to Glasgow in 1906, though he travelled again, visiting Paris sporadically from 1904 onwards. Endowed with innate painterly virtues and a subtle sense of tone, Hunter accepted Cézanne but stopped short of the Cubists. His real delight lay in using the blazing colour adopted by the Fauves; occasionally generating a rhythmic pattern that reminds one of his special admiration for Matisse.

Peploe studied in Paris and painted for a while with Fergusson on the *Côte d'Azur*. The oldest of the trio, it is he who is most obviously concerned with Cézanne's type of formal analysis and the Cubism it partly inspired. In comparing him with that masterly 'modern primitive', sophisticated eyes may at times find his Northern vision and touch a shade too blunted and ponderous; but a number of floral still-life studies are exceedingly strong while his portraiture and landscape paintings are often exciting and memorable. His most impeccable achievements sometimes seem to have occurred early in his painting career, while he was under the influence of Whistler and Monet, when every small sketch became an immediate and lively delight, a genuine poem in tone.

Fergusson was a true Francophile. He twice made his home in Paris and absorbed all contemporary developments in French painting, adapting them to his own ends – the residue of Impressionism, the structural inflections of Cézanne, the wild hues of the Fauves, the exotic decoration of Matisse and even a post-Cubist type of stylisation. This latter mode was employed as a means of insinuating into the soft warm bodies of female nudes, a rhythmic geometry that never quite realises Léger's dogmatic view of solids but occasionally sails close to the smooth formulae of Art Deco. A self-taught artist, Fergusson's approach was instinctive and subjective rather than intellectually controlled, so there are uneven areas in his work. Broadly

speaking, his landscapes are impressive and satisfying, while his luscious pink nudes and overblown blossoms often seem embarrassing in their excess of sensuous reaction.

In passing it is worth mentioning Fergusson's sporadic connections with literature and ballet. Between 1911 and 1913, he was art editor of the periodical "Rhythm", initiated by Middleton Murry and Katherine Mansfield; and he wrote a personal account of "Modern Scottish Painting" which was published in 1943. Margaret Morris, whom he first met in Paris in 1913, became his wife and he was inevitably associated with her famous dance Movement.

I have given a rather fuller report of the activities of these four men because they constitute a powerful concerted expression and one which naturally bears upon and leads directly to the beginning of our subject in 1945. But before looking at the group of artists who provide the mature centre of Scottish Painting at this date, I should for a moment discuss briefly the contributory roles played more recently on the evolution of art in Scotland by official bodies of artists: the academy along with other societies, and the national art schools, of which there are four. These organisations differ in character to some degree one from another and have produced a variety of often conflicting influences on the shape or direction of artistic affairs.

A well-intentioned but cumbersome Institution for the Encouragement of Fine Arts had been inaugurated in 1819 but, as artist members of it had no executive or voting power, its days were numbered and in 1826 – 57 years after its English predecessor – the Scottish Academy was born. The founder members were a splinter group of artists who broke from the Institution and re-formed to include eventually most of the distinguished talents of the day. For much of the time since 1839 it has been more or less a permanent tenant of Playfair's neo-classical building at the foot of the Mound; the road joining the High Street to Princes St.

The nature of academies is to be exclusive and reactionary and they are to be respected as protectors of traditional values, guardians of professional standards in matters of performance and craftmanship, (though the carving up of the R.S.A.'s collection of Hill-Adamson Calotypes in January, 1977, has not enhanced this facet of its image.) The original educational aspect of the Royal Scottish Academy of Painting, Sculpture, and Architecture was manifest in the Royal Institution School, from 1908 absorbed into the Edinburgh College of Art; but it has continued to assist youthful enterprise through competitive awards and bursaries.

Even allowing for the climate prevailing today, in which academy doors everywhere are more easily unlocked, the R.S.A. in recent years has behaved in a liberal and enlightened fashion not generally observed in other countries; and it has encouraged promising young artists by promoting them to the ranks of associate membership. Thus, a fair proportion of vital new blood is continually being absorbed into the establishment. But the structure of any 'establishment' body is inevitably monolithic and stuffy; being bound to preserve the privileges and respect the prejudices of a conservative majority. Far from being transformed, therefore, by a regular intake of younger artists, it is more likely to draw their teeth and rob them of that shining privilege of youth – the right to rebel. Indeed, there is a case for saying that the young definitely need a properly reactionary symbol against which they may revolt and that, had the R.S.A. been less forward-looking, Scottish Art might have been much more revolutionary and *avant-garde* in spirit.

Yet the Academy does have sterling virtues and it has laudably persisted in con-

cerning itself with art education by making sure its annual student competition continues to be effective and worthwhile. The relationship it enjoys with the schools of art is closer than might at first appear. This century has seen a change in the life-style of the visual artist. It is now an exception, for example to find a painter who exists by his painting alone. Those days of *la vie Bohème*, when starvation in a garret was an essential prerequisite of undiscovered genius, have been left to the operatic libretti where they more properly belong. Today, most painters in Scotland teach for a living and paint when they can, not purely for pleasure, like the ubiquitous Sunday painters, but because it is central to their existence. This not only allows them to live and support a family if necessary, but to be choosey about when and where they exhibit or sell their work. It gives them valuable independence. A good painter, of course, may not necessarily be a good teacher, but the obvious expectation is to find the best painters functioning in both the Academy and the schools of art. In the event, this now appears to be the case, since the majority of the Academy's members are, or were, on the staff of one of the four schools; a self-perpetuating fact that attracts charges of 'closed shop' elitism. Luckily such charges can be countered in part by the reverse not being true; not all art school teachers are members of the Academy.

If one may distrust the Academy's vested interest in this area of education, its recent role in the importation or display of special exhibitions for the period of the Edinburgh Festival each year is a matter for commendation. For true missionary zeal in carrying out operations of this sort single-handed, however, it is to a society that is younger and traditionally opposed to the Academy in every respect, that one must turn. The Society of Scottish Artists was the pioneer behind the concept of loan exhibitions.

The S.S.A. was founded in 1891 at a time when fledgling or adventurous spirits could find no vehicle for showing their work; being too young and experimental to engage the interest of the very few commercial galleries or win anything but rejection slips from Academy exhibitions. It therefore mounted, and still does, an annual exhibition of its own. It also created for itself a structure that would ensure its own constant regeneration and prevent the accumulation of dead wood. The lynch-pin is a rule whereby professional members – unlike associates and academicians in the R.S.A. – do not automatically have their work hung each year but have it scrutinised and voted upon by a democratically-elected selection committee. This wise regulation has paid dividends and the society continues to be a vital instrument and showcase for youth.

Appreciation of the visual arts in Britain is generally keener and more widespread than it has ever been, but this is a comparatively recent phenomenon. A growing public caught the habit during the Second World War – things of the spirit assume their true significance when life is uncertain – and along with Arts Council policies, the proliferating media (from cheap prints and paperbacks to cultural television programmes) have been prompting and feeding it ever since. It should be realised, however, that when the S.S.A. was founded, Scotland was visually illiterate and interest in the fine arts was confined to an educated minority.

For this reason the Society's published aims were twofold – to hold an annual exhibition and to promote interest in the arts and crafts in Scotland. This secondary objective led to a celebrated series of loan exhibitions and other occasional groups of

work which were certainly of service to the public at large but also did inestimable good as a stimulus to native artists by bringing them a first-hand taste of what was going on elsewhere.

In 1913, for example, the S.S.A. exhibition included a number of pictures by Cézanne, Van Gogh, Gaugin, Sérusier, Matisse, and Severini; but it was the annual show of 1931 in which the Society made its most important early contribution to international understanding by inviting a selection of twelve large paintings by a contemporary Norwegian artist, Edvard Munch. This introduction into Scotland of the great Northern master of 20th century Expressionism was a friendly nudge to our painters' elbows that must have helped them to recognise and even realise similar tendencies in their own inheritance. It is interesting to note in passing that the Munch paintings were brought to Edinburgh by Fanny Aavatsmark, a young Norwegian writer and critic who later became the wife of the painter Sir William MacTaggart, grandson of William McTaggart.

This is not the place for a long list of important or influential exhibitions, but it is worth remarking how the excellent custom still prevails. Loan collections between 1945 and 1960, for example, included Modern German Expressionists (1950), Picasso, Redon, Lurçat (1952), Nicholas de Staël (1956), Appel, Dubuffet, Francis, Riopelle and other Abstract Expressionists (1958).

Most of the painters in the following account have played roles in the development of the S.S.A. and its youthful character and enterprise are highly valued. Though it has had conservative periods in the past and has been regarded almost as a junior branch of the Academy – for whom it acted as feeder and training ground – its mood today is closer to that independence which occasioned its birth and its preferences are conscientiously *avant garde*. Yet this too can breed exclusiveness of a different category by destroying any catholicity of outlook; what may be right for a small group is not necessarily so for a big society; and academicism is no respecter of idiom or style.

Artists band together for odd reasons – because the going is tough, because they share points of view, or simply to further their careers. This gregarious characteristic is often misleading as painters are fundamentally individual and solitary operators, well aware of the lifelong aspect of personal discovery that attends and defines the evolution of their vision. The story of art is one of personal rather than group achievements.

This may partly explain why younger artists now seem diffident about or even antipathetic to belonging to a society of any kind. They are especially cool, of course, towards those that smack of 'establishment', but most repositories of authority have been called to question in the liberal mood of our times. Again, it may be that the young, in keeping with Schumacher's excellent philosophy, are content with the useful camaraderie of smaller units. The growth over the last two decades of many more private and commercial galleries, providing a wider spread of exhibition facilities, has also weakened the cause of the societies; a one-man show, however tiny, is infinitely more attractive and does the painter greater justice than a handful of works buried in the cumbrous department-store conditions of a large, mixed exhibition.

One of the official bodies to suffer in recent times from this youthful reluctance to be elected or involved has a Royal Charter and a structure similar to that of the

R.S.A., but is not exactly the spinster sister its title might suggest. The Royal Scottish Society of Painters in Watercolours came into being in February 1878 and for many years was the sheltered domain of artists whose gentility was beyond doubt and was nicely reflected in politely refined landscape or floral studies that demanded no responsive epithet stronger than 'charming'.

But the appearance of R.S.W. exhibitions began to change – subtly at first and then radically as a new type of member was elected – after the last war and through the influence of artists like Gillies and Maxwell, who recognised that watercolour had unique traits and could be used to extend a vision previously held in thrall by the character of oil paint. Elusive, volatile and not always predictable, it is a medium which offers peculiar rewards to those who control it. The small-scale portability of its paraphernalia and its quick drying properties have always made it ideal for notes and sketches, but it can also bring special qualities to statements more considered and profound. Its transparency can create intriguing veils of colour and, when employed in a broad fashion, it can sidestep detail or over-emphasis by suggestion or implication. In this way too it can evoke subtle nuances or atmospheres and invoke a sense of mystery. Most exciting of all, however, is its immediate nature, which demands a spirit of performance from the artist who chooses to keep his page wet so that his quick, spontaneous reactions are inevitably communicated to the spectator.

The English are usually seen as heirs of a great watercolour tradition, but the attributes listed above have continually been explored by a large number of R.S.W. members and the Society, whose annual show bears little resemblance to those of the R.W.S. South of the Border, is the centre of a vigorous contemporary school of watercolour painting that has no parallel elsewhere. In its usage, the medium assumes powers of expression previously thought impossible outside the field of oil painting. Strangely enough it goes almost entirely unremarked elsewhere.

Two

MATTERS CULTURAL

Mention has been made of the four art schools or colleges in relation to the R.S.A., but it would be useful to add a word here as they naturally create spheres of influence by inheriting certain local emphases or traditions and by reflecting the attitudes or propagating the philosophies of their staffs. It is, of course, the staff that determines the character and reputation of an educating body at any given time. Though there is a tendency in some places to preserve both continuity and quality by singling out the best post-graduates and re-cycling them into the teaching area, such inbreeding is unhealthy and inhibitive if not leavened by appointments from outside this magic circle. Broadly speaking a fair amount of cross-fertilisation does occur, so that the personal aura of each of these establishments is diffuse rather than sharply defined. Nevertheless, there are distinguishing marks.

The West coast is served by the Glasgow School of Art and the South-East of Scotland by the Edinburgh College of Art. These are naturally larger than the two colleges providing a like education in the North-East – the Duncan of Jordanstone College of Art in Dundee and Robert Gordon's School of Art in Aberdeen, also called Gray's. But it would be wrong to assume that they all drew talent exclusively from local catchment areas, as students are free to opt for colleges outside their own districts and do so.

Rivalries exist, of course, and the ancient vendetta between Glasgow and Edinburgh, for example, produces a fine art echo in complementary studios. This smouldering inter-city feud seems to have been in existence since the very foundation of the places themselves and, part myth, part reality, it reiterates, perhaps, something of the internecine strife that once characterised the Italian states, always at loggerheads with one another. Though damaging in several ways, such exaggerated incompatibility – as Graham Greene's *Third Man*, Harry Lime, reminded us – may produce a cultural phenomenon like the Italian Renaissance . . . if one cares to wait four hundred years. Theoretically, of course, art is supposed to short-circuit all such barriers of resistance by the universality of its powers of communication, but artistically creative minds are no less inclined to prejudice than others and there is a long record of antagonism between painters of these two cities. There is a sense too in which the personalities of their two art schools can be identified with the characteristics of the separate ways of painting that are habitually and somewhat loosely referred to as the Glasgow and Edinburgh Schools; the Western bold, vital, sturdy, and down-to-earth; the other an elegant matter of poetry and *belle-peinture*.

Since 1945, outside influences on Scottish Painting have become more frequent and insistent. In this period, our lives generally have been dominated by the pressing

problem of how to cope with the complications that arise from the astonishing new speed and range of communication. The almost instantaneous dissemination of information has meant that the impact of a brushstroke in New York can swiftly reverberate around the world, influencing a legion of artists *en route*. An effect of this has been the rapidly-induced birth of international art movements; there have been international styles before, but never so many in so short a time.

No painter can afford to ignore these developments but, at the same time, he is not obliged to subscribe to them. The charge against Scottish Painting has often been one of parochialism; a familiar accusation in the case of small schools situated off the beaten track. In the past this could occasionally be substantiated but quickly excused, because the artists concerned were indeed far from the aesthetic trade-routes. Nowadays, the media make this explanation invalid. However, the fact that painters may still seem to be ignorant of new developments in the larger world outside their province does not illustrate an ostrich syndrome so much as a genuine reluctance to accept every novel idea unthinkingly. The Scot is a canny man who remains unimpressed by fashionable trends and he prefers to bide his time and question propositions deeply before taking from them what he thinks might be useful. A native independence primes a desire to work out a personal salvation rather than to jump on any convenient bandwagon. In this context, his sequestered geographical location may be seen as a welcome circumstance.

Other aspects of contemporary international styles must also have made Scottish artists suspicious. Through an international circuit of dealers, art was now big business and was supported by a literature of glossy trade magazines – useful for the photographs they carried rather than the promotional essays whose sense, lodged tightly in quasi-scientific jargon, is often difficult to unravel. Internationalism bred art fairs, biennales and open painting competitions with huge prize monies; occasions which might seem to distort aesthetic values by introducing a competitive spirit into an area of activity where it is alien and distasteful. All these elements, however, conspired to produce a remarkable decade.

The 1950's were comparatively unruffled, though they did play host to Abstract Expressionism and the beginnings of Pop Art; but the 1960's introduced such an explosive proliferation of ideas – novelty often pursued for its own sake – that it will be long before these have all been properly sifted and assimilated to determine the significance, or otherwise, of each one. Sometimes in that restless decade it seemed as if art, by its ever-changing fashions and extravagant behaviour, was adopting the style of *haute couture* or the pop music scene; though it was amazingly prodigal in its creativity, the period also was surely one of extraordinary affectation and occasional decadence. Barriers between art forms were made meaningless by mixed-media objects or multi-media events and happenings. The whole basis of Western art, rooted as it is in the Italian Renaissance, was challenged in works that deliberately flaunted anonymity, ignored durability, emphatically assumed the patterns of play, encouraged audience participation and made sorties into domains previously occupied by other arts or even sciences.

From there it was only a stone's throw to the concept that everyone was an artist and all life a work of art. Such definitions, however, inflate the commonplace and take us through the looking-glass by seeking to exalt activities which provide a pleasant therapy for those engaged in them but, as far as creative achievement is

concerned, cannot match the enlargement of experience to be found in the work of a gifted individual who has developed special talents to a high degree.

In the natural hiatus which followed in the early 1970's, some approximate assessment of this phenomenal burst of activity became feasible. We had obviously been witnessing revolution and the position still looked confused. Art seemed to have been moving – and still was – in all directions at once. But it was possible to detect four main itineraries – one across to technology and science, one limited to the abstract grammar of form and colour, one releasing an inner world of fantasy, and one reflecting and commenting on the human condition. This last included the deliberate exploitation of forms adopted as a common denominator by the mass media, and a reflective concern for man's environment.

A great deal was now being written and published about contemporary art and it had become fashionable for some artists to explain their intentions at length – a procedure that would seem to deny the strength and validity of their formal creations. While Pop Art ran towards a New or Super Realism based on photographic enlargement, Conceptual Art arrived to take the visual arts for a ride towards literature by reducing the visual content and increasing the flow of words; experiences were not realised in formal terms but documented in verbal or photographic records. In the early 1960's, each new movement seemed to bring its own petty tyrannies, but ten years later, when the tempo slackened it looked as if fashion herself had been made an ass and, for the first time in history, we might truly say "anything goes". Neither was there any longer an art centre of the Western world, but a point of balance in mid-Atlantic with sub-centres, such as London and New York, on either side of the ditch.

During the long assault from all these alien influences, the climate and content of Scotland's own backyard did not, of course, remain unmarked. Despite my general qualifications about the canny nature of Scottish artists, home-grown varieties of international modes most certainly appeared. A number of Scots have gone out and carved their names on the international carousel – the painters Davie, Gear, and Turnbull, for instance. The latter is also a sculptor and was a member of that seminal discussion group which foregathered at the Institute of Contemporary Arts; at such a meeting in 1952 he saw the very first Pop imagery – 'found' or 'ready-made' matter culled from printed advertisements and magnified out of context on a projection screen – presented by another Scottish artist, Eduardo Paolozzi.

Paolozzi was born in Leith (like J. D. Fergusson) in 1924. Although primarily a sculptor, the impact of his drawing and printmaking cannot be ignored here because he has become an indefatigable performer, an irresistible figure throughout the international art network.

In tastes both aesthetic and popular, Italo-Scots have made a considerable contribution to the native culture so it is only logical that Paolozzi should have been one of the founders of Pop Art in Britain and an instrument, thereby, for the reconciliation of cultural tastes that once opposed each other. The various aspects of Pop Art, of course, have been as diverse as its derivations, but one of its fundamental impulses was to validate commonplace facts and figures of contemporary life as artistic subject matter; in particular the mass of photographic and printed imagery processed by the media and the materialistic influences of its technology, with its reliance on mechanisation and techniques of mass-production.

[23]

In this visible core of our daily life, man and machine are inextricably locked together in a struggle for survival. This interface, eulogised by the futurists and satirised by the Surrealists (with whom Paolozzi's ideas often coincide) and others, is the ultimate fruit of the Industrial Revolution and the proper domain of the Industrial Designer – guardian of the human element in the dilemma. This is the point where Paolozzi is mostly to be found and it is no coincidence that so many of his drawings and sculptures are couched in the machined language of industrial design; as if they had come straight off the drawing board or workshop floor; in the big white metal sculpture (*Poem for the Trio M.R.T. 1964)*, whose writhing tubes encircle a form like an automobile radiator, it is not too difficult to imagine the "Laocoon" re-phrased in 20th century terms.

Over the years, like all good designers, he has assiduously kept scrapbooks and research notebooks where one may discover the sources of many of his visual concepts. In 1972, he donated much of this sort of material – including comic strips and early science fiction magazines – to the University of St. Andrews where it is kept under the heading of the "Krazy Kat Archive". In some ways, his early imagery with its symbolism or anthropomorphism, is more likeable because of its friendly, emotive or haptic qualities. These tend to disappear in the 1960's when collage or assemblage, always active principles in his creative thinking, are deliberately limited to the geometry of machine forms.

Therefore, despite their decorative colour patterns and Byzantine complexities (which he enjoys), the *Wittgenstein* series of prints and sculptures, for example, remain coldly mechanical plans or totems assembled by a computerised robot, perhaps, from odd blue-prints or spare castings. The robot is naturally another of Paolozzi's interests; he has always adopted the central role of an inspirational or planning force in control of highly skilled craftsmen who carry out his designs.

The reader will come across more than a few similar expatriates; and because of the fierce nationalism that sometimes beats in Northern breasts, attitudes towards them can be strangely illuminating. The effects created are paradoxical. Patriotic feelings and nostalgia increase in the hearts of those far from their native shores; while those who remain at home tend to regard those who have gone as having renegued, as being somehow less than Scottish and guilty, in an indeterminate way, of betraying their national heritage. On the other hand, an interest that is more than proprietary is usually taken in any Scot acclaimed abroad, whatever the circumstances; though an artist must always be prepared for the bluff, vernacular dismissal frequently used to destroy any pretensions he may have about his vocation – "*Him a painter? Ah kent his faither!*" A national refusal to recognise talent, perhaps, drives some of that talent abroad.

It is through the media that one first becomes aware of new developments or adds to a personal store of historical knowledge. But such hearsay, though valuable, must eventually be reinforced by first-hand experience in the form of exhibitions of the subjects themselves. We have already seen evidence of proselytising activity among groups of artists like the S.S.A., but there are two independent official bodies which have not only done excellent work in this area, but have been a powerful influence for good on the arts of Scotland generally. For one of them this function is a *raison d'être*.

Originally entitled the Arts Council of Great Britain (Scottish Committee),

the Scottish Arts Council was independently named in 1967. Under the aegis of its first exhibition officer, Ellen Kemp, it had already begun a collection of contemporary Scottish art and initiated programmes of exhibitions, some of which were sent on tour throughout the country. Thus was established a missionary and information service of fundamental importance to the cultural health of the nation and one which is still in operation today.

Though in their frequency, range and scope, these early shows were comparatively limited, Mrs. Kemp secured a number of unusual triumphs, not the least of which was the presence, at a private view of a collection of his lithographs in the Council's gallery (then in Rothesay Terrace), of the great Russian master of Surreal fantasy, Marc Chagall. The occasion was not without a minor tragedy, however. John Maxwell, who spoke fluent French and held Chagall in especially high esteem, was also there; and someone finally hurried him forward to be introduced. Quite accurately, but most unfortunately, he was presented as one who had also studied in Paris – "with Ozenfant". That was enough for Chagall to whom this very name was anathema and with the outraged cry, "*un mathématicien*", he abruptly aborted the encounter. Two men with much in common had faced each other momentarily only to part without an exchange of words.

The Council promotes the visual arts in several other ways – by assisting deserving enterprises or group activities and by making monetary awards to individual artists as yet unestablished. The latter function, which looks praiseworthy at first sight and has much to recommend it, is equally open to question and brings into close focus the entire philosophy of state patronage in relation to an artist's whole existence, his integrity, motivation and freedom of action.

Since the early days and through the perspicacity of Mrs. Kemp's successor, William Buchanan – who had a *succès d'estime* in 1965 when he introduced the first major show of Kinetic art to be seen in Britain ("Art and Movement" at the R.S.A. Galleries) – the Council's exhibition record has grown admirably and remained consistently catholic in its span of subjects, favouring no aspect unduly at the expense of others. This is confirmed by the constant criticism it receives from every quarter – one cannot please all the people all the time. It has organised an embarrassment of splendid occasions. But it was the larger Arts Council of Great Britain which sponsored a brilliant show whose peculiar impact must haunt the recesses of many memories and whose content is unusually significant to the present account. This was the collection of watercolours from the Nolde Foundation, Seebüll, which was exhibited during the Edinburgh Festival in 1968 at the Scottish National Gallery of Modern Art. Skilfully selected and presented by the gallery's Keeper, Douglas Hall, these small paintings were a spiritual continuation and confirmation of that same Northern mode of Expressionism, foreign but not alien, which was first recognised and understood in Scotland through the Munch exhibition of 1931. It was yet another reminder from outside of the aesthetic changes to be found above the fiftieth parallel. In the dramatic genius of Emil Nolde, profound thoughts or impulses are transmitted with an intensity and an immediacy that is overwhelming; washes of miraculous colour paraphrase the sky as it moves restlessly over a bleak landscape or invoke other images where dark undercurrents of fantasy break the surface.

It was not only the character of his work that made Nolde a familiar figure to

the Scottish imagination, but the fact that he was, in the conduct of his life, an outsider, a loner (forbidden to paint by the Nazis) living in isolated circumstances, communing exclusively with the natural elements. Several kinships with his vision are to be discovered in Scottish art; one that springs readily to mind is contained in the big sky paintings by John Houston.

The Edinburgh Festival deserves further mention and is the second influential institution – though it materialises only for three weeks each year and is, I suppose, more of a demonstration than an organisation. The Edinburgh International Festival of Music and Drama was launched in 1947; the inspired brain-child of three men – Rudolf Bing, H. Harvey Wood and Sir John Falconer, then Lord Provost of the City. Its original aim sprang from immediate post-war conditions and was a determination to re-kindle the spirit of cultural interchange between people of all nationalities. The timing and setting were ideal. Programmes were arranged, players and visitors converged on the city and, in an exalted spirit of celebration, the child was born; a spectacular success, a matter for rejoicing. It still is and should continue to be so – in spite of inevitable changes in direction, character and emphasis. But its effects have been more extraordinary and catalytic than its founders, I imagine, ever anticipated. Single-handed, one might say, it has put Scotland on the cultural map of the world.

Though the visual arts were never included in the title when the Festival was christened, they have always been understood as having a role to play – even though it be that of Cinderella. Each year an official exhibition is organised by the Festival Committee and thereby many Scots have been able to see anthologies of paintings by great masters, both old and modern, on their doorstep; experiences which could not be otherwise acquired except by extensive travel. Unique collections of the work of Rembrandt, Delacroix, Cézanne or Braque are just some of the more obvious blessings the Festival has produced. Such occasions, however, grow steadily more scarce as costs rise and galleries or private individuals become more reluctant to lend works. But other benefits attend the Festival and there are usually around fifty or more exhibitions to be seen simultaneously in the capital, occupying every available wall or vacant space and ranging from large events that may be of historical importance, to tiny one-man shows that are first issues and may never be heard of again.

Three

SINCE 1945

Readers will recall that I left them with the Scottish Colourists and roughly in the era defined by the 1930s. In 1939, the Second World War intervened and the period under review here properly begins with its termination in 1945. It should be remembered that, although Scottish Artists have never been absent from the international stage, the mainstream of Scottish painting has maintained a sturdy independence. This has not stemmed from any insular ignorance of what might have been happening elsewhere – painters still assimilated what they wanted from out-side – but from a deliberate recognition of natural preferences within themselves which put up a resistance to the dictates of every current fashion. Thus, while the art world was being tooled up to produce variations of Abstract Expressionism in the 1950's, the mature centre of Scottish painting was rather different.

As the curtain rose on the post-war scene, four painters in particular seemed already to be speaking with genuine authority. Their statements, though not similar in kind, were related by the fact that they were poetic rather than prosaic and that they shared a pure delight in the sensuous joys of handling rich colour and pigment. These were three men and one woman – W. G. Gillies (1898–1973), William Mac-Taggart (b1903), John Maxwell (1905–1962) and Anne Redpath (1898–1965). Anne Redpath had, quite happily, forfeited valuable painting time to bring up a family, but was, by then, building up a considerable reputation.

Though they were later identified as being the founders of what, through common usage, has come to be known as the Edinburgh School, these artists never formed themselves consciously into any group nor ever regarded themselves as anything but individuals with similar tastes and inclinations. **W. G. Gillies** and Maxwell were closest together, and remained so in spite of the fact that the younger man – whose complex vision and manner of working involved lengthy contemplation – was seldom persuaded by the irrepressible Gillies to accompany him on his memorable painting trips all over Scotland from the Moray Firth to the Mull of Kintyre. These expeditions were most frequent in the 1930's when the three men first began to mature as artists. In 1932, Gillies shared a studio with MacTaggart; both were on the staff of the Edinburgh College of Art which Maxwell also joined in 1935. All four had been students at the college and had spent some time in France. Between 1923 and 1934, Anne Redpath lived there – for the most part on the *Côte d'Azur*; while MacTaggart, in a certain measure for reasons of health, also travelled quite extensively in the South of that country. At separate periods and with different masters, both Gillies and Maxwell studied in Paris; Gillies with André Lhôte and Maxwell with Fernand Léger and Amédée Ozenfant at the Académie Moderne –

strangely austere mentors for the naturally free spirits that were to be released so eloquently in the ensuing work of these two Scots.

Though his rather formal attitude to still-life may be traced to this association, Gillies otherwise developed in a very personal and uninhibited way. His painting is a perfect reflection of a blithe spirit and never ceases to communicate his delight in the visible world; in the Lowland landscape especially, (for he was a countryman by birth and natural inclination) and in the flowers and still-life objects which he lovingly collected around him. His acute ability to observe and select was trans-figured by a fine lyrical quality and the principal elements in his mode of expression were line and colour. The line is sinuous, taut, decisive, full of truth and grace; while his colour schemes often go beyond purely sensuous attraction to strike chords of a rare beauty that is original and haunting. In matters of arrangement, his energy and invention always seem to have been boundless.

His landscapes are predominantly romantic in vein, whereas his still-life themes may often assume more classical or decorative properties stemming from the French influences acquired in the 1920's. Yet, in both subjects, the underlying impulse is broadly pantheistic. Spontaneous and sympathetic reaction to what he saw in front of him, made Gillies extremely prolific and a wizard in matters of performance. His vision burst instantly into flame, while Maxwell's which often involved mysteries of the imagination lodged far inside him, smouldered only slowly into life.

In externalising these visions, **John Maxwell** took infinite pains and was severely self-critical, frequently destroying what did not satisfy him even after months of concentrated work. Though his output was, therefore, small compared to that of Gillies, he was also magically poetic in a way that distinguishes him from his peers and makes a paradox of his studies in France with the post-Cubists. His origins in the lazy conservatory atmosphere of the Stewartry of Kirkcudbright permeate his recurring themes of nudes and flowers and birds. His motivations were those of a poet and his withdrawn personal feelings combined with his contemplative moods to produce a fusion of qualities that are, at one and the same time, both sensual and metaphysical. From his profound knowledge and love of people, gardens, music and poetry, he created an ideal world, heightening reality by using a gentle, expressionist fantasy as his catalyst. A master of technique – the proper physical treatment of pigment always obsessed him – he took great care to keep the rich, sophisticated surfaces of his oil paintings fresh and moved watercolour across the soaking page with miraculous subtlety.

William MacTaggart quite naturally picked up the ground swell of Ex-pressionism that activated his grandfather's seascapes and which he saw more explicitly put forward in the paintings of Munch. Thus his vision is a combination of this emotive, northerly temperament and the intellectual concepts of French painting since Cézanne to which he was exposed in his youth. Set in a family en-vironment that was culturally fertile and barred by ill-health from normal schooling or the pursuits of youth, the young MacTaggart early dedicated himself to the easel with a fervour that completely denied physical weakness and has persisted through-out his life. Landscape, seascape and still-life are his most frequent subjects and, from a relatively calm outset, his vision has engulfed these themes in mounting storms of colour that are held in rein by a superb disposition of dark tones and the broad, sensuous handling of pigment which is his family inheritance. He uses colour

to produce mood as his own grandfather used effects of light to produce weather and atmosphere.

Like that of Gillies, **Anne Redpath's** vision was balanced on a point of celebration where she wished to share her joy in the physical appearance of things. Like Gillies too, she gathered around herself in magpie fashion a treasury of still-life material – much of it quite exotic – and even expressed her delight by arranging pieces in the rooms of her house so as to create an environment that was a work of art in itself. Similarities between these two painters end there; for Anne Redpath relied much less on line and more exclusively on colour, texture and pigmental contrasts of the richest variety. The touch in her pictures that is so undoubtedly feminine – in all the best and most vital senses of the word – derives not only from choice of subject or flair for decoration and pattern, but from a sensitivity to *matière* that is almost culinary.

In pictorial arrangement, she could be imaginately diverse, but the strength of her designs was subservient to the emotion and feeling generated in each picture, where the appeal was to the heart as well as the head and everything was, at the same time, carefully wrought and magnificently sensuous. But it is obvious that she recognised the attractions of abstraction. This is visible in the several ways in which she has simplified or flattened reality; most significantly in her habit of producing a dichotomy between a table-top and the articles standing upon it, by tilting it forward so that it becomes a vertical plane. She had her charming or pretty moments, but there are splendid resolutions to be found in her cosily-neuked harbours, closely-huddled hilltop villages, or church and chapel interiors; images built to withstand the test of time.

It is clear, therefore, that the principal figures in this opening sequence tended to prolong and re-affirm the recurring association with France that was last encountered among the Colourists; and that they also confirmed a general preference for colour and qualities of surface – for *belle peinture*. This term is very often used abusively about the Edinburgh school, but as long as such inclinations are not over-indulged – *any* excess is destructive – or patently run counter to the theme of an image, there can be little wrong in transmitting enjoyment in the physical properties of a medium. Whether it is to be hard-tack or cherry pie is more than literally a matter of taste and depends on the individual and the moment.

I should stress, perhaps, that none of these protagonists was actually a native of Edinburgh and that the city was merely their local centre of gravity. Gillies was born in Haddington, MacTaggart in Loanhead; Maxwell came from Dalbeattie and Anne Redpath from Galashiels – though its deadly rival Border town of Hawick, where she lived after her return from France between 1934 and 1949, invariably claims her as one of its own famous daughters.

There was another Border painter and contemporary of this group, the effect of whose painting was not felt in Scotland until 1970; shortly after he retired from an internationally distinguished career as an art teacher in London and had re-settled himself in the hills he had loved as a boy. **William Johnstone** (b1897) hails from Denholm and arrived late (1919) at the Edinburgh College of Art, having had to make a choice between painting and taking over his father's farm. Like Gillies, he studied afterwards with Lhôte in Paris and went on to become one of the first Scottish artists to recognise and adopt an international style of abstraction

which was biomorphic rather than geometric in the character of its forms; whose sources derive, that is, from organic rather than mechanistic origins. By 1937, he had already produced a major statement in a big painting called *A Point in Time*, but constant administrative duties kept him from any continuous spell of work and it is only since he gave up public life that he has been able to pull the threads together and resolve his remarkable talents. Johnstone's primary concern has always been with the rudiments of visual language, with defining structure, generating rhythms and patterns; this appears in his writing and teaching and in the strength and tension he is able to create with a stroke of pen or brush.

Though his achievement has been more widely recognised in England, its character bears the indelible stamp of his Border roots, the hills, trees and mists, the sudden bursts of sunlight; even when at his most abstract, the implication of these forms or atmospheres is present to create a mood that is recognisably romantic or overtly Expressionistic in the Northern manner. He uses a dark calligraphy, a linear element which has obvious affinities with the spirit and letter of Celtic art. Such qualities give his abstractions a pleasantly human *raison d'être* and enrich their vocabulary. His watercolours and drawings reveal his spontaneous analysis of basic essentials and have a mood of contemplation, a simplicity and grace that are quite Oriental. He enjoys appearing high on the tightrope so that the spectator catches his breath, while the performer balances fragments in space for his own delight with an apparent nonchalance that disguises superb control. The instinctive gesture, preceded by a zen-like spirit of contemplation, was eventually realised in three dimensions when, in 1973, he made a series of plaster reliefs in which the immediate decision (wrested from a lifetime's experience) only gives up its monumental mysteries when lit or viewed from a variety of angles.

During his time as Principal of the Central School of Arts and Crafts, few of the great artistic personalities of the age were unknown to Johnstone and he moved easily in rarified atmospheres without ever losing the pawky wit and iconoclastic sense of fun that is so much a part of both his art and his racy, penetrating conversation. It is instructive to compare the relaxed urbanity of this former expatriate's attitude with those of Gillies or Maxwell, who were usually ill at ease with cosmopolitan ways or 'big city' habits. This was not, of course, because of any feeling of inferiority on their part – Maxwell, for instance, was an extremely cultivated personality with sophisticated tastes in music and poetry – but was, I believe, the result of inborn shyness and a distaste for discussing with strangers anything to do with painting; the mainspring of their lives and, therefore, most personal and sacred to them.

This is well illustrated by an incident during a trip South they made in 1954 for the opening of a joint exhibition at the New Burlington Galleries. Then, as now, many Scottish artists were diffident about showing in London; not so much from any fear of comparison or of being ignored or ridiculed, as from a healthy suspicion of high falutin' London customs – a point of view probably stemming from a combination of reticence, self-sufficiency and pride. Soon after their arrival, Gillies and Maxwell found themselves rather unwillingly playing host at the breakfast table – seldom a promising rendezvous – to several Metropolitan art critics. For talk of an aesthetic tenor or even a conversational drift in that direction, the guests, however, waited in vain while two of Scotland's foremost painters sat gravely

debating the complex problem of installing a kitchen sink. Nevertheless, I am sure the great Cockney artist, J. M. W. Turner, whose 'rum business' definition of painting is a warning to every critic, would have understood and approved behaviour so deliberately unpretentious.

While the Edinburgh school inscribed a neat arc of continuity over the war years, when Scotland was isolated from Europe, it would be wrong to suppose that the artistic life of the people was entirely divorced from external influence. Stanley Spencer was working as a war artist at Port Glasgow between 1943 and 1944 on a series of shipbuilding murals (now in the Imperial War Museum) and was also privately engaged on a new version of a favourite theme – *Resurrection: Port Glasgow* – the central panel of which is now in the Tate Gallery. Though it certainly caught the interest of many shipyard workers, Spencer's remarkable and solitary presence there had little effect on aesthetic developments at the time.

These were however disturbed by a far more numerous invasion, a racial influx that not only made an immediate impact but was to provide a vigorous and lasting infusion of pure spirit into the national culture. The source of this was the arrival of Polish soldiers and refugees, many of whom were to remain beyond the end of hostilities and to become naturalised subjects. The Poles are highly civilised and innately attuned to all forms of artistic expression. Though not without some uneasiness, the two peoples proved temperamentally compatible; as did, in some measure, their separate traditions, so that Scottish culture is richer for this commingling. Blended spirits multiply in the second generation and Polish surnames now flourish in art school registers.

At the beginning of the war, two Polish names in particular assumed significance in Glasgow; those of the painters Josef Herman (b1911) and Jankel Adler (1895–1949). Herman arrived in 1940, Adler early in 1941. That year, both men exhibited in Glasgow and Herman had another one-man show in Edinburgh (at Aitken Dott) in the year succeeding. Towards the end of 1942, Adler went to London and Herman followed suit in 1943. Though his stay in Glasgow was short-lived, Adler seems to have acted as a catalyst on a local group of artists and writers who had just founded the New Art Club and were in the process of organising the New Scottish Group which was finally launched, with J. D. Fergusson as President, in 1942. As an attempt to encourage an artistic revival in general terms that would be distinctively Scottish in character – in painting this meant reaching backwards instead of sideways across the Channel – the enterprise proved to be only a minor success. No matter how willing the spirit might be among the activists concerned, such developments cannot be engineered but will take their own course and grow only out of the propitious situation. The Group, in fact, lasted no more than four or five years; the Club that engendered it, less than twenty.

At least two painters of some consequence now emerged who were related to this period of lively Western Scottish activity; they were also strongly influenced by Adler's personal brand of European modernism with its late dash of Picasso. **Robert Colquhoun** (1914–1962) and **Robert MacBryde** (1913–1966) were both Ayrshire men – the former was born in Kilmarnock the latter in Maybole. Both studied at the Glasgow School of Art and MacBryde went on to further study in France and Italy before making his home in England in 1939. During the war he

worked in a factory and engineering works while Colquhoun enlisted and eventually settled in London. Becoming inseparable companions in 1944, they remained based in London and were associated with John Minton, John Craxton and the angular form of Romanticism that was typical of the war and immediate post-war period.

In Colquhoun's imagery, which is the more obviously volatile and influenced by European trends, a single human figure generally plays the principal role. An evocative puppet, often dramatically clad and be-hatted, it is a highly romantic symbol but one that is also emblazoned, almost, in terms of heraldic simplicity. Calligraphically cunning and mannered, the design is locked in an emphatically linear system which incorporates other iconographical elements, as the figure is accompanied by emotive attributes or symbols – birds, animals, furniture or other man-made artifacts. Bold colour adds emotional tension and pattern to the drama of compositional arrangement.

Though he also painted people, the content of the archetypal MacBryde painting is still-life material – tables with fish and lamps and dishes of fruit; fruit that is always sliced to reveal pale cross-sections of thin skin, juicy flesh, rows of seeds, shapes that are as deliciously refreshing to the eye as their originals would be to the mouth. Formal matters are simplified to a decorative balance where line weaves magical rhythms around seductive orchestrations of colour. The intention in such pieces may well be similar to that of Georges Braque in many of his still-life studies, but whereas the Frenchman's visual poetry is classical in its structural organisation, MacBryde's is romantically inclined and discloses intricacies of pattern that dance and sing to a lilt decidedly Celtic in its inflection. Colquhoun and MacBryde also designed together the set and costumes for Leonid Massine's Scottish ballet, *Donald of the Burthens*, produced by the Sadlers Wells Ballet at Covent Garden in 1951.

Among the Polish invaders who decided to stay, **Aleksander Zyw** (b1905) is the most distinguished. Zyw arrived on the tide of war in 1940 and, when he was eventually demobilised in 1946, married a Scot and settled in Edinburgh's Dean Village. While he has exhibited in his adopted country he is not a familiar figure on its cultural stage. Neither, on the other hand, is he a member of any fine art international jet set nor a biennale playboy and he has always seemed more interested in private contemplation or self-revelation than in any prize-winning public acclaim. Yet, both he and his painting are in a true sense cosmopolitan; he has a second home in Tuscany and his work is seen regularly in Italy, France and Poland. Though he has had little direct influence on Scottish art, his example has been unusually interesting. Pausing only for a diverting moment of decorative fantasy around 1950, Zyw's painting over the years has moved steadily from a robust realism, through a vocabulary of Expressionist phrases that become increasingly abstracted, towards an economy of statement that is austere, quiet, intellectual and pared down to the bone and essence.

Three years after the big retrospective show of his work at the Scottish National Gallery of Modern Art in 1972, he showed a suite of ninety-five paintings and drawings entitled *An Instant of Water* which confirmed a constant element in his vision seemingly determined to research those basic energies which, working in concert, bring order out of chaos. The formal connection between these analyses of water and earlier studies of the wrinkled, writhing trunks of olive trees is obvious; and

there is something scientific, in the way he seeks to isolate, in the rhythmic flow of water, the patterns and convolutions that signal the presence of energy. In many respects, his art has long been primarily concerned with movement and with a complexity of small forms that eventually coagulate in a mass; rather than with anything static or patently simplified.

In order to arrest the movement for close examination, Zyw employed a camera, finally seizing upon a close-up photograph of a particular current in the Water of Leith. But, in the main, his conclusions are gentle and reflective, being derived from the visual equivalent of keeping an ear close to the ground – or just above the gurgling stream – and, unlike the frozen moment in the photograph, the images seem cut from a continuum of perpetual motion.

In 1945, the four leading painters of the Edinburgh school were influential not only by example but through their own painting; and three of them had access to even greater influence through teaching at the College. MacTaggart was in charge of still life classes, on a part-time basis because of his health, and Maxwell was a highly sensitive and sympathetic teacher who approached the task with humility and a respect for student integrity that was typical of his personality. But it was Gillies who had the magic touch, who could see what was wrong from the studio doorway and had identified and solved the problem in one of his terse phrases even before his steps reached the easel. Basically a shy man with a warm heart, he had a canny sense of humour and his manner was sincere, quietly controlled and gently decisive. He utterly lacked any affectation, being unassuming but firm in his loyalties, forthright and honest in his opinions. Small in stature, brisk in movement, he was the epitome of the little Scot with the big heart and talent whose determination seemed forged of the iron that ploughs a useful furrow. One way or another, he always seemed to get matters arranged to his liking.

He was appointed Head of the Drawing and Painting School in 1946 and was Principal of the College from 1959 to 1966. Those who might have questioned his habit of bringing the best students back into this closely-knit teaching fold could not deny its success and, under his tutelage, painting at Edinburgh went through a happy golden age whose fruits are still visible.

Simultaneous with Gillies beginning to teach at the College in the early 1930's, was the passage through it of three students from the Kingdom of Fife who were to become painters of real consequence, but whose achievements have never, perhaps, been adequately recognised in Scotland. **Wilhelmina Barns-Graham** (b1912) comes from St. Andrews and has recently returned to live for part of each year in that neighbourhood. In 1937 she was a post-graduate travelling scholar and in 1940 she moved to Cornwall. She has a house in St. Ives where she has long played a role in the artistic milieu of the town. Beside her perennial interest in drawing the bones of land formations, her prevailing concern has been for basic patterns of order and disorder, and her dynamic groupings of geometrical forms are a singular Scottish contribution to the international language of Constructivist painting. This type of visual solution has not been arrived at in an arbitrary fashion but is the logical out-come of a studied approach to the abstract grammar of visual design; a predilection visible in certain formalisations of landscape – flattened and hardened into classically decorative postures that lie close to Ben Nicholson's handling of still-life material –

[33]

which she was making in the 1950's. In recent canvases, shuffling and jostling coloured discs, some divided into segments, produce optical beats and structural resolutions.

William Gear, who was born in Methil in 1915, eventually became one of the first Scots to win a reputation in the post-war international scene even before the shock waves of American Abstract Expressionism began rolling across the Atlantic. After college he studied with Léger (1937–38); and he later lived in Paris from 1947 to 1950 where he naturally associated with the painters of the Ecole de Paris and the highly expressive Cobra group – an international association of artists (1948–51) founded by Karel Appel and so-called because its original members came from Copenhagen, Brussels and Amsterdam. He was, in fact, among the first to make the aesthetic connection between America and Europe and, in 1949, shared an exhibition with Jackson Pollock at the Betty Parsons Gallery in New York. In 1951, he finally came up with a formal theme which has since been his principal vehicle – a series of interlocking diagonal rhythms with jagged profiles often stressed by black outlines and mainly illuminated by a characteristically Scottish feeling for rich colour.

While these two painters left Scotland early in their careers, **Charles Pulsford** (b1912) did not make his home in England until 1960. Born in Leek, (Staffordshire) but brought up in Aberdour, Pulsford was twenty-one when he arrived at the Edinburgh College. He studied there from 1933 to 1937 and did some post-graduate work before being awarded a Fellowship in 1939. Appointed to the staff after the war, he left in 1960 to teach first at Loughborough School of Art and then, from 1964 until his retirement in 1972, at Wolverhampton Polytechnic. Though a somewhat rugged intellectual, he is also a man of compassion and feeling who is keenly aware of man's plight and position in the universal order of things. In Scottish art he is an odd man out who, with the tenacity of a bull terrier, has consistently followed an independent path and owes little or nothing to outside influences. His abstract symbols have a classic dignity that reflects the timeless philosophical or mystical concepts which find expression in Greek mythology or Christian belief; and his power and energy as an extremely creative teacher have helped to raise the sights of many students so that they might comprehend objectives on horizons more distant than those visible from the confines of a studio or the vernacular of a particular period. While he has never forced entry into the international circuit, his own art is universal in its outlook. For too long his expatriate position and his aloof, unconforming nature have helped to deny any general appraisal of his true value. His imagery tends to be writ large and has embraced both the decorative or emblematic formality proposed by colourful geometrical divisions, and the bland, sensuous effect of heavily impasted variations in monochrome. Lately, he has extended his enquiries into three-dimensional polychromatic constructions in a mixture of media; and most recently, he has concentrated on researches into creative behaviour that involve practical and filmed work with live performers. Stagnation or repetition are foreign to such an enquiring mind.

Pulsford joined the college staff in 1947; at the same time as the English artist Leonard Rosoman (b1913). Rosoman's influence was stimulating and profound as he communicated his delight in recording the extraordinary nature of the visible world in general and human behaviour in particular through a vision that was

sharply analytical but still filled with an innocent sense of wonder. A keen draughts-man and an intensely subtle composer in the off-beat manner deriving from Degas through the urbane American, Ben Shahn, Rosoman is a man of many parts who does not consider illustration or exhibition design to be beneath his dignity. His transformation of the College building for Richard Buckle's Diaghilev Exhibition at the 1954 Festival was an aesthetic smash-hit. Until his departure in the mid-1950's he represented attitudes to art that were refreshingly open and different.

1947, in fact, was a significant year in Edinburgh and its vintage properties should be appreciated. This was the year the Festival was inaugurated. One of the unofficial sideshows, as it were, was an open Exhibition of Modern Scottish Painting by the Society of Independent Scottish Artists; a large and rather *ad hoc* group which rented a big hall in Murrayfield for the purpose. This gesture seemed to signal the return of youth to creative pursuits after the dangerous business of war and the show contained work by former members of the now defunct New Scottish Group plus a handful of talented younger artists, among whom **Robin Philipson** (b1916) is a key figure. One of the leading painters of the generation immediately following that of Gillies, he was yet another personality to join the Edinburgh college staff in 1947. Born at Broughton-on-Furness, he went to school in Dumfries and studied art at Edinburgh from 1936 to 1940; thereafter serving in India during the war. He has been head of the painting school since 1960. Philipson confirms and supports two elements already identified – the feeling for *matière* and the Romantic engagement that pushes towards the Northerly Expressionist type of vision. These are evident in his love of sensuous pigment or coruscations of colour that vibrate with intense energy; and in the kinship with men like Rouault, Soutine or Kokoschka that is proclaimed in his early works. The latter artist, at one point, became his idol. Since 1956, however, he has forged a style of his own that is entirely personal, impeccable in presentation and often stunning in its technical brilliance. But his imagery is also heavily symbolic, his themes often didactic and even grand in concept to the point of echoing the whole human predicament.

Though his technical virtuosity could make the banal appear fascinating, theme is of prime importance to Philipson and its faithful interpretation, its precise trans-lation, governs his every move. In character, his choices of theme frequently favour those with an emotional flashpoint of some kind – whether it be the physical struggle embodied in fighting cocks, the sensuality of figures 'waiting' for sexual encounters, the sumptuous splendour of empty church interiors, the spiritual agony transcend-ing trench warfare in the First World War, the brutal martyrdom of an individual, or (more recently) the Crucifixion itself. All these have contemporary references and his current obsession is an ambitious series of variations on a *Threnody for Our Time* in which he has attempted to analyse one of the more explosive problems confronting mankind – the question of colour, or race relations, of the polarity of black and white.

The psychological nub of the racial problem is the great fear of miscegenation and Philipson depicts such inter-racial coupling with a sensual poetry that celebrates this fleshly ritual, its preface and postscript, without offending taste. This is partly due to his use of the mood found in his 'waiting' figures; he also makes use of their poses and, adjacent to the love struggle between white man and black woman, we may discover the brooding presence of a third party or some animals from a

[35]

symbolic bestiary which predominantly includes the zebra and the monkey.

Philipson's vision often contemplates the distinct demands of the world of the flesh and that of the spirit. A protracted and complex series of illnesses has brought him close to death several times; and he has lately shown he can be more austere in design and equally successful on a modest scale by setting poetic observations to a calmer, gentler measure.

Of course there were many other personalities among artists of the generation before Philipson contributing to the scene in Edinburgh. In Donald Moodie (1892–1963), there was a truly prodigious draughtsman whose qualities of analysis and fluency, especially in rendering the head or nude figure, put his graphic work on a par with the finest drawings in the great European tradition. Penelope Beaton (1886–1963) was a spirited and refreshing painter whose landscapes in particular are delightfully full of candour and a brusque but sensitive lyricism; while R. H. Westwater (1905–1962), a splendidly gifted but often controversial individual, was the liveliest of portrait painters who had a penetrating eye for character and also doubled as a journalist writing informed reviews from a viewpoint that was gratifyingly catholic. William Wilson (1905–1972) is principally acknowledged as a stained glass revivalist who fused original traditions – largely ignored in the Victorian era of painted glass – with a style of design that was pleasantly fitting and contemporary. But he was also the author of dashing watercolour landscapes, much of whose immediate appeal is due to his always having worked on them *in situ*.

Another influential figure at this time, Adam Bruce Thomson (1884–1976), was primarily a landscape painter who found many of his best subjects locally around Edinburgh or in the adjacent Border country to the South. His sensitive paraphrases nicely combine spirit of place with a telling strength of design. His paintings are pigmentally quite rich but loosely handled enough for them not to look at all contrived; indeed, the very natural manner of his approach and the unpretentious lyrical measures he often achieved are the hallmarks of his art. Outliving all his contemporaries, he also remained active in great old age and, shortly before his death, showed a freshly painted work in the R.S.A. – a view across Edinburgh looking towards Arthur's Seat – which was widely recognised as being something like the consummation of a lifetime's experience and the epitome of his spontaneous, gentle and untroubled vision.

A student contemporary of Barns-Graham at this period was **Denis Peploe** (b1914), the son of S. J. Peploe. In 1937 he followed the post-graduate path taken by Gillies and Maxwell to André Lhôte's studio and, after a post-war spell as art master of Fettes College (where he succeeded both Wilson and Westwater and preceded myself), he spent a time working in Cyprus before joining the staff of the College of Art. For a long time his canvases could be readily identified by his predilection for rock forms and textures – of which he found a fruitful supply in the Highlands of Scotland – and by the heavily-impasted chunks of pigment he frequently used to convey them; pigment that was rich in substance or profile but subtly quiet and unassuming in colour. Latterly, however, he has relinquished such sculptural inclinations in favour of decorative qualities of pattern and hue, producing a variety of landscapes or still-life paintings which depend on witty calligraphy and schemes of colour. So now he works in a vein that is more sophisti-

cated and elegant; a manner which, in the way it delights by both its cerebral and sensuous attributes, seems a stone's throw from some of the conclusions reached by Georges Braque and reminds us of Peploe's earlier links with France – something he shares with his father who found a hero in Cézanne.

Important personalities were appearing simultaneously elsewhere. Philipson's exact contemporary at the Glasgow School of Art, for instance, was the distinguished portrait painter, **David Donaldson** (b1916), who is now head of the painting school there. Donaldson, who was born in Chryston, Glasgow, studied at the school from 1931 to 1938, and has become one of the best portraitists in the land. In an era when serious interest and a genuinely creative or even reasonably interpretative performance in this genre has, until comparatively recently, been at a premium, he has consistently been able to prove that a portrait may be a work of art as well as a study of character. No fashionable darling of society, he works in a bold style, using a direct approach and enjoying the handling of paint with a bravura and verve that are almost operatic. He also essays a wide range of other subjects which demonstrate his respect for the human figure as a vehicle of expression.

Parallel with Donaldson in Glasgow, **Alberto Morrocco** (b1917) was studying at Gray's School of Art in Aberdeen (1932–1938). He then won a travelling scholarship allowing him to study further in France and Switzerland. After war service, he returned to teach in Aberdeen and in 1950 was appointed head of the painting school at Duncan of Jordanstone College of Art in Dundee – a position he still holds.

A founder member of the 47 Group of artists who exhibited annually together in the Aberdeen Art Gallery from 1947 to 1950, Morrocco is another successful portrait painter who has many interests besides and his paintings reflect a physical delight in the appearance of things – of landscape, still-life and genre aspects often deriving from holiday scenes in continental resorts. His is a good-humoured and uncomplicated art that depends on a spirited performance which he is readily able to produce, being endowed with considerable energy and a spontaneous natural facility.

Meanwhile, overlapping with Donaldson at Glasgow School of Art was the man who, from 1960 until his untimely death ten years later, was the influential head of the department of drawing and painting at Gray's School of Art, Aberdeen. **Robert Hederson Blyth** was born in Glasgow in 1919 and studied at the Glasgow school from 1934 to 1939 before going on to complete a post-diploma year at Hospitalfield College of Art, Arbroath, under the tutelage of James Cowie. During the war he served with the R.A.M.C. (there are paintings by him in the Imperial War Museum) and he joined the staff of the Edinburgh College of Art in 1946 where he soon became an admirer of Gillies and a frequent companion on the older man's painting expeditions. In 1954 he was invited to take charge of the painting school at Gray's and in 1955 and 1956 gained popular distinction by designing the poster for the Edinburgh Festival. His early works are thoughtful, poetic and meticulous in the dry manner of Cowie, his first mentor, but in dealing with the romantic subject matter of fishing villages, his attitude to pigment developed a sensuous quality he was never to lose when handling later themes such as footballers or atmospheric and occasionally rather florid landscapes. A long phase concentrating on these preceded a final group of paintings where cooler notes evoked a more limpid and lyrical mood. As a man and a teacher, he was always sympathetic and unassuming.

Reference has been made to Hospitalfield and the work of James Cowie.

Hospitalfield, or the Patrick Allan-Fraser School of Art as it is more correctly known, was bequeathed in trust in 1890 as a place for post-graduate art studies. Now partially modernised with proper studio accommodation, the large house and its grounds are at the disposal of groups of students who live in and are supervised by a Warden – normally a painter of some reputation appointed by the Trustees who include representatives from the four Scottish art Colleges. He acts as a director and tutor and if he is married, which is usually the case, his wife takes charge of administering the domestic affairs of the establishment.

James Cowie (1886–1956) who was Warden from 1937 to 1948, had for two years previously been head of painting at Gray's. An Aberdeenshire man from Monquhilter, he did a teaching course and started to read for an English degree before a passion for drawing led him to attend the Glasgow School of Art at the mature age of twenty-six. His paintings often combine dry observation with classical allusion and the objective style of realistic analysis he adopted now looks strangely relevant in the light of the New or Super Realism and the way it has been echoed or assimilated in Scotland; especially, perhaps, in recent work by Peter Collins who at present lives and teaches in Dundee.

As Henderson Blyth left Glasgow for the East Coast, there arrived one who was destined to die far too young but managed to pack such a frenzy of expression into a brief span that she is probably the most momentous painter of the period. **Joan Eardley** (1921–1963) was born in Sussex and her family moved from Blackheath to Glasgow in 1939. In the following year she began at the Glasgow School where she quickly became a prodigious student under the benevolent eye of Hugh Adam Crawford (b1899), the head of painting and an especially gifted teacher. Withdrawn and reserved in character, she did not readily communicate by the spoken word, a circumstance, perhaps, that may account for the ferocious intensity and almost desperate energy to be found so often in her visual communications. Considering the immense strength, depth and breadth of her vision, it is difficult to think of any other woman painter who has matched these qualities. Hers is far from being the epitome of a gentle feminine point of view, yet the tragi-comic images of Glasgow urchins which she painted with so much warmth and compassion must represent a personal interpretation of a theme that is seldom absent from the work of women artists.

Speaking generally, these touchingly human commentaries which brought her early recognition occupied only half her inspiration while the other was engaged with landscape and through it, eventually, with the elemental forces of nature; with the recurring drama of air and water in stormy motion. Around 1950, she discovered the little village of Catterline clinging to the cliffs on the North-East coast just South of Stonehaven; and it was down on its shore that she so often stood painting in the teeth of a wintry gale, committing the tumult of howling wind and thunderously breaking seas to a large canvas weighted down with boulders in order that it should not take flight. The thrilling late works painted in these exposed conditions are the summation of an impressive talent excelling in a spontaneous type of paraphrase which employed an economy of means one usually encounters only at the end of a very much longer lifetime of experience.

A great deal of the emotive drive in these paintings depends on the immediacy

of her reactions, on the swift expressiveness of each bold gesture; and we are in-evitably put in mind of Turner's late essays – though unlike that great master, she worked on the finished painting *in situ* rather than in the studio – and of the Abstract Expressionism we now feel they presaged. It is as if Eardley, in considering American gestural painting of the 1950's, had decided to refer it to its roots. If the attitude of most Scottish painters to this transatlantic phenomenon was principally hostile at this time, it was probably because they found its formless riot of pigment and emo-tional fragmentation embarrassingly effusive and undisciplined, altogether too much to stomach. There was in Scotland, therefore, no consequence to Abstract Expressionism more significant than the paintings of Joan Eardley who, at one stroke, formed a link with the past and put us in touch with a contemporary inter-national movement. Yet this Sussex-born girl had succumbed to the spell of her adopted country's traditions, formed as they must partly be by climate and geo-graphy, and her tempestuous orchestrations of atmosphere are not without echoes of that Northerly feeling of *angst*.

It was in 1947 that **Lord Haig** (b1918) returned to live and work at Bemersyde, the estate the family had acquired in 1921 and occupied in 1924. From being an undergraduate at Oxford he went straight into service with the Royal Scots Greys in 1939. Captured in 1942, he was a prisoner until the end of the war when he went to the Camberwell School of Art (where William Johnstone was principal) to study with Pasmore, Gowing, Coldstream and Rogers. During vacations he worked with Paul Maze. Like Eardley, his primary interest is in landscape, but he is less inspired by its romantic aspects than by its structural or classical possibilities. He is, by upbringing, an inheritor of the cooler disciplines that anglicised the spirit of Cézanne and trembled on the brink of abstraction. In his lyrical extemporisations on the Border landscape he knows and loves so patently, he marries a keen and sensuous reaction to the forms and colours in front of him with an intellectual response to their essence and its arrangement on canvas. From time to time he enriches his vocabulary by travelling to paint subjects in Venice or Malta, for instance, but basically his open and relaxed structural approach remains best suited to the material in the hills and rivers around his home.

In 1947, **Alan Davie** (b1920) was working as a professional jazz musician; in the past he has also survived by making jewellery, but he is a particularly fine saxo-phonist. Since 1950, however, his magic imagery has loomed large on the inter-national scene. To stay in Scotland or to go abroad in search of fame and fortune is a common dilemma facing Scottish artists and to adopt the latter course has increa-singly of late seemed to involve changes of heart or principle too fundamental for many to accept. But Davie did go, feeling stifled despite a distinguished student career at Edinburgh College of Art (1937–1940); and he found himself hammering out an original language that has provided a stream of visual metaphors from his own personal experience. The liberation of his intuitive approach owes much to the coincidence of American Abstract Expressionist masters like Jackson Pollock, but Davie has poetic leanings that are evident not only in the literary, eccentric titles he often affixes to paintings, but in his deliberate use of symbols and a decorative richness which, springing from his Celtic flair for linear pattern and colour, lends an iconolatrous and narrative quality to his pictures. But it is, perhaps, for his exhaustive and elaborate invention that he is most memorable – and this must be

related to his improvisatory prowess as a jazz-man; each painting looks like a fragment from some vast continuum, some creative power supply into which he is able to plug himself at a moment's notice. There is a great and immediate sense of performance, but behind its mounting excitement lies a deeply satisfying aesthetic sensibility.

The big canvases by this remarkable improviser, juggler, entertainer and magician may be roughly divided into three broad groups – the gestural actions of the 1950's the more colourful and organised schemes of the 1960's and the sharper, richer patterns resolved in the 1970's. In each of them Davie moves as if he were exploring an inexhaustible compendium of games, waiving rules and playing with chance. Along with the potent symbol, one notices in his development the gradual emergence of ritual fantasy, the growing dominance of colour (smooth and glowing like enamelling) and an increasing definition of design. Often too, formal events tend to invade the pictorial field from the edges. While earlier periods show some affinity with Abstract Expressionism of the American or COBRA variety, the latest works seem more individual, fearless and assured. Sometimes, one feels, he treats forms as if they were still-life objects, and he is frequently preoccupied by exciting feats of balance or subtle qualities of paint surface.

Joining Davie and Gear on the international circuit was a third expatriate artist who has divided his energies between painting and sculpture. Though only slightly younger than Davie, **William Turnbull** was still studying at the Slade School of Art in 1947. He was born in Dundee in 1922 and before the war worked in the illustration department of a periodical publishing company in that city. After distinguished service in the RAF, he went to the Slade in London from 1946 to 1948, worked in Paris until 1950 and then returned to live permanently in London. Another Scot to recognise instantly the significance of the large paintings of the New York School of the 1950's, he was most influenced by Rothko and Still. Though early work revealed his own personality – his sculpture was figurative while his painting relied partially on the handwritten brushstroke – he has constantly moved towards a form of Minimal Art whose point of view is impersonal and whose appearance is marked by austere reduction and simplification; the mechanically precise restraints of this international style probably derive from Malevich's Suprematist experiments in Russia around 1913. Much of his business has been with the distillation and purification of the grammar of art, so it is hardly surprising that, during one of his teaching spells at the Central School of Arts and Crafts (then flourishing under the aegis of William Johnstone), he developed a fundamental tool that was later to be widely misused and cannibalised – a Basic Design course still regarded by many as the finest ever produced.

By strange coincidence, flying seems to have been part of the lives of both Turnbull and Davie (who is a keen glider pilot), as well as those of two contemporaries who were content to make considerable reputations at home. Both **William Burns** (1921–1968) and James Cumming (b1922) served in the R.A.F. and Burns retained a passionate interest in flying which eventually led to his death in a murky dusk at the end of a solo flight from Dundee to Aberdeen. A painter who had made a major contribution to Scottish art was thus lost too soon. His importance lies in the way he took a vernacular theme and gave it an international dimension of style without ever losing its individual nature; that is the measure of his integrity.

Somewhere over the rugged North-East coast, whose sea-towns and fishing harbours were the constant source of his thematic material, disaster overtook him. It seems oddly paradoxical that the instrument of his death should have been that which abetted his bold vision in its original point of view. In both his life and work, Burns was something of an outsider, a strong and ebullient personality who often seemed formidable until closer acquaintance brought into focus a vein of humour and the warmth of spirit that kindles friendship. Born in Newton Mearns, Renfrewshire, he studied at the Glasgow School of Art from 1944 to 1948, spending vacations at Hospitalfield. His artistic progress was a pilgrimage, a search for a way of symbolising his subject which would not be purely cerebral but would convey the physical essence of its character and various parts through a disposition of form and colour; so that one might, thereby, almost smell the salty tang, the tar and the fish, or hear the gulls mewing as they wheeled over the breaking surf. To this end, his paraphrases always incline towards, but stop short of total abstraction; and their design – from around 1960 onwards – was frequently suggested by aerial views he obtained in the course of his favourite hobby. Like Eardley, he came out of the West to find his greatest moments on the Eastern sea-board; and like Henderson-Blyth, his survey of North Sea fishing harbours was fundamentally romantic and involved an extremely rich handling of pigment which one would readily attribute to the Edinburgh School.

Though another loner whose thinking has always been independent of the Edinburgh School that bred him, **James Cumming** (b1922) does share its general predilection for impeccable surface colour and presentation. But there are powerful intellectual forces at work behind the physical beauty of his painting, and they have been deliberately concentrated on two opposing facets of his experience; a romantic contemplation of a lonely community in the Hebrides has been replaced by a reflection upon the nature of universal order. Cumming was born in Dunfermline and had begun studying at Edinburgh when war took him for service in the R.A.F. from 1941 to 1946. After resuming and finishing his course, he was awarded a travelling scholarship which enabled him to spend fourteen months in Callanish on the Isle of Lewis.

There, in 1950, he established his identity as a painter, and for eighteen years afterwards, the local characters, their possessions and surroundings were the source for paintings that are Expressionist in spirit but often – and most noticeably, perhaps, in arrangements of still life on lamp-lit table-tops – seem to stem from a post-cubist type of analysis, whose superficial appearance sometimes faintly recalls Vorticism. After a short fallow period, he turned his mind to the origin of life itself and from microscopic observations of human cells, proteins, alkalis, fibres and other minutiae, he embarked upon a long series of paintings which are often mathematically composed and may look entirely abstract but are based on cellular constructions that actually exist in the natural world. Latterly, he has also discovered links between the linear patterns found in such cellular structures and certain undeciphered symbols used by prehistoric man; links he believes to be significant and which provide him with an inexhaustible visual vocabulary. In another sense, this takes him back to Callanish and the portentous presence of its standing stones.

This notion of a basic language made up of units common to man's experience of the universe is supported by a study of early ornament and may account for the

apparently Celtic rhythms that can occasionally be read between Cumming's lines. These inflections relate him to Alan Davie. The differences between the two men are obvious – Cumming is quietly calculating and highly polished while Davie is effervescent and carefree; and their distinctly separate visions rest on quite disparate bases – Cumming's language is drawn logically from scientific research and procedure while Davie's is a haphazard and personal affair of ritual symbols and dances. Yet both are concerned with abstracted signs and forces; and both seek to seduce the eye with sensuous colour effects. In some of Cumming's recent paintings, the human figure is re-introduced within the framework of a vocabulary that is otherwise abstract; and he has returned to treat the still-life table theme. In company, Cumming smoulders with a ferocious energy that may burst out in a stream of fantastic humour or stimulate lively discussion. With these qualities, as well as the patent sympathy he displays for those embarking on a creative life, he has made a very personal contribution to teaching at Edinburgh since 1950.

Now the reader must forgive a slight change of gear as I lapse temporarily into the first person to describe something of the career and painting of **Edward Gage.** Born in 1925 in the village of Gullane, East Lothian, my first twelve years were spent idyllically only a lapwinged golf course away from a golden-duned beach and a mere loup over the wall to the house and garden of Greywalls, a gracious piece of English environmental design by Sir Edwin Lutyens originally planned for the pleasure of King Edward VII. Educated at the Royal High School of Edinburgh (where I was encouraged by Arthur V. Couling – a contemporary of Gillies' – and later by Paul Rayner), I began studies at Edinburgh College of Art in 1942; resuming in 1947 after service with the Scots Guards, The Royal Scots and finally as a staff officer in the Far East. A post-graduate year in 1950 was followed by a travelling scholarship the year after.

Using Cumming's Hebridean interlude as a precedent, I gained permission to spend most of my time painting rather than visiting galleries and went to Deyá, an ancient and magical village perched between mountain and sea in Mallorca (then but a gleam in a travel agent's eye), to find myself as a painter. Here I was assisted by the kindly example and friendship of the poet, Robert Graves, who first taught me how to look for the significance behind events and occurrences, re-awakened my interest in the Greek and other Myths, and by his own personality and achievement, gave me a yardstick for measuring true greatness. Thereafter, I was art master at Fettes College for sixteen years – during which time I also worked professionally as an illustrator and stage set designer – before joining the staff of what is now the Napier College of Commerce and Technology.

As a student, I was strangely much more influenced by the work of artists like Diego Rivera, Stanley Spencer or Graham Sutherland than that of any of my instructors; though I could see their qualities and learned from them in class. There were exceptions, however, in the case of Rosoman and Maxwell, whose work I admired for the intellectual and imaginative properties invested in it. Rosoman's painting exemplified a central desire of my own to invent unusual pictorial structures, while Maxwell's poetic fantasy sympathetically detonated my own romantic imagination; as none of us are exclusively male or female but a balanced mixture of either sex, so are artists neither purely classical nor romantic, but a *mélange* of these two sides of the creative nature.

[42]

I share William Blake's belief about art being a spiritual activity; and I think of painting primarily as a means of communicating my thoughts, ideas and observations by making an image a vehicle of metaphor in the same way as a poem is for the poet. Thus, the efficient transmission of the message in question is more important to me than idiomatic or stylistic developments and I will often vary formal approaches to suit the subject; trusting my own intuitive 'handwriting' to stitch the whole *oeuvre* together. Neither have I any qualms about moving freely between real and imagined events, between things seen with what Blake called the 'outward' and the 'inward' eyes; nor in adopting whatever degree of representation or abstraction seems right for the matter in hand. Perhaps because I find people provide the chief fascination in life, however, my work is predominantly figurative, and even if the human figure is not actually there, its presence is generally felt, inferred or even symbolised – as has happened recently, for instance, in the standing forms of trees.

My early paintings were often couched in a vein of expressionist fantasy involving potent symbols of birds, moons, jesters, goddesses, queens and other personal or contemporary versions of significant mythological characters – especially from Greek sources. Some of these familiars, like the deified woman and plummetting Icarus, are with me still and make their re-appearances from time to time in each change of circumstance as my vision evolves towards more considered and economical solutions. From the visible world, observed incidents of a bizarre or humorous disposition generally attract me; I find still-life of little interest, but the thematic moods and forms of landscape, though I have been long in appreciating the immense poetic power of that subject, now absorb me deeply.

While new tigers arrived to sniff at its gates in the decade that began in 1950, Scottish painting maintained its own equilibrium and the most successful group of younger painters to emerge seemed content initially to work from the experiences of Gillies, Maxwell, Redpath and MacTaggart, who were then all painting more or less at their peak. Though the influence of three of these impinged quite directly, so that traces are visible, Gillies is inimitable and his influence indirect – a matter of spirit and attitude rather than anything tangible. Such examples, of course, allowed for a wide choice of direction and future development – an advantage which the enthralled younger painters appreciated – and most of them have, in turn, pushed their own visions towards new frontiers; some even beyond those of Scotland or France. But, in doing so, they have lost neither the prevailing love for pleasing surface and colour nor the vein of poetry that continually informs the work of the old quartet.

Once more, the group that cohered visibly was a loose one of like minds, dispositions and tastes; and one more, it consisted principally of four members – David McClure (b1926), David Michie (b1928), John Houston (b1930) and Elizabeth Blackadder (b1931). All contemporaries at the Edinburgh College of Art, they were the centre of a youthful circle which gathered particularly around Anne Redpath, who much enjoyed stimulating company and whose son (David Michie) was one of the new quartet.

Though a respect for Gillies and Redpath is fundamental in his work, of the four it was **David McClure** who assumed most of Maxwell's poetic themes and fantasies. Born in Kinlochwinnoch where his father was trained as a furniture

designer, he began to read English and History at Glasgow University. This was interrupted in 1944 by a period of war service in the coal mines during which he discovered that a previous interest in painting was beginning to consolidate. On his release, he joined the first of the Fine Art Degree courses which are still held by the University of Edinburgh in collaboration with the Edinburgh College of Art. He was awarded a travelling scholarship to Spain and Italy, after which he taught at the College before being made a Fellow in 1955. A period living in Sicily acted as a catalyst on his imagery by injecting an element of social satire and commentary into the narrative line that frequently lurks in his painting. But generally his work celebrates the visual beauty of the things he loves and the best of it produces thrills of sensuous pleasure at the richness of its handling and the immaculate manner of its making – for matters of presentation are extremely important to him. Highly intelligent signals of enjoyment, they have winning ways and though they may be self-indulgent at times, they are usually most carefully disciplined.

He has often repeated variations of a still-life theme involving flowers, a marble table-top, a white dove, a violin and a picture on an easel; he has made attractive records of local landscape and coast; he indulges in occasional fantasies; and recently he has adopted the female nude as the main motif in a series of big interiors. While communication of his enthusiasm for the figure as a desirable object gives these pictures a heady intoxication, they remain objective and sail close to the Symbolist tack of Gauguin or the ecstatic, pattern-forming simplifications proposed by Matisse. McClure's own influence now radiates from Dundee where he has taught at the Duncan of Jordanstone College of Art since 1957.

From similar roots, **David Michie** has forged an art that is less consciously poetic, perhaps, and more intellectually entertaining by virtue of its very personal sense of humour and a daring outlook on pictorial design. Born when his mother was living in St. Raphael – his father was an architect – Michie began art studies at Edinburgh in 1946. Interrupted by two years of National Service, his course ended with a travelling scholarship to Italy, after which he taught part-time before joining the staff of Gray's in Aberdeen. In 1962, he returned to teach at the Edinburgh College where he now occupies a senior position. To have a mother or father who is a distinguished painter can make life difficult for a young artist, the formation of whose own style can hardly avoid being strongly influenced by that of the parent, either towards tacit agreement or open revolt. Michie has survived this embarrassment uncommonly well and though he naturally shares many of Anne Redpath's preferences, he has, for example, jettisoned the rich textures that frequently appear in his earlier work and developed in the direction of a flat and simplified organisation where colour remains intensely important but is thinly applied, and where decorative elements of line and pattern are given more emphasis. More positively than McClure, therefore, he proclaims some kinship with Matisse, who was the first to isolate such elements of rhythmic decoration and to create a type of structure whose architecture seems to have grown organically in a series of arabesques. A family liking for the exotic is reflected in his unusual choices of subject – the sign board of a shop, a back-garden swimming pool – which are generally selected because of some idiosyncratic appearance. These, in turn, become the raw material for deploying visual language in a vivacious manner that vibrates or explodes with elegant wit. Though he is a serious and dedicated man with a strong sense of duty, Michie has a

profound sense of humour which expresses itself in a cerebral fashion that is also quite typically French.

The progression in **John Houston's** painting has also been towards a simplification of the image. Of all his gifts it is his power as a colourist that has provided continuity; but increasingly, he has used colour to produce atmosphere in a way that exposes strong Expressionist inclinations. Houston is a Fifer, born in Buckhaven and brought up in Windygates, and he has been teaching at the Edinburgh College of Art ever since the end of the travelling scholarship awarded him by the College in 1953. A draughtsman of penetrating skill, an arranger of unerring ability whose sensitivity to mood allows full rein for his communion with the elements, his manipulation of colour has, in the past, had something of Bonnard's talent for invention and surprise. Predominantly figurative, his previous themes have included gardens, flowers and birds as well as landscapes, sea coasts and skies; emotive fragments paraphrased in varying permutations of abstract, realist or expressionist idioms. Houston is unusual in that he is prolific but has a low wastage ratio; and his development is seldom stationary.

Recently he has concentrated on evoking the changing lights and moods of weather that occur in vast tracts of water and sky which he has contemplated in Scotland or by the North American Lakes. This he does on large canvases in a gestural manner that flows with deceptive ease and in which formal matters are often compacted to a minimum – a circle of sun, a trailing cloud or reflection, a divisive horizon, an intrusive patch of foliage – while he confronts us with sonorous orchestrations and pulsating schemes of colour that become sources of atmospheric light. Here he shows a relationship with Nolde or Monet as well as with Mark Rothko, whose big, environmental fields of colour represent the more tranquil side of American Abstract Expressionism.

Houston is married to **Elizabeth Blackadder,** who was born in Falkirk and, like McClure, was a fine art degree student at Edinburgh. She has taught at the College since 1956. Though rejoicing in feminine traits – a collection of pretty things, a love of pattern – her sense of design is taut, restrained and dignified in a way that few men can emulate. Yet another artist who paints what delights her and communicates that delight, she does so by placing reality at one remove and subtly distorting or reducing it to an essence of signs, movements and colours; but without ever losing its point of reference.

The decisions she makes are often exciting because she seems to take enormous risks while remaining apparently relaxed. Her recent solutions to still-life begin from the ambivalent attitude to space proposed in Anne Redpath's tilted table-tops. In her elaboration of this principle, the amount of two-dimensional vertical space is normally generous; so that the formal structure depends on the variety of the objects themselves and the manner in which they hold each other in tension at different intervals. This may suggest a rather cool or intellectual vision, but these extemporisations are often hauntingly beautiful in colour and their character is further softened by the nature of the selected articles and the loving care with which they are translated into pigment. These beloved bits and bobs illustrate her predilection for the colour drama of veined or striped patterns – an agate, a tulip's head, a child's indiarubber ball, ribbons, carpets, Easter eggs, rainbow fans and so forth. Recently, however, forms have appeared in her work that are patently

geometrical or even Cubist in derivation; while, conversely, she has successfully transfigured such subject as flowers and pussy cats that are normally clichés in the repertoire of 'lady artists'. Her other favourite theme is landscape and here interpretations often concentrate on condensing layers of atmosphere into a mysterious ambience of tones and colours which sometimes reaches an unusual pitch of sensuous appeal. This artist has achieved a peculiar academic distinction because she is the only Scottish woman painter ever to be elected to full membership of both the R.A. and the R.S.A.

If one continues taking events chronologically, the next group of names encountered are not bound by anything much more specific than contemporaneity; their contributions remain individual. It is interesting, however, to note that four of them – Balmer, Busby, Callender and Reeves – are, in fact, English by birth and only Scottish by adoption. Sometimes one tends to think that the general drift of artists makes a creative drain flowing only from North to South, but that is far from the truth; Joan Eardley's is not a singular instance and Scottish art has often been well hanselled by Southern incomers.

The West Riding of Yorkshire, **John Busby's** native heath, is quite close at hand. Born in Bradford in 1928, he studied sculpture and painting at Leeds College of Art before coming to work in Edinburgh in 1952. Three years later, his achievements were recognised by the Edinburgh College of Art and he was awarded a postgraduate year followed by a travelling scholarship to France and Italy. Since then he has been a member of the College teaching staff. He made his first Scottish home in Prestonpans but recently has moved inland from the East Lothian coast to the village of Ormiston. Busby is a man of parts; a devout and evangelical Christian, he is also musical (his wife is a professional singer) and a serious student of the fauna of Scotland who has continually made pen studies of birds. In this respect, it is easy to appreciate the value of his presence on the coral Atoll of Adalbra in the Indian Ocean where, for six weeks in 1974, he lived and worked with a group of scientists sponsored by the Royal Society. But Busby is also an activist. Among many other things, for example, he is a founder member of the Society of Wild Life Artists and was a long-serving committee member of the original 57 Gallery – a small organisation of unusual significance to which I will refer again shortly.

Compared with that of most of his Scottish contemporaries, John Busby's painting has a cooler and less emotive temper that puts more obvious store on objectivity and intellectual control. He does rely on the expressive power of colour, but even then there is nothing overtly sensuous in his handling of pigment as he modulates each tone and hue with a subtle precision which admits nothing haphazard. It is as if a smooth English accent had been only slightly roughened and broadened through Scottish acquaintanceships. Yet the difference is not merely in superficial veneer. The attitude behind the manner in which he treats his subjects – the structure and movement of three of the elements personified in the land, the sea and the sky – has a deliberately poetic angle to it that is unmistakably English in the same way as Paul Nash's vision reveals his origins. Nash, of course, used metaphor and symbol to mark hidden forces in Nature, whereas Busby's business is with expressing the essential spirit of things; it is not at all at odds with the divine inspiration in Blake's quatrain that begins – "To see a World in a grain of sand."

But though he is no visionary in the Blakean sense, there is a quality in his painting that is unmistakably religious in the wider definition of the term which goes beyond mere religiosity of theme (though he has, in fact, painted a mural of *Christ in Majesty* for the Church of St. Columba by the Castle in Edinburgh). The lyrical element, of which he is quite conscious because he has often explicity called his paraphrases *Canticles*, is a heightened way of seeing and it is crucial to his art. Each painting is a spiritual offering of praise for an expression on the marvellous face of nature; and in it he distils the essence of a visual experience, exalting it in atmospheric colour-ways quite splendidly refined. Formal movements are reduced to simple striations of undulating bands that never seem dull or uncomfortably austere. He has discovered the roots of these sensations to be unconfined, as likely to appear in Jordan as in East Lothian or the Pennines.

Reduction of the visible world, this time towards more patently decorative ends, is also a principal characteristic in the work of **Barbara Balmer** (b1929); though her interpretation remains firmly fixed in a figurative idiom and her line of poetry derives from the isolation of particular aspects observed in traditional themes such as still-life, interiors, landscape and the occasional portrait. Born in Birmingham, she studied for two years at the Coventry School of Art, spent one year in industry as a display artist for Rowntrees of Scarborough and then won a scholarship to Edinburgh College of Art. Her time there extended to four years including post-graduate and travelling awards. She now lives in Aberdeen, lectures at Gray's School of Art and is married to George Mackie, himself a gifted illustrator-typographer and a delightful painter on an intimate scale. His gouache records are always full of diverting information and although they are designed with some rhythmic intent and formal strength, these emphases are softened by a remarkably sensitive manipulation of pigment which subtly evokes mood and atmosphere.

Atmosphere is less immediately resolved in his wife's painting where it is usually the outcome of careful gradations of colour and tone. Indeed, when her work first appeared it often seemed as if her feminine urge for decoration might confine her role to that of a charming storyteller with a well-modulated voice. But behind her clear-eyed imagery lay inclinations towards poetic allusion and a surreal suggestion of mystery which have led to a widening of her vocabularly.

At the centre of her vision lies an acute awareness of orderly structure, and there is a mailed fist beneath the pretty velvet glove – a hard and linear precision, a virile inventiveness and authority of design. Now, as maturity has brought resolution, the qualities in her painting are more easily listed, involving as they do natural elegance, refinement of form, meticulous execution, exciting arrangement and the strong reflection of her feeling for and desire to express pattern; her relish for flat design, close tone and subtlety of drawing. Her language is one of simplified and decorative realism which eschews obviously sensuous traits like thick paint or rich colour, but reaches out to embrace the poetic implications of mood. Her process of reduction includes techniques that are deliberately mechanical – hard edges (often straight), a clearly defined tonal system – and a formality dependent on linear rhythms. The smooth hardness of her surface is substantiated by her preference for painting on wood rather than on canvas.

While these attributes are admirable enough, their effect has sometimes appeared superficial and illustrative. Recently, however, and especially in a group of oils

whose theme is the Tuscan and Umbrian environment observed in drawings made over two summer visits, conclusions have been different because forms have become more classically decorative. The grey-green hue of the ubiquitous olive leaf is a dominant colour in these bleached paintings where sunlight is gently transcribed into relationships of tone. The atmosphere is that of misty morning rather than the blistering heat of midday and, like stage sets tidied before opening nights, no dust or dirt mars the orderliness of pictures whose mottled frames echo the patterns of chiaroscuro within them. Abstract elements have now become the primary content of such images and one admires their calculated display of balletics – the swaying tree-trunk arabesques, the spring of an arch, the lift of a tower and the dancing facets of light and shadow.

Despite the fact that youth is no longer on his side – except quite literally speaking – **Robert Callender** (b1932) continues to find himself type-cast as the angry young man. With his independence of thought, his sympathy for youthful endeavour and his dislike of paternalistic establishments, this is not altogether unexpected. Nor is it surprising that he has been voted President of the S.S.A. for two terms of office so far and, moreover, that after having been elected an Associate of the R.S.A., he proceeded to resign in protest at what he considered to be a lowering of standards in a subsequent election.

Born in Nottingham, Callender studied at South Shields Art School and Edinburgh University before going to Edinburgh College of Art in 1954 where he eventually became a post graduate and travelling scholar. Later, he lived in France, lecturing in Aix-en-Provence; and obtained a scholarship to travel in Italy and Spain from the British School in Rome. Since then, he has taught at the College in Edinburgh and was chairman of the 57 Gallery in the 1960's.

One of the first painters in Scotland to explore areas of the language of Pop Art – which he did with a degree of wit for some years – his individual achievements, which often seemed obscured by the idiom he had adopted, became evident at last in a big retrospective show mounted by the New 57 Gallery in 1970 at the William Robertson Building, Edinburgh University. Callender's strength as an artist depends on positive elements in his own rugged personality – he is honest and outspoken – and he then appeared to be both appalled and highly amused by the habits of the admass society. But he also nourishes a romantic Wordsworthian feeling for Nature – for the grandeur of mountainous landscape, for instance, or the pebbled and rocky precincts of a deserted shore of the kind that would have sent Ruskin reaching for his watercolour box. He nurses a desire to crystallise his thoughts in symbols that range from the blatantly common to the highly poetic. When these opposing attitudes occur in the same work, or when an object that is intrinsically vulgar is seen through his eyes as a thing of formal beauty and mystery, the effect can be electrifying and not a little surreal. This happens most spectacularly, for example, in several painted wooden reliefs he once made based on shooting galleries he had observed in amusement arcades at Blackpool.

Among his significant attributes are a hawk-like, analytical eye (he was once a medical illustrator) that roves restlessly in search of fresh grist; and a meticulous technique which, even at its most mechanical, somehow contrives not to appear so. Callender has tended to follow international mainstreams and this technical accomplishment has given him the freedom to slip easily from the satirical juxta-

position found in Pop Art's re-assemblage of images from the mass media to the dead-pan boundaries of Photo-Realism. But he is, above all, a potent maker of icons, who once proved that ability by imbuing a Lilo with almost as much sensuous appeal as one finds in a Venus by Titian. As he has embraced a wide variety of theme, so he has changed scale, treatment and media of expression to encompass everything from environmental constructions on the one hand, to intimate pen and ink drawings on the other. His early paintings were generally large and quiet paraphrases of remote landscape. Then came a long series of Pop works full of autobiographical or social comment; the first often humorous, the second usually satirical. Sometimes, however, the satire went unemphasised, as if he thought a mere facsimile of the subject viewed in isolation as an art object were enough comment in itself.

Recently, Callender has found a use for his own type of realist observation and detailed analysis in a way that relates broadly to mainstream developments while returning at the same time to his first point of departure. Now the desolate aspects of landscape inspiring him are in the North of Scotland. A group of pictures interpreting weather-scarred uplands scattered with boulders or occasional sheep – in one a sheep stands transfixed like Hunt's *Scapegoat* (Callender enjoys aesthetic in-jokes) – was followed by a descent to a lonely sea-shore where he contemplated the elemental attractions of pebble and stone piled together in a heavy shingle,
tumbling rock forms, the rippling, flooding tide and mysterious pools. His conclusions sometimes are rather too obviously mechanical or seem intent on astonishing the spectator by his sheer technical skill or tenacious labour. But there are other times when water surfaces become abstract formalisations of light and movement, when the sculptural qualities inherent in promontories of rock have been subtly reinforced, or when the limitations of pencil have been extended to a bravura capable of realising effects of mood and weather. These are moments of real poetry and significance.

Poetry again it is that quickens the vision of the fourth of this group of English-born painters; indeed, one might say that great chunks of it are embedded in the strata of his imagery. **Philip Reeves** (b1931) comes originally from Cheltenham and studied at the School of Art there before going to the Royal College of Art in London. Since then he has taught at the Glasgow School of Art. In some ways he is the antithesis of Callender, whose versatile and extrovert nature is variously attuned to current developments. However, the landscape sources recurrent among Callender's numerous interests are the heart of the matter as far as Reeves is concerned, and this deliberate concentration is suitably matched by a single-mindedness of purpose, a gradual growth in stature, that is as quietly confident as it is impressive.

Reeves is a distinguished and constantly practising etcher and printmaker so it is hardly surprising to find intimate and craftsmanly qualities in his painting. There are self-imposed limitations, for he eschews oil paint in preference to mixtures of gouache and collage – though he does not allow this to restrict the scale of his work to any great extent. Nor has this discipline produced a noticeable poverty in expression or physical impact; on the contrary, within his chosen scope of action he uses pigment as sensuous in its own surface as anything manufactured by Joan Eardley in her breathtaking paraphrases. One wonders, incidentally, whether either of these artists, had they remained in the South of England, would have eventually communicated through that rich quality of matière which is such a Scottish hall-mark.

Early gouaches by this highly individual master of *papier collé* announce his almost exclusive devotion to landscape. Though they are imbued with romantic inclinations, they reveal, nevertheless, an attitude which is already analytical rather than descriptive. By 1968, collage had become his main vehicle of expression and in its deployment he indicated his feeling for subtle textures and colours, for the slabs and interlocking forms of rock, turf, water and sky. These elemental properties he translates and reduces into layers and strips of paper, torn or cut and overlaid with atmospheric paint that is often near to monochrome.

Though he is a consummate designer, there is nothing purely decorative in his paraphrasing and he is content to evoke richness from comparative austerity – transfiguring the humble materials he employs. Occasionally, his expressive, searching and haunting marquetry rises to a low relief; but it makes its greatest impression through the self-effacing mask it adopts and behind which one recognises the authority and strength which derives only from a truly profound and mature spirit.

Despite the fact that they originally hail from different parts of the East Coast of Scotland, the next three artists have for long been resident influences in Aberdeen. The work of Fred Stiven (b1929), William Littlejohn (b1929) and Ian McKenzie Smith (b1935) also represents various degrees of abstraction in the process of formalising from natural sources. In addition, Stiven and McKenzie Smith have both, in their separate ways, been active in publicising aspects of art and design more widely and in integrating them with other disciplines or the daily life of the people.

In company with Dr. John Holloway, a scientist at Aberdeen University and an assistant editor of *Leonardo*, **Fred Stiven** designed and constructed an exhibition *(Integration)* in the early 1970's which was an attempt to put forward "common ground between the scientist and artist"; while McKenzie Smith was, for five years, Education Officer in the Scottish Committee of the council of Industrial Design and since 1968, has been director of Aberdeen Art Gallery and Museums. Under his thoughtful and highly imaginative management, a gallery whose collection has always been remarkably well-stocked has become the antithesis of those forbidding temples of aesthetics where staid and reactionary principles are reverently enshrined and makes, by its lively programmes of events, a positive contribution to the community.

Fred Stiven, who was born in Fife, composes low reliefs of wood so that, strictly speaking, he could quite ligitimately also appear in a survey of contemporary Scottish sculpture. His art, as we shall see, depends on 'found' material for its form and atmosphere so that the creative procedures involved probably relate it as closely to Kurt Schwitters' *Merz* assemblages as to the more definitely sculptural reliefs in wood, metal and other materials once produced by the Constructivist, Vladimir Tatlin. In this respect his innate craftsmanly instincts are shown by the refinement and precise arrangement of his constructions; a trait perhaps inherited from an ancestor in the 19th century who was renowned for the cunning design and fashioning of his snuff boxes. In fact, Stiven trained as a designer at the Edinburgh College of Art and, prior to National Service in the army, was a lecturer in typography. On release from the forces, he worked four years for Fife Education Authority and, in 1958, joined the staff of Gray's School of Art.

As intimate in scale as a small picture, his painted wooden reliefs are neatly boxed behind glass almost as if they were museum pieces; trapped and isolated in these narrow surrounds they still bear the unmistakable marks of a natural environment, of the action of wind and water on the seashore, for instance, where their components lay separate and became finely weathered by time. Stiven beachcombs in remote corners, often on the North-West coast – Ullapool is a favourite place of his – where driftwood is plentiful at certain seasons. In such discovered fragments of material some aspects must obviously be purely aesthetic, but because of their previous existence as parts of a whole object – a fishbox, raft or pier – flotsam and jetsam retain atmosphere and invoke human associations. Ready-made units, some of which may even be worn by the hand of men, they are poetic agencies, evocative tokens obliquely rather than directly touched with nostalgia, and thus are food for romantic contemplation or even introspection. So they encapsulate the passage of time thereby awakening an historical sense – the presence of the fourth dimension.

That is the mood of Stiven's lyrical boxes of tricks; the form they take, however, is more classically abstract and post-Cubist in its general derivation. His chosen *bois trouvé*, already changed by the play of the elements, undergoes a further metamorphosis at his own hands during the business of assembly where a process of whittling, honing and sanding ensures that the planes of these fragments fuse or interlock in a carefully balanced design engineered to give pleasure through arrangement of mass, plane and interval.

But it is the final whisper of pigment, introduced with such subtlety into the various grained surface textures already present in the stuff of his media, which unifies each work, punctuating or articulating the forms and gently emphasising the particular atmosphere. Within the fairly narrow limits of his very personal idiom, Stiven creates a remarkable variety of formal solutions and emotive suggestions.

Unlike Stiven, **Ian McKenzie Smith** is a native of the North-East coast who has lived most of his life with the North Sea at his elbow; dramatic weather lowering the sky over its grey planes to produce a spotlit theatre of effects, its cold white *haar* ever ready to erase the warm and bright definition of a summer's day. Like Stiven's reliefs, McKenzie Smith's abstracted paintings pulse with atmosphere, though it is not at all nostalgic in quality but more directly a distillation of some quiet, elemental state of weather as it hangs, perhaps, softly poised over sea-town streets or breakwaters. His pale images imply space and hint at specific forms clearly enough for the quizzical spectator to hazard a guess at their origin, yet, like Cézanne's landscapes, they also preserve the integrity of the picture plane and can be appreciated as two-dimensional design. While they do so, one cannot but notice how the interlocking systems they describe are not entirely unrelated to Stiven's compositional gambits.

McKenzie Smith was born in Montrose, a coastal burgh of some historical and cultural significance, and is a former student of Gray's School of Art who also worked at Hospitalfield. His first job was a stint of school teaching in Fife. One of the initial champions in Scotland of the hard-edged Minimal and colour-field painting which grew out of Abstract Expressionism in America in the early 1960's, he was a particular admirer of the Englishman, Richard Smith, whose concept of paint and canvas being a single entity led to his actually extending canvases into three-dimensional shapes.

At one time, McKenzie Smith experimented in the same vein, though he generally adopted colour schemes dependent on grey tones rather than intense hues.

However, this engagement with landscape or elemental sources – probably re-awakened on the return to his native sea-board in 1968 – reinstated the rectangular format, softened harder edges and encouraged surfaces that were obviously hand-wrought, painterly and luminous instead of being mechanically anonymous. Always cool and lyrical, his conclusions are now vitalised by a certain immediacy of gesture and characterised by a nature which is at once relaxed but fastidious – the latter especially in matters of presentation, in which he is impeccable. From misty North Sea allusions, he has recently moved towards a freer reaction to similar phenomena, in which a Zen-like detachment seems to add an oriental measure of refined contemplation. The inspiration for some of these abstract paraphrases is still clearly the sky and his gestures speak with an economy that precludes any self-indulgent welter of expression and is bent on ordering a beguiling poetry of shape and colour.

Imperceptibly wringing pure chords from narrow parameters of colour which, in other circumstances might well be dismissed as 'pastel', his notation murmurs in light tones more impressive than many a shout of blatant hue. As his brush splodges, dabs, trails and washes over the unprimed canvas, the effect is exhilarating and, very soon, sources other than skies appear – angular movements conjure walls or the profiled ridge and pitch of a line of hills; we find ourselves on the verge of resolving a hidden landscape. Lately he has also put together small studies where collaged sheets of paper or glass-fibre combine with pigment. Like his paintings, these things are slices cut from Nature's moods; diaphanous poems about delicate atmospheres.

William Littlejohn is another born-and-bred North-Easterner who comes from the town of Arbroath, just fourteen miles down the coast South of Montrose. It may seem surprising, perhaps, how fertile the North Sea coastline from Dundee to Aberdeen has proved and continues to be both in producing and attracting painters – James Morrison, James Howie, Gordon Bryce, Ian Fearn and Robert Cargil are a distinguished few among a large number of contemporaries whose work, unfortunately, cannot be examined in detail within the limited scope of this present book – but one should not forget the existence of art colleges at either end of that stretch nor of Hospitalfield lying in between. Littlejohn studied at Dundee from 1946 to 1952 and taught for thirteen years in Angus schools before being appointed to the staff of Gray's in 1966. In 1970, he succeeded Henderson Blyth as Head of Drawing and Painting.

Quietly shy and retiring in personality, his innate gentleness is complemented by stability and strength of purpose. For much of his painting life he has been involved with pictorial structures of considerable complexity, where formal inter-relationships are further complicated, first by an iconography which often contains a simultaneous appreciation of facets normally separated by time and space – like seeing through the walls of an interior, for example – and secondly, by the ambiguity of the visual language he uses to achieve such ends. His language hovers attractively between abstraction and representation, as if endeavouring to capture the best of both possible worlds; a language that is quite consciously sensuous and lyrical in its romantic ambiences of tone and colour; a language sweetly intent on pleasing the senses through the measured order of its construction. Once again we

find an artist taking immense pains in the presentation of his material.

It is clear that processes of analysis and synthesis are at work to some extent in Littlejohn's vision, but it is also distinct from others in the way he arranges for representational elements to live so happily in abstract company. His work is enhanced by colour schemes more vital than those favoured by Stiven or McKenzie Smith but which also spring from the coastal environment – schemes where the misty blues and greens of reflecting sea-light or the pale ambers and umbers found in floats and nets activate subtle floods of grey. He keeps his pigment predominantly thin. An emphatic but considered calligraphy also enlivens his imagery, though it never gestures out of control, even when describing the splattered commotion caused by a seagull's fluttering invasion of his studio – an important theme from the beginning of his maturity which allowed him to create an arabesque of disturbance within a classically ordered stillness.

The still-life-studio-window subject matter, in fact, provided for a long series of big, handsome, even tempered variations which eventually seemed to lead towards some profession of his kinship with Ben Nicholson; especially as his style became less decorative and more concerned with the intellectual values of abstraction – though texture and pattern are deeply embedded qualities he has never relinquished. Most recently, however, he has been developing forms which are more severely abstracted in character; heavily textured images, these paintings show him experimenting with watercolour, collage and a wider set of scales.

The artists now appearing in this account all began to gain some recognition in the 1960's. I have referred already to the tumultuous nature of this decade. Outside influences did begin to have a catalytic effect within the country; especially, of course, among younger artists who started seriously to question the values inculcated in art schools where, for so long, canons of painting had been broadly based on late 19th century French ideas.

Though at first the revolution was almost imperceptible, it quickly gathered momentum and soon many new directions were being explored and modified to suit individual or group inclinations. The situation was exacerbated by the increasing number of students attending art colleges. The number of artists with really promising futures who emerged did not increase in ratio it never does – but there were more people dedicating their lives to some kind of creative production for which there were few outlets.

The annual Academy and Society mixed exhibitions were not predisposed to accept experimental or *avant garde* work while private galleries at the end of the 1950's were extremely thin on the ground and inclined to discriminate in favour of artists who had already arrived. No new gallery matched the splendid reputation which continues to be enjoyed by The Scottish Gallery (Aitken Dott) in Edinburgh where highly professional standards have always been maintained and Scottish art has benefited from the enlightened sensibility of directors like Mrs. Proudfoot or the late Bill Macaulay. At the period in question, this gallery was almost the only respectable private outlet for a painter's work.

In response to the new demands, however, commercial galleries began to appear – many in Edinburgh and a healthy few elsewhere in the country; though I have never understood why Glasgow seems to have thrown up less than its needs and Cyril

Gerber's lively Compass Gallery is a lonely champion of contemporary art. Some of these mushroomed and died, others stayed the pace and are with us still. But from the artists' point of view, another and very special type of gallery arose to pioneer a different and altogether altruistic concept.

In 1957, Daphne Dyce Sharp, then a sculpture student at Edinburgh, rented a room on the second floor of number 53, George Street to use as a studio with the intention that when she, or any friends, might want to put on a one-man show, it could serve as a gallery. Shortly afterwards, she moved to a more convenient studio and it was then decided to turn the room into a permanent gallery to be run BY artists FOR artists. An Association was formed under the chairmanship of the architect, Patrick Nuttgens (now Director of Leeds Polytechnic), who presided over the drawing up of the constitution. In 1966, the gallery moved premises to what was later the first section of Rose Street to be redeveloped into a chic pedestrian shopping precinct. It also adopted a prefix and called itself the New 57 Gallery.

Robert Callender remained a guiding light until 1969, since when Sandy Moffat has played a leading role in its affairs. Now it is located more permanently in larger quarters above the Fruitmarket. I shall later have something to say about its recent activities and instructive exhibition programming, but here I must stress how, from its inception, it has made a sound and lasting reputation for itself as well as an impact on Scottish painting which is out of all proportion to the diminutive scale of the physical space it occupied. I have no doubt that the chief reason for these circumstances lies in the fact that the gallery arose out of genuine necessity and is administered by a committee of artists. Quasi-benevolent busybodies have always taken it upon themselves to propose ideas they believe society needs and then seem naively surprised when their projects come to grief. If a thing is really needed, the people concerned themselves will make it happen.

As we resume examination of the work of individual artists, the point of origin in the case of the next three is Glasgow. Two of them, John Knox (b1936) and Ian McCulloch (b1935) actually exhibited together at the 57 Gallery in 1962. **William Crozier** (b1933), whose painting I intend to discuss first, never did and has, in fact, spent most of his time living and working outside Scotland; though he has shown on several group occasions at the Richard Demarco Gallery and once in a company that included Knox and McCulloch. The three of them do have something in common. While they all understand the sensuous appeal of rich pigment or colour that is their natural heritage, they cannot regard it as an end in itself but merely as the vehicle for communicating ideas.

Born in Clydebank, Crozier studied at the Glasgow School of Art from 1949 to 1953 and thereafter worked in the discipline of theatre decor for two years. Since then, he has lived in Paris, Dublin and Malaga and has taught at the Bath Academy of Art, Corsham, and the Central School of Arts and Crafts in London. At the time of writing, he is Head of the Fine Art Department in Winchester College of Art.

Crozier's gifts are quite personal. He has two outstanding qualities. One is an inborn flair for pictorial invention which never appears to be the result of laborious preparation or problem-solving, but seems rather to have flowed spontaneously, though always under some inspired control immediately sensitive to such values as rightness of balance. Despite deliberate eccentricities, the spectator implicitly trusts the artist's instinct and is willing to believe he can put no foot wrong. The

second is his gift for paraphrasing the visible world in a way that quickens the senses because it is broad and robust yet still profound enough to convey the tremendously energetic or throbbing pulse of Nature; thereby his statements are endowed with a meaning which is intensified and heightened by poetry. The mood I suggest he achieves is the very antithesis of the pastoral lyric and more akin to the convulsive but measured abandon, the primitive force that beats inexorably throughout an orchestral composition such as Stravinsky's *Sacre du Printemps*.

Like Samuel Palmer he allows us to identify with the spirit of a place or event, but at the same time his concern is for moody expression and the agitation of his brushstrokes, his sweeping design and complementary colours also come within hailing distance of the troubled genius of Van Gogh or Francis Bacon. Angular and sinister skeletal figures have made their appearance in his imagery. Though frequently intense, his colour schemes – red, green, blue and black often predominate – are adventurous without being at all vulgar and also contribute to a physical satisfaction indicative of a secondary characteristic – a decorative quality that is bold and beautiful in its simplicity.

Knox and McCulloch were among a small and lively bunch of painters who, in the later 1950's, stepped out from the comparative shelter of the Glasgow School of Art into the full Westerly blast of Abstract Expressionism. Both of them, bowing to irresistible, emotive force, reached for large brushes dripping with strong colour and proceeded to cover big canvases with gestures whose freedom and directness were admirable in themselves. **Ian McCulloch** was born in Glasgow. He went to the art school in 1953 and left in 1957, spending some time also at Hospitalfield; since 1967 he has been a lecturer at Strathclyde University. He is a founder member of the Glasgow Group, another body born in the West almost simultaneously with the 57 Gallery in the East, but assuming a slightly different form. The reason for its being, however, was similar – the lack of outlets for the work of fledgling artists. Though the exact history of its inception is confused, it certainly built itself around the diploma class of 1957 at the school of art whose student list, besides Knox and McCulloch, included Carole Gibbons, Anda Paterson, James Spence and Alastair Gray. But the inspiration behind its conception seems to have come from two slightly older painters, James Morrison and Allan Fletcher. (The latter was a most exciting artist and his studies of lamps in slabs of grey impasto echo something in the *oeuvre* of Nicholas de Staël; he died tragically young from a trivial accident in Florence). At first the band called itself the Young Glasgow Group and each year rented the McLellan Galleries in Sauchiehall Street for an exhibition of members' work. Though time has inevitably changed its original character, the group still exists and holds its annual show; but it is only half as local as it once was and allows 50% of the space to exhibitors from outside the city.

After the immediacy and freedom of his early period, the pendulum swung the other way in McCulloch's work, which entered a phase of rigid control and formal austerity. Now he reduced his language to a basic grammar, a shorthand mixture of notations that were either frankly geometric or, if organic in derivation, were described in the anonymous and economic style of the universal diagram. His was a hard-edged, slim library of simple shapes that were quite rudimentary and commonplace – stripes, foliate and floral designs which he mirror-patterned and, in kaleidoscopic repetition, coloured with bitter sweetness or scumbled with mech-

anical tone. His work at this stage suggested the invasion of the organic world by the machine.

In later developments, the nature of his language remains the same; bright colour is used to attract the spectator to the message contained in the forms and symbols. Now, however, his reduced vocabulary can more easily be seen in relation to the way in which Pop Art adopted mass media techniques or the evocative use of collage in assembling fragments of printed ephemera, for example, so as to produce a particular result. Not that McCulloch physically employed collage; rather he borrowed the creative effect ensuing when a variety of images from different sources are juxtaposed. As his messages now concern certain aspects of *"la condition humaine"* – Vietnamese victims, emigrants, family groups, soldiers – the human figure naturally becomes a prominent feature, but, in representing it, he uses line; not a line at all remarkable for its aesthetic refinement or varied sensitivity, but a bold outline of even thickness, a common denominator of a line whose type is also preferred by Patrick Caulfield – for other reasons. Underneath the linear design, colour moves freely and often independently to increase the complexity of the whole image and even produce shaped masses of its own, running counterpoint to the line. Thus the eye is seduced by the colour first, then the intellect is challenged by the jig-saw pattern and, finally, the mind is engaged with the human problem.

The progress of **John Knox's** art has, in general terms, been parallel to that of McCulloch's. Having established his reputation successfully in an Abstract Expressionist vein, his vision then became even more severe and geometrically orientated in its reaction than that of his friend and contemporary. Colour virtually disappeared – except for thin lanes of yellow· and red, for instance, within tiny facets – and he used the white ground of canvas as an open, virginal field on which collections of mechanistic fragments could be scattered, forming intellectual propositions held in tension to a balance and order. His procedure was not unlike that exploited by Elizabeth Blackadder in her still-life arrangements of favourite things, but the result was infinitely more clinical, being drawn anonymously in black with an engineer's precision, and seemed more keenly intent on exploring and defining concepts of space. One of his titles, the *Battle of San Romano*, for example, deliberately refers to the *Rout* of the same name painted by Paolo Uccello, that father-figure of linear perspective. Such reference to the Italian Renaissance is significant, perhaps not only for its symbolism of rebirth, but for its rational and mathematical consistencies which also appear to be part of these paintings. Some of his *San Romano* equations Knox translated into low relief by inscribing them on transparent sheets of clear perspex which were then slotted into a box as receding planes; thus an elementary definition of space was made and a certain kinetic effect produced for the viewer as he passed in front of the container.

At the same time, his titles and inspirational sources began to move West across Europe and to settle in Amsterdam. Representation of subjects and objects was realised in a visual shortand which was deliberately naive but just as deliberately commonplace and diagrammatic as the calligraphy McCulloch reduced for himself; lodged in the *cliché* as distinct from any fine art terminology and with more than a hint of some attempt to create a popular (rather than Pop) art vernacular whose currency might be universally understood. Here a technical relationship with Caulfield's idiom is more directly relevant than it was in McCulloch's case.

Subjects now included pots of flowers, streams of water, chairs and a frequent basket of pears; they were usually presented as single items and given realistic tone and colour through a style of painting that is also anti-fine art in the frank brevity of its handling. The theme of pears, which, in its eventual ubiquity, came little short of posing a *cliché* of its own, led to a visual catalogue of childish gastronomic delights that may also be appreciated as a series of still life studies and drawings updating the old Dutch mastership of that genre to the glossy magazine advertisement pages which extol our twentieth-century materialism. Though merely "food, glorious food", his jellies, sundaes, cakes, cherries and Knickerbocker Glories – sometimes set within museum interiors to be contrasted with an abstract canvas by Piet Mondrian – often assume a monumental resolution which pleases aesthetically as much as it may stimulate or disgust individual palates.

After leaving art school, Knox studied at the André Lhôte Atelier in Paris. For many years now he has lived in Dundee, lecturing at the Duncan of Jordanstone College of Art alongside **Denis Buchan** (b1937), to whose work I now turn. Like Littlejohn, Buchan is a native of Arbroath and a former student of the Dundee College where he has been a lecturer since 1962. From similar beginnings – gestural action with rich pigment – to those of Knox and McCulloch, Buchan reacted with much less polarity and has never really been diverted from the gutsy punch of the gesture or the dynamic of a loosely-knit composition where immediate improvisation has played some role in its design. In a sense, he has been content to develop inside the idiom itself, pushing it to its limits in certain directions.

Between 1965 and 1970 was a transitional period when he began to retreat from indulgent use of sumptuous pigment. Earlier works, in fact, are succulently decorative organisms variegated in their thematic material; in them, his allusion to the visible world, though fragmented, is explicit enough to make identification of the human figure, for example, an easy matter. But, parallel to Knox, he did move slowly and deliberately into a more austere vision which rejected emotive reference in favour of geometric formality and a structure indicative of spatial concepts. Here he depends on straight lines and the reiteration of mechanical, templated shapes – like the angle-iron which might be the support for a shelf – often clustered at the edges of his large square canvases. Where forms, hitherto, seemed to occupy space fully, they now are dominated by it to become mere points of reference in a definition of its extent. This actually produced an original, more personal kind of vision. In contrast with Knox at this time, Buchan created spaces that were dark and atmospheric; although they were realised in a simple geometry of thin white crosses, they were also illuminated by narrow bands of light and stained with a patchwork of bright colours.

Since that period, however, he has returned to paraphrase and rearrange separate elements from his every-day experience in a bold, rumbustious, calligraphic language that is very much his own and involves orchestrations of hue where chords of red or grey, for instance, are laid on a black ground base. Varied in scale and still broadly handled, these vigorous pictures are so physical and full of energetic activity that the noise they make is splendid. There is also a residue of Pop Art in his imagery – aeroplanes, cars, umbrellas and an Allen Jones type of striding female torso, have been recurring devices – which is improvised in an uninhibited fashion. But it would be wrong to regard all this as sensuous indulgence once again; his

pictorial solutions are excitingly balanced, not by intuition alone but by intellectual intervention as well.

The chronological point of balance in this rather sketchy narrative now lies around the middle of the 1960's and I cannot withold any longer some comment on the catalytic contribution made by the Richard Demarco Gallery. We have discovered extraordinary years occurring in 1947 and 1957; the next important date was to fall one short of this ten year cycle. The gallery in question opened at 8, Melville Crescent, Edinburgh in 1966 and it would be no exaggeration to say that art in Scotland was never to be quite the same again. Because of it, our national experience was enlarged, our knowledge extended and our prejudices sometimes usefully shattered. On the other hand, worst fears were also confirmed. From time to time there were failures and errors of judgement, but the enterprise remains an unique phenomenon. Galleries tend to reflect the character and taste of their directors and none more surely than this. Richard Demarco has been in the business since 1964 – long enough for an *enfant terrible* to become something of a legend as Northern champion of *avant garde* culture, a creature of dynamic energy and tenacious purpose. Enthusiasm is his battery charger. Though always in danger of becoming debased through constant hyperbole – discrimination is not the better part of Demarco – his burning responses to whatever project or work of art currently obsesses him have been the principal factor behind his remarkable achievements.

There are contradictions too in the romantic nature of this ebullient little Italo-Scot. Trained as an artist, he always feels himself primarily to be one (his topographical line drawings are fluent, crisp and intelligent) rather than a dealer; bereft entirely, at one point, of gallery premises, he felt himself more than ever a gallery director; but he is disinterested in art as a commercial proposition. To the objective onlooker, he may appear as an unusual amalgam of impresario, evangelist and teacher; Demarco, in fact, left teaching in 1964 to direct the Traverse Art Gallery. Two years later, his reputation earned him the monetary backing to open his own establishment which immediately adopted a pioneering role that was significantly useful because its programme included much new and experimental work – often of major and international standing – which otherwise would never have been experienced firsthand. In certain respects it did some of the Arts Council's job and when the financial going got tough – as it always seems to have done for Demarco – the Council eventually came to his aid.

The gallery's programmes during the Edinburgh Festival – the competitive Open 100, for instance, or contemporary art shows from Canada, Poland and Romania – have been even more stimulating and controversial and have done a great deal to put the city firmly on the artistic map. Demarco is devoted to Scotland and has had a lifelong love affair with its capital so that he is prepared to sing its praises at the first hint of a foreign accent; one of his recurring dreams is that it should become the cultural Mecca for which he believes it to be ideally suited. The highspot of these Festival contributions was undoubtedly the Strategy-Get-Arts show he brought from Dusseldorf in 1970 and which was dominated by that singular performer, prophet and survivalist, Joseph Beuys.

After his first encounter with Beuys, Demarco began to question his own philosophy and the image the gallery had created. Finding them rather too smart and fashionable, he decided it was time to identify with a new art and think about a

[58]

new type of exhibition space; a concept that would lend itself, perhaps, to multi-media and inter-disciplinary events of all kinds. At this time too, the Scottish Arts Council had itself begun to assume the role his gallery had formerly played. After a period without any premises except an office in the New Town – when it still had the inspiration, nevertheless, to bring such disparate geniuses as the Cricot Theatre and Buckminster Fuller to a temporary venue at Forrest Hill – the gallery took up its present accommodation at Monteith House in the High Street. Recently it has been in a period of transition, when new ground is being broken but old footholds not yet relinquished.

The new territory so far has included the vital notion of Edinburgh Arts. This was initiated in the summer of 1972; a protracted aesthetic jamboree involving students (mostly American), teachers and professional artists; and embracing a variety of didactic situations from traditional lectures to all manner of explorations, improvisations and participations. Instead of being a temple for contemporary art, the gallery has, in a way, become a faculty of it. More recently this experiment has developed into a pilgrimage of discovery in time and space that takes in Europe; not the Europe restricted to the Art Fair parameters of Basle or Documenta, but that wide area of human creativity whose traces are visible and may usefully be cross-referenced; megalithic remains, for example, like the standing stones of Carnac and Callanish. There is a real sense in which modern man needs to find his identity afresh in ancient roots. The Richard Demarco Gallery seems to have its finger on our pulse as it leads the *avant garde* backwards into pre-history.

Demarco has not ignored Scottish art, but often prefers to show homegrown produce that would not normally be entertained properly in other quarters so that those inclined towards establishment attitudes have treated his activities with suspicion or a fair amount of scepticism at the least. Yet he has more than made his point and has done much to induce a more catholic and open-ended situation, an altogether freer atmosphere, a constructive intercourse and exchange of ideas between artists in Scotland and many other nations. It is some proof of this that artists of international calibre like Jon Schueler and Gerald Laing have chosen to live and work in Scotland during the last decade. Some Scottish artists in particular owe a great deal to Demarco's enthusiastic sponsorship. Such a one is **Patricia Douthwaite** (b1939) who, in more than one sense, lies eccentrically outside the familiar patterns of behaviour in Scottish painting – diverse as we have discovered these to be. Douthwaite is a self-taught artist. Born in Glasgow she first studied dancing and mime (she won the Phyllis Calvert Award for the latter) with Margaret Morris and was encouraged to pick up a brush by none other than J. D. Fergusson. She then went to live among a group of artists in East Anglia and, in 1960, married the distinguished and successful illustrator, Paul Hogarth. She also worked in several theatres as a set designer and admits to an admiration for the work of Col-quhoun and MacBryde – though she has never been interested in fine art aspects of painting. Thereafter, she has lived alternately in Paisley, Cambridge and Mallorca.

Due to its nature, her work does not change so much as grow richer with maturity but it has always had an astringent and purgative effect as her pictures are Expressionist caricatures and parodies of her own sex, wherein she strips it almost naked of all dignity and self-respect. *Almost*, that is, because she constantly reminds the viewer by empathy of the humanity lying imprisoned beneath her images of care-

worn flesh, however they may seem beset by phobias or burdened by the tawdry impedimenta of sexual commerce. Her drawings tend to look like a collective protest where the grim joke is not only on her subjects but on all of us who bear witness. Menace is one of their common ingredients and her figures often seem to be reacting in voice and gesture to some awful iniquity or violence. Frequently her deliberately naive, child-like imagery is compelling, her pictorial design arresting.

Of course the distortions she invents with caustic wit and a bitchy eye for detail make a strong psychological impact. But an odd paradox is how she evokes the dark and nasty facets of life so often with such sweetness and light. Her drily pigmented canvases are seductive in arrangement of colour and pattern, her themes, on the other hand, sometimes appear to concern types and characters who would be at home in Tussauds' Chamber of Horrors. Her vision of life indeed seems formidable and pitiless at times; figures are pinned out, as it were, like butterfly specimens on plain (often white) grounds. Skeletal creatures with crumpled forms, their mutilations not only cause social comment through caricature, but seem to rail against the very mortality and weakness of the flesh itself.

They are, perhaps, the *dramatis personae* of some modern morality play, for the skull is quite often discernible underneath the features of a face and elongated limbs twist into postures of dramatic irony. Certain subjects, in fact, have actually been theatrical and certain specific personalities have been identified. But there are other images which are universal in their commentary; bizarre notes of horror lodged in formal conclusions whose rhythms and hues are intrinsically matters of considerable attraction. The grim humour of Douthwaite's vision is typified, perhaps, by the metaphysical symbol of the laughing skull; hers is a disturbing catalogue of legendary creatures both ancient and modern whose distorted and chalky profiles, tortured grimaces and gestures, black chokers and white bandaging, are the unmistakable marks and trappings of a genuine *angst*. Recently, however, she has paid tribute to a heroine in a series of paintings on the theme of Amy Johnson.

Douthwaite is not the last we shall see of an Expressionist painter in this contemporary sample, but, for the moment, I must proceed to another aspect of figurative art where the emphasis is predominantly on representation and in which the effects of extreme realism are essential to the imagery. Very recently, this mode – it may take close observation of minute detail into the category of *trompe l'oeil* – has proved attractive to a fair number of younger Scottish painters. In a time of confusion where there is infinite choice it does, of course, provide a secure anchor in its close reference to the visual appearance of things and the traditions of painstaking and craftsmanly technique demanded from its practitioners.

Various home-made brands of what has been severally called Photo, Super and New Realism have increasingly made their debut. However, if scale and execution are not gigantic and quite obviously derived – as Scotland was able to see in examples ("Aachen International" at the R.S.A. Galleries) from Peter Ludwig's collection in the 1974 Festival – this mode must be transfigured by some poetic or didactic intention. Otherwise, of course, it all too easily slips into a narrative genre where "every picture tells a story" and where, instead of real psychological tension or emotion, one is left with only the prosaic echoes of Victorian sentiment, cloying no less for being seen in a modern context.

We have already noticed Robert Callender skirting round these areas, but the

four artists whom I now choose to demonstrate different ways in which this idiom can be creatively employed are Peter Collins (b1935) Neil Dallas Brown (b1938), work in Edinburgh, while both Collins and Dallas Brown originally hail from the Moray Firth and are now based in Dundee. **Peter Collins,** in fact, has not always painted in this manner. Though born in Inverness and now a member of staff at the Duncan of Jordanstone College of Art, he studied at Edinburgh and was initially influenced to some degree by the work of John Maxwell. In 1968, however, he had a one-man show at the Scottish Gallery which established his reputation as a painter of considerable promise and individuality. His message at that time was cerebral and metaphysical while giving some *raison d'être* to hard-edged, abstract, colour-field painting by using it to convey poetic or philosophic ideas.

Two themes, in particular, were abstruse and audacious. In one, he attempted to symbolise and evoke the mystic drama inherent in the immense play of power which extra-terrestrial forces exercise on the earth's surface. Here he seemed to charge the austere stock-in-trade of circle and straight or undulating line with profound significance and great variety; partly drawing inspiration from the spine-tingling verses in St. John the Divine's Revelation of the opening of the Sixth Seal. In the second, he resolved and arranged cryptograms to reflect the contemplative, Oriental aesthetic of Chinese art. These cyphers cohabit on the same ground but remain aloof from one another, challenging the viewer with their optical puzzles. His personal inclinations could be identified in his use of colour for its emotional or symbolist properties and, in the cosmic works, through his preference for an unfolding spiral of Art Nouveau arabesques pushing against the stiff geometry containing them. Though the show was mightily impressive it was a failure financially and Collins never explored these propositions any further. Whatever his reasons may have been, I believe his decision has left Scottish art one visionary the poorer.

Though the character of his messages remains generally the same, he now externalises ideas in a Realism dependent on meticulous attention to the detail of circumstances, imagined, not observed *en masse*, but brought together in a composition usually for some didactic or symbolic purpose. Something in this approach might seem to suggest, perhaps, the Surrealism of Magritte or Dali and, while Collins certainly relies for the disturbing bite in his imagery on procedures like those used by Magritte in a dead-pan fashion, his own technical facility is more polished and sophisticated in an academic tradition to which Dali has continually subscribed. Of course, unlike Dali, he eschews exaggerated distortions and is not patently obsessed with illustrating Freudian fears and fancies. Because of their fastidious presentation and attention to detail, surface and texture, however, his paintings represent a deal of laborious application and there is always the feeling that respectful admiration for the time and skill involved in their production is expected from the spectator. Collins' art might best be defined in the original French derivation of the word Surreal which is a combination of "Super" and "Real" – a heightened realism of the kind experienced in dreams – even though he does not move so very far from reality itself. The evocative juxtaposition of significant elements in a situation made deceptively realistic – might be the ultimate description of this method. Certain of his recent subjects have revealed his concern for ecological matters.

Country matters of a rather different, nay, Freudian sort provide some of the

incident in **Neil Dallas Brown's** dream and nightmare world where Surreal atmospheres are entertained in a more definitive way than in anything proposed by Collins. Brown was born in Elgin but studied at Dundee where he now teaches. Northern by birth, he is much more of a Fifer and has lived and worked in the Kingdom since early childhood. Post-graduate study in London and extensive travel abroad, however, may have contributed to the forging of a vision whose nature is universal rather than insular in its connotations. Indeed, many of the characteristics frequently associated with Scottish painting – sumptuous colour or expressive gesture, for instance – have no place in his art.

Restricted mostly to earth-coloured monochromes, Dallas Brown's language employs a smooth but broad and painterly approach in which subtle chiaroscuro, silky draughtsmanship and gently polished surface finishes are important factors. The sensuous dream-world of melting images he obsessively couches in these terms is balanced in a twilit zone somewhere between private myth and disturbing actuality; and is illuminated by a sinister and voluptuous symbolism. This is an area of suggestion, inference and understatement where forms tend to be fluid, inter-mingling with one another. Bacon has used it to conjure unspeakable horrors, but with Dallas Brown it is a means of infusing his country matters with a heavy, potent sensuality which leaves no doubt that there is something nasty in the woodshed.

Initially, the setting and source of such physical encounters was the landscape itself, represented as a faintly unwholesome version of Eden riven by the surging forces of Nature. Here one sensed the menace lodged in the gaping beak of a bird of prey or the secretive lust lurking beneath the warm blanket of night and insinuated into flesh and bone lying interlocked on the grassy, hillocky, fertile ground. On recent occasions, however, he has sought and found sexual metaphors in the en-closed environments of popular musical performance where, for example, in the eager hands of a female singer, the microphone becomes almost too explicity phallic. As if he were reacting obliquely to some of the tendencies of Pop art, further influences from what was the affluent materialist society have also invaded his imagery and his female torsos – we never see their faces so they never reveal their identity but remain de-personalised – sometimes seem to have been intentionally cast in a soft-pornographic mould; perhaps in protest. Like Philipson, he adds animals, dogs particularly, as a symbolic bestiary underlining the brutal nature running through many of his fantasies.

In the work of the last two artists – Collins (metaphysical) and Dallas Brown (erotic) – we have seen how Realist procedures, far from being considered as an end in themselves, have been gradually extended and modified so as to give credence to conclusions which are, in effect, fundamentally Surreal in concept. This tendency crystallises in **John Johnstone's** painting. Born in Falkirk, Johnstone now lives and works in Edinburgh, teaching at the Art College where he was a student from 1956 to 1960 and became first a post-graduate, then a travelling scholar. A retro-spective show at The Scottish Gallery in 1970 illustrated his development as a painter since the end of his student apprenticeship in 1962. In the earliest pictures, small symbols inhabit or move across rich surfaces and coruscations in a fantastic manner that reminds one of both Paul Klee and Odilon Redon; so that the stage, as it were, is set in anticipation. In the mid-1960's, there was a change towards representation and we encounter a female figure enclosed by interiors whose forms

swing around it in hard-edged convolutions or arabesques to create rhythms which patently recall the spirit of Art Nouveau. Thereafter, things moved rapidly and between 1967 and 1968 he was exploring possibilities central to Surrealist traditions in a style that is closely parallel to that of Magritte, but contains important differences.

The dead-pan literal description – an over-all characteristic of the Belgian master's work – is only present when Johnstone depicts man-made objects such as walls, stone or iron-work. When he is describing natural phenomena – upland territories, sky, figures, animals, birds – he reacts strongly to feelings so that his touch exhibits this sensitivity and involvement; the soft undulation of hills or the sharp silhouette of mountains, in fact, fill key roles in his pictures. In this kind of painting, the poetic quality of the idea is always more significant than the grammar of the language, but his techniques are flawless and satisfying. Many of his metaphors concern the disturbing effects produced by deliberate ambiguities of space – a landscape invades a room, armchairs sit admiringly in a landscape – and he makes use of telling Surrealist devices for detonating surprise.

He deals in violent contrasts of hard and soft treatments, edges and textures, or of light and dark tones. Often he has juggled with scale – a solitary cow stands on a large Victorian green-mantled table-top which happens to be an extension of a landscape's plane; he has played with perspective – one is left uncertain of the real inclination in a carefully rendered brick wall; and he has manufactured upsetting illusions – a rectangular pit opens in front of an idyllic, though paper-strewn glade, a picture is cut by the descent of a roller-blind screen, or a bird's shadow has features painted on it. He has also devised fascinating metamorphoses – a torso of a contemporary Daphne sprouts leaves; but many things add to one's enjoyment of his work – wit and humour as well as metaphysics – and there is a classic stillness in his images, an intelligence and deftness of execution that commands attention. This quiet authority is even more marked in recent paintings – often featuring a sea-bird – which are less alarmist in their intention and more poetic in a way that is almost subliminal – a matter of mysterious ambiences of light and atmosphere.

Stillness and silence are qualities present in the art of **David Evans** who brings to representation something of the austerity and hip coolness of Minimal Art but also puts a slightly lyrical edge on the matter-of-fact approach exploited by Magritte. Though he has performed tricks with scale, his pictures have no need of sleight-of-hand, deliberate distortion or fantasy, relying instead on rhymes such as the juxtaposed echoing of forms which are similar but vastly opposed in size. Though Welsh in origin, Evans has lived and taught in Scotland long enough for him to have become a strong influence. Born in Monmouthshire and brought up not far from Ebbw Vale, he (and his twin brother) studied first at Newport College of Art (1959-62) and then at the Royal College of Art in London (1962–65). Evans then travelled abroad before being invited to teach in Edinburgh where, apart from taking up a Fellowship at York University (1968–69) and a brief visit to America, he has remained ever since.

The quietness and calm in his paintings, the apparently classical and monumental way in which forms are stripped of trivial detail, simplified and resolved, is merely the outward appearance, an orderly shell that is in striking contrast to the inner feelings, psychological tensions and pent-up emotions they contain; human predicaments

[63]

sometimes felt so powerfully that they seem on the point of exploding. Much of this tension comes directly from the structure of his pictures; the single figures evoke a persistent loneliness, seeming to confirm the inescapable truth of the separateness we experience one from another and embodying something of twentieth-century man's dreadful inability to communicate satisfactorily with his neighbours. Heads and bodies are frequently turned away from the spectator and Evans uses perspective – whether it be in the powerful suction effect of a deserted motorway receding far into the distance, or, more intimately, in the gentle pull of an empty tabletop in a room – to create a strong atmosphere of nostalgia. He conveys emotion too, not only through the soliloquy of his bland and nearly anonymous actors, but by their placing on the stage and, more especially, by the way he paints the environment, investing landscape or furniture with such an extraordinary suggestion of anxiety that a wine-stained tablecloth, for instance, becomes shockingly charged with symbolic meaning. Admitting none of the dust or clutter of every-day existence, he favours, like Balmer, an imagery that is neat and cleanly swept; his vision is altogether precise and sharply defined, leaving nothing to the imagination – visually that is. In his technical method, Realism is so meticulously attended to that on some occasions – his painting of napery, for example – it might seem to discard any contemporary influence and be descended from the dry, colourless style applied by the 19th century French Neo-Classicist, Jacques-Louis David. Indeed, no one could accuse Evans of being extravagant with pigment. Unlike Johnstone, only very occasionally will he add a typically Surreal touch by subtracting one leg of a bench or otherwise challenging the viewer's belief; in the main he allows his artificial version of reality to make its own strangely haunting impact.

Simultaneous with the emergence of these national excursions into the universal regions of Surrealism was the arrival of the Scottish Realists, two of whose central figures – John Bellany (b1942) and Alexander Moffat (b1943) – are my next subjects. Strangely enough, they both paint in ways which, were they to be categorised in a general sense, would more properly be called Expressionist; though to be sure, that part of Expressionism they occupy has most to do with the human condition or the type of social (and even Socialist) comment one finds in the satirical paintings and drawings of Max Beckmann or George Grosz during the decadent 1920's in Germany. The group, in fact, might be more exactly termed the Scottish Social Realists and its concept of Realism is not without its debt to the example set by Gustave Courbet in the 19th century, who believed the mode to be "the democratic art".

Though they may not, at first, seem very agreeable, dissident young voices are an invigorating ingredient in any healthy community. Finding a common political purpose and aesthetic inspiration, these Realists came together in Edinburgh about the middle of the 1960's. Their ardent champion and mouthpiece was, and still is, the poet Alan Bold, but the members themselves were active as well as vociferous and became largely responsible for the enterprise latterly shown by the New 57 Gallery. Under Moffat's chairmanship, the Gallery's policy of bringing occasional one-man shows across the Border was extended to the organisation of such major events at the annual Festival as the posters of John Heartfield, the graphics of Beckmann, the paintings of R. B. Kitaj and the "*Merz*" of Kurt Schwitters. During Festivals too it promoted a series of big group shows of work by a score of its own supporters

and these "20 BY 57" exhibitions effectively signposted the future; in them one could sense the local groundswell of youth on the move and catch a glimpse of new tendencies and schools of thought as they first began to coalesce. The lease the Gallery had on its tiny premises in Rose Street ran out at the end of 1973 but, after spending fifteen months in the wilderness, the New 57 was back in business safely installed in part of the upper floor of the Scottish Arts Council's Fruitmarket Gallery. This large space, one of a number vacated when the market moved from its traditional stance by the Waverley Station and below the North Bridge, had recently been leased and adapted as an exhibition area with facilities for the New 57 Gallery and the Printmakers' Workshop (more of that later) above.

The Scottish Realists also acted as a reforming body in castigating refined taste and *belle peinture*; parading a hair shirt; cocking a snook at fashion as well as the Establishment; and refusing to eschew the human aspect, whether in the use of the figure or in the content of the image. Bold's definition of Realism (in the catalogue introduction to the Scottish Realist show at the Arts Council Gallery, Charlotte Square, in May 1971) as being "the desire to transform the world of objects into a communicable vision", was certainly wide enough to encompass the considerable diversity existing within a group which then, besides Bellany and Moffat, contained Robert Crozier, William Gillon and Ian McLeod.

Because of his political and aesthetic attitudes, the group also found inspiration in the personality of Fernand Léger and in 1962, Crozier, observing Léger's work at firsthand in Paris, declared that the Frenchman had "revived heroic composition with imagery that was wholly modern". To confirm Crozier's conclusion, Moffat and Bold went on a pilgrimage to the Fernand Léger Museum at Biot in the South of France and returned convinced of the master's immense importance to all the group. In a gesture of defiance at the current fashion for small and tasteful easel paintings, they adopted Léger's massive scale. In the early days too, Bellany and Moffat were even more actively involved in demonstrating their democratic beliefs and, at the Edinburgh Festivals from 1963 to 1965, ensured their work was made available to the man-in-the-street by hanging paintings on the railings at the foot of the Mound Steps.

Generally speaking, the art of the five artists concerned at that time was vigorous, uncompromising and even, at times, brutal. But among the images there was already seeping in a welcome mellowness of touch, a greater depth of feeling, as each man began to mature in his own fashion. Once closest to Léger, Ian McLeod's stereotyped figures and machine forms gradually drifted towards Magritte's Surreal insinuations; William Gillon has always been something of a prophet of doom and his symbolic figures readily move the spectator to pity or horror; while Robert Crozier remains the intellectual performer of the group and has translated forms easily from two to three dimensions at will.

Without doubt, however, it is **John Bellany** who has constantly created the most powerful and moving images to consolidate his position as a highly original painter. His realism, overlaid as it is with Expressionist distortions, assumes a personal symbolism in which fish, fowl and metamorphic suggestion loom large. But his own obsessions have universal connotations and he sets them, like monuments, in large spaces with an eye for dramatic pictorial arrangement that is often arresting. Because of their expressive character and fantastic nature, they most

frequently seem to proclaim kinship with the spirit of Goya's *Los Proverbios* than anything-else; an observation that is borne out even more forcibly whenever he has picked up the etcher's burin.

Bellany was born and brought up in Port Seton and the background of the fishing community there has shaped both the iconography and the atmosphere of his vision. As well as the fishing boats and creels that one would naturally expect to find, his forms include more personal or particular metaphors and symbols like the skate (traditionally an ambiguously sexual fish as far as fishermen are concerned), the lobster, animal heads and skins, veiled people and the occasional skull. Death, destruction and the sinister side of human nature are signalled in his work; and so are the repressive effects of Calvinist attitudes. Perhaps that is why one so often catches a whiff, behind his imagery, of cold blood and fish scales on the windswept quayside; and why, in the imagery itself, it so often seems as if some weird or unholy ceremony, some watery witchcraft has just taken place.

It is, indeed, a nightmare world he envisages wherein grotesque figures with hollow eyes sit up in large beds mouthing or staring at us and inviting contemplation of their piteous plight. The frontality of many of their postures is not the only hint of a reference to the old Byzantine iconolatrous style because his colours are chosen with an eye to their richness and emotive propensities; but they rage with Expressionist fervour rather than glimmer with hieratic splendour. Nevertheless, he is undoubtedly a maker of images and these are definitely icons with hieratic and ritualistic plans and purposes of their own. Early pictures were usually busy with objects and human beings but, for some time now, his large canvases have been more sparsely populated and the totemic figures in them are introverted, keeping themselves separate from other events and creatures to remain locked incommunicably in their private agonies.

It is such universality of theme, clothed in an extremely personal and rich vernacular, which has given Bellany acceptance in England, especially in London where any vernacular is normally anathema or dismissed as incomprehensible and the precise language and clipped tones of international manners are the customary passports to recognition. Contemporary Scottish painters have, of course, often scored considerable successes beyond the Border, but Bellany's vision speaks in a salty local dialect which is quite out of tune with current fashion. Bellany, in fact, has lived mostly in London since 1965 when, after finishing his studies at college in Edinburgh, he went on to spend three more years as a student at the Royal College of Art. He now lectures at Croydon College of Art.

Alexander Moffat, on the other hand, has preferred not to teach and, from 1966 to 1974, worked as a photographer with the Scottish Central Library. Born in Dunfermline, the son of a Schoolmaster, Moffat ended his four years at the Edinburgh College of Art in 1964 and, deciding he wanted a change from the paradoxically stuffy but rarified atmosphere produced by matters purely aesthetic, went to work for two years in an engineering works. One of the most intelligent and articulate members of this socially-committed group of painters, he was invited, along with Bold and Bellany, to visit Berlin, Dresden, Weimar, Leipzig and Halle in 1967 as a guest of the Ministry of Culture in the East German Democratic Republic. There, his profound interest in Expressionist art, and especially in the sardonic humour resident in Max Beckmann's imagery, was confirmed.

The thematic gist of his own paintings has a similar Brechtian theatricality which, although mightily expressive, distances or disengages emotions, allowing the spectator more easily to get the moral message, to appreciate the didactic narrative. This he does in a figurative iconography that is full of symbolic gestures and devices, visual metaphors which might seem rather drily doctrinaire were the whole content not wrought into a design – often self-contained and heraldic – whose expansive movements create a strong but gracefully balanced and memorable image. The passing show of Moffat's charades and the actors in its human comedy actually do recall, in their mood and attire, some of the flavour of Berlin in the 1920's; and the way they are caricatured undoubtedly has stylistic links with Beckmann's art.

Principally, Moffat is concerned with choreographing ballets of figures in movement who occasionally even defy the laws of gravity and float or dance in a narrow space in front of a background often graphically flattened so much that perspective has almost been ironed out of it. In this performance, it is the strength and pliability in his deployment of line that produces the action and, coupled with the lively patterning of colour, gives each occasion its distinct moment of grace. He also enjoys and has a flair for painting people and making pictures of their portraits. During the 1973 Festival, at the invitation of the Scottish National Portrait Gallery, he mounted an exhibition ("A View of the Portrait") of 42 examples of his portraiture from 1968 onwards. Here no piper had been paid to play the tune and there were no pretty or deceitfully flattering personifications of big business or high society, merely groups of the artist's friends and acquaintances – painters, poets, musicians and their wives. The familiar idiom was used to unusual effect. In general, the mood, therefore, was one of smouldering emotion set in a certain realist drabness; but this was countered by the invention of designs made to reflect the nature of the subject so that no dullness or repetition is ever evident. On the contrary, in each canvas he had made a consciously creative effort – the resulting compromise between his own vision and the character of the sitter – so that his compositional solutions are intriguingly varied and original. It was particularly interesting to see what capital he made from double (husband and wife) portraits, which are inevitably rich in psychological contrasts and complements.

Though my brief is primarily concerned with developments in painting, no artist works in a vacuum. He must be affected, to some extent, by others operating in totally different media. In fact, a great revival of interest in ceramics, tapestry and printmaking had been occurring since the beginning of the 1960's to bring about what was virtually a modern renaissance of these ancient arts and crafts. Printmaking, of course, is a popular and natural extension to painting, an alternative medium for the painter to explore, and its recent growth was encouraged by the remarkably adroit concept of the Workshop which has been a phenomenal agency in the promotion and encouragement of artistic activity generally over the last decade or so. A movement towards printed means of expression has spread like wildfire and the art schools or colleges now have flourishing departments of printmaking.

The many advantages of this type of image are, however, offset by one grave disadvantage, because the equipment necessary for most forms of printmaking is quite beyond the financial resources of the majority of artists. Scotland, I fancy, is unique in having set up (again with assistance from the Scottish Arts Council) no

[67]

less than four communal workshops where artists may use such facilities in return for a modest fee. The archetype of these, the Printmakers' Workshop, was established in Edinburgh by a quiet American called Bob Cox in 1967; originally in Victoria Street. It is situated above the Fruitmarket Gallery and has since been directed by Kenneth Duffy. Besides offering facilities, the shop has done much to further the gospel of print by showing loan work and organising an "Original Print" travelling exhibition each year. The Edinburgh example was soon followed by the Glasgow Print Studio, the Peacock Printmakers' Studio in Aberdeen and the Printmakers' Workshop in Dundee. Painters like Philip Reeves and George Donald are deeply involved in making prints and there are certain artists who work almost exclusively in this media – Willie Rodger, Carl Heideken, Anna Molin, Malcolm McCoig, Michael Rochslau and Tim Armstrong, for instance.

The ceramic renaissance was initially due to the inspiration of Katie Horsman, a gifted potter (and no mean hand at watercolour painting either) who, for longer than she cares to remember, was in charge of ceramics at Edinburgh College of Art. For a number of vital years around the turn of the 1950's and 1960's, she brought in a whole series of guest potters from the Western seaboard of America to augment her staff; the monumental scale and broad, sculptural approach these men professed had the profound effect of not only revolutionising local attitudes to pottery but, by their example, attracting fresh and lively talents into the discipline. In 1970 a distinguished potter called Merilyn Smith, in collaboration with her husband and several like-minded colleagues, established a Ceramic Workshop in Edinburgh; occupying a building almost vertically above the Printmakers' old premises in Victoria Street. They received a grant from the Arts Council; but though the name was the same, this Workshop's aims were different. It reckoned to pay its way by supplying the materials of the craft; thus allowing its operators the freedom to experiment and invite internationally well-known artists who had no previous experience of the medium to come and work with it. The shop held a significant show ("Earth Images") at the Scottish National Gallery of Modern Art in 1973, but shortly afterwards collapsed financially – not without considerable acrimony on all sides. The larger ceramic adventure, however, continued and Scotland has an extremely healthy and vigorous population of artist-potters.

The Weavers' Workshop had an equally brief existence. Founded in 1971 and lodged in Monteith House, the High Street (later to become the Demarco Gallery's second home), it set out to encourage the creation of works of art in textiles by offering facilities to artists and, as the printmakers had also done, by organising shows of collected hangings. Despite support from the Joint Crafts Committee and resolutions that were broadly enough based or internationally inclined, this project also folded after only a few years. Once again the loss has not affected the growth of the medium and successful artist-weavers are numerous in the country. Edinburgh has become one of the most important international centres for tapestry. This is partly due to the fortunate adjacency of the Edinburgh Tapestry Company (the Dovecot Studios) and the tapestry section of the College of Art; as well as the inter-relationship between them. Pioneer work was done in the 1950's by Sax Shaw, but the leader of the renaissance was undoubtedly Archie Brennan – now Master Weaver and artistic director at the Dovecot – who formerly ran the section at college which is now the charge of the gifted tapestry-artist, Maureen Hodge.

Brennan, whose own work has often employed the mass media vernacular of Pop, greatly extended the Dovecot's range by giving prominence to commissioned work done to designs by artists of international repute such as Harold Cohen, Eduardo Paolozzi, Hans Tisdall, John Craxton and many others. He has improved the quality of such works by encouraging the artists to exploit the medium properly and to work in close cooperation with his team of weavers. As to sculpture, painting's big brother, it would be only fair to say that we are still waiting for a renaissance here and that this wide-open field contains only a few exceptional figures.

Looking back over the last fifteen years or so, it can be seen, perhaps, that far from being wrapped in a cocoon of provincialism, Scottish art has been continually crossing frontiers and assimilating external developments; always determined to relate itself to wider horizons. Strangely enough, if one had to identify an area generally more reactionary than others in this respect, it would probably be painting. I have put forward reasons already to explain the canny Scottish attitude towards new or alien influences. There is above all one direction which has never, to my mind, been properly explored or naturalised. It is here, I believe, that the art colleges have failed Scottish art – because they have never really been able to tolerate, far less encourage the serious study of the abstract language of visual communication. (I discount all these makeshift courses in 'Basic Design' – most of them bowdlerisations of Bauhaus methods – which were fashionable for a moment or two in the 1960's.

Just why abstraction should appear to be such anathema to local art schools is difficult to comprehend. It posed a threat, perhaps, to the figurative styles prescribed by the majority of painters on the staff of these schools and it made unaccustomed analytical demands on their methods of teaching; in short, I suppose, they were not prepared to promote the study of an idiom in the pursuit of which they personally did not believe. While this point of view is understandable in human terms, intellectually speaking it is highly questionable. After all, it is surely a long time since the validity of abstraction as an acceptable alternative to the representational approach was in any doubt whatsoever; and does not visual expression in Scotland actually begin with a form of linear abstraction?

Despite the educational bias against it, however, the abstract mode, as we have discovered, has had its subscribers all through the period under review, beginning with William Johnstone and Wilhelmina Barns-Graham; though the latter painter reduces matters to terms of mechanistic austerity more often palatable to English than Scottish temperaments. Regardless of their distinguished reputation in history as engineers, Scots are more naturally predisposed as we have seen – to art which is romantic and emotive rather than classical and abstract. The most Minimal and reductively inclined artist we have yet encountered is William Turnbull, but now, in cool contrast to the inflammatory Scottish Realists I have recently described, is the moment to look at several younger painters working in an abstracted terminology. The first two, Kenneth Dingwall (b1938) and Colin Cina (b1943), are relatively severe and intellectual in their processes of creation.

Of the two, **Colin Cina** is the more overtly cosmopolitan. Born in Glasgow, he attended the School of Art there from 1961, but in 1963 moved to London and continued his studies at the Central School of Art until 1966. William Turnbull, coincidentally, was teaching at the Central during that period. Since then, Cina

has been painting and teaching in London (at the Central and Wimbledon Schools of Art). In the summer of 1966, he made his debut in the last of Bryan Robertson's "New Generation" shows at the Whitechapel Gallery. At that time, his colour fields and formal structures provided an environment for surreal fragments of an entertaining nature whose derivation was contrastingly organic. (As we shall see when we look at his work, this residue of organic bits and pieces balanced in clinical surroundings is also characteristic of Dingwall's early and transitional paintings.) Thereafter, however, Cina began to dispense with these little personal idiosyncracies in order to emphasise structural elements. Consequently, his reticent proposals became increasingly architectonic and even downright architectural in their inspiration; because they came to fruition in a series based on observations of swimming pools – a theme he developed on a visit to America when he rediscovered the value of a *motif*. In these paintings, he made use of the technical draughtsman's axonometric projection and, following a similar train of thought, seemed also to be referring to the eccentric and often puzzling perspectives one finds in Oriental painting.

After detailed analysis, the subjects were simplified into a hard-edged device. In 1967, too, he began to change the rectangular shape of canvases to suit the formal dictates of the *motif*. Colour now articulated tonal or structural matters and, of these pool images, Cina himself has averred that Suprematism was their real progenitor. This claim is supported by the planar architecture evident in a painting like *Neves Loop* (1967/68) where the title is merely "Pool Seven" read backwards and the design is also reversed pictorially. Nothing, perhaps, better illustrates the intellectual inclinations behind many of his ideas. His compositional equations were initially suggested by linear progression and for a while he began orchestrating colour by the same kind of notation. This led to the *MH* series in which canvases were no longer specially shaped and fields were activated by a few select chevrons drawn in line; a thin narrative to be read in a lateral scan.

With *MH4*, these economical, elegantly controlled and immaculately handled paintings were further reduced within a single predominant hue where an abbreviated collection of linear accents divide or repeat, isolating or echoing space to a rhythmic beat. Since 1972, the diagonal zig-zag element has become fainter and paler while broader vertical intervals have gradually become more imposing. The introduction of mottled surfaces has rendered even shallower a pictorial depth that is already shallow; and his work seems to go on refining itself and growing ever more analogous to the conditions of music.

The debt to American painting (Barnett Newman and the expatriate German, Josef Albers, in Cina's case) is less evident in **Kenneth Dingwall's** vision, but it is there nevertheless, and the impact of a year he spent in the United States (1973–74) teaching at the Minneapolis College of Art and Design lies simmering in his memory. Five years older than Cina, Dingwall comes from Clackmannanshire and attended the college in Edinburgh from 1955 to 1959. After a post-graduate scholarship, he went to Greece for a year and worked at the School of Art in Athens. A decade ago, his painting consisted of simplified backgrounds of colour and pattern on which small fragments, which looked as if they might be specific objects but actually evaded recognition, were laid out like illustrated catalogue lists (as Jim Dine has laid out drawings of tools and so forth). Hues were sometimes sweet and strong and the brushstrokes he employed were quite obviously rhythmic.

Then came a gradual shut-down; colour darkened, marks were smaller and less frequent – just rows of pale blue dots on dark blue, for instance, or red gestures and arcs dropped over a system of blue and dark blue stripes. In another example, the nakedness of a subcutaneous and vigorous red movement is visible only behind a central pillar-box aperture; though elsewhere it does bleed and seep through the neutral over-painting in red-stained gashes which seem to be on the point of healing in the way skin grows over a wound. It is as if he would respect a psychological desire for secretiveness by stoically drawing a veil of strictly polite manners across emotions and tensions he felt within; while at the same time, satisfying an aesthetic desire for economy, simplicity, anonymity and refinement of form. Almost he seems aghast at recognising an unexpected stridency in his former work; a growing hesitancy and dislike of display makes him withdraw from any obvious statement lest it be altogether too coarse and vulgar, too raw and ostentatious.

At the moment of writing, there is one painting he has had on the stocks for three years; in it, the pattern of signs and movements is only apparent shining mysteriously through layers of grey opacity; peeping from beneath an orderly occasion, it still beats a rhythm, but it also becomes part of the blind drawn over the surface of the painting as a disguise – it blends with its own mask. There is a technical mystery in how this seepage occurs through pigment which is physically non-transparent and yet actually suggests that the surface layers of it may, despite their appearance to the contrary, be transparent after all.

Eventually, this bleeding of colour itself disappears and all communication is reduced to that sensitive and superficial skin which had once been a neutral cover and is now a varied monochrome activated by the textural rhythms imposed on it by highly controlled brushstrokes of fatty pigment. There are many grey essays in which short strokes of thick paint dance along rows to produce a weave almost as tactile as basketwork. Though the reduction therefore, is extreme, the effect is still sensuous; and the plasticity of the paint carries in it something of the mood of the painter – as well as his heritage in the delights of handling pigment. His literal ideas have also led him to explore the third dimension; he has joined several little canvases with umbilical tapes and has built small rectangular planes modestly jutting out from each other like bookcase dividers; again, these are all treated with neutral textures. His drawings, which are heavily toned with graphite-workings, have similar Zen-like qualities of reflection and hypnotic repetition. Though he works with formal resources that are minimal, like Albers he does not lose the personal touch of physical involvement and, rejecting more mechanical means, he applies paint by direct contact of his brush with the canvas. It is for this reason, I believe, that his reduced imagery, while remaining in a solid state, seems to vibrate gently with energy and to be alive with sensation.

Since 1963, Dingwall has taught at the Edinburgh College of Art. Of the next two painters, George Donald (b1942) also teaches at Edinburgh, while Alexander Fraser (b1940) is on the staff of Gray's School of Art, Aberdeen. Both of them actually grew up in the Granite City (Fraser was born there) and their work individually over the years has stood at varying stages between abstraction and representation. Though its drift has often been towards the former, representational sources or points of reference have remained identifiable – but sometimes only

obliquely visible as if sighted on one's peripheral or subliminal vision.

Alexander Fraser it is who began from quite a traditional standpoint. In 1969 he was using watercolour – not a frequent choice of medium among young painters – in a time-honoured fashion to describe quite freely his personal contact with the North-East coastal environment and especially the little village of Muchalls where he still lives. His theme was often autobiographical too in a natural but nicely eccentric way, and his paintings atmospherically married his carefully selected forms to the contiguity of sea and sky which provided the background to his private world. The coastline here is generally composed of cliffs where the aspect – as it is theatrically isolated and treated in James Howie's paintings, for example – is of a vastly receding plane of dramatically lit water that stretches from below one's feet to a darkly cold and forbidding infinity of horizon. In Fraser's distances, little coasters and trawlers roll and pitch while, in the foregrounds, between buildings formalised so that their identities become like cardboard cartons, simplified figures or animals are held in tension while a flag streams out in the breeze, a child's swing moves or paper aeroplanes chase each other across the drying green.

Though rather like toy-making, this concept of objects being fashioned out of folded planes of card or paper may have been a means of dissecting and re-assembling their structure and is therefore related to a certain amount of fragmentation of form; in his work at this time, components had become separated, establishing for themselves dynamic areas of pattern and design. But, at first, his records of everyday experience were so uniquely arranged and mantled in mood that they assumed the heightened significance one expects from the pen of a poet. Later developments, though less completely nailed to the rational facts of inspirational sources, are just as impeccable in their presentation and satisfying in their physical realisation. There is, indeed, extreme aesthetic pleasure to be gained from such abstract qualities of shape, colour, texture and pictorial arrangement, which he deploys so subtly; and from the way he allows these elements to move independently of the reality that fathered them, though they obliquely suggest their derivations. Now these are the structure and feel of weathered portions of buildings and other artifacts – of wooden doors, concrete blocks, wire mesh, corrugated paper, cork and all manner of rubbed, scraped or stained patinas. Altogether desirable, his images stand provocatively balanced between abstraction and description, structure and decoration, austerity and hedonism.

Fraser was a distinguished student at Gray's, where he has taught since 1966, and was awarded post-graduate and travelling scholarships so that his studies finally ended in 1964. **George Donald** is married to Fraser's sister. Though he spent his youth in Aberdeen, he entered the Edinburgh College of Art in 1962. After a post-graduate year, he won a travelling scholarship which took him through Turkey, Iran, Afghanistan and Pakistan to India, where he explored Nepal, Kashmir and Bengal. In 1968, he studied at Benares University. As one might suppose from this intensive sojourn, it was not his first encounter with the East; he was born in Ootacamund, a hill station in South India, and passed his earliest years in Madras and Cochin. There has always, therefore, been a deal of Indian influence inextricably woven into his imagery. This reveals itself in his predilection for strong, dense colour which often suggests mood in the style that a *raga* indicates, musically, the time of day or state of mind; and in his love of joyful movements and patterns which,

in their abstract dynamic, generate something rhythmic and balletic like the choreographic line of a dance. In other words, the Indian influence is not a flavour directly coined from an art form like Rajput painting, but is more of an aesthetic assimilation of the tenor of Indian life with all its attendant festivals; a recognition of what is significant to him in the ritual displays of its exotic culture. This influence is a tangible business of real objects or people rather than a two-dimensional matter of pictorial style; and perhaps because of this, Donald has always been pushing into some kind of low relief or other. At first this was a question of cutting out and advancing certain areas or facets in the general design of a flat image; rather in the structural method used for those Victorian toy or model theatres whose little cardboard actors and settings – with backcloths, ground rows and flats – were pushed onstage to assume their appropriate position in planar recession; or like large versions of those puzzle boxes where, viewed through a window, something has to be manipulated through a hazardous environment.

Indeed, Donald's frames did become shallow boxes in which particular shapes or planes were jig-sawed and set in front of others; thereby causing a mild kinetic effect on the spectator as he passed in front of the work. Some of the shapes so developed are representations of animal or vegetable material, but others are more abstract – arabesque, tongue or lightly inflated balloon shapes – and are often decorative centres in a vigorous scheme of patterning which involves a strong and sensuous range of colour opaquely applied. A man of great energy and humorous invention, these qualities kindle the atmosphere of such paintings (or painted reliefs); however, yet another influence is visible in them as the inflection and application of the colour patterns somehow also convey part of the mood of British Pop Art. Like Philip Reeves, George Donald is heavily engaged with printmaking and he has used it as a means of experimenting both thematically and formally in areas that are even more explicitly the byways of Pop; he has mixed the image and the printed word, he has used photography, he has made sexual jokes and satirised such lamentable exhibitions of popular taste as appear in the Scottish souvenir trade with all its execrable phoney pawkiness and tartan mania.

Later formal developments concentrate mainly on the select arrangement of the more abstract and patterned facets from these boxes and the principle of suddenly penetrating a fairly rigid division; border-crossing, in fact, is one of the occasional activities indulged by these decorative fragments. But it is in his choice of medium and its exploitation that Donald displays the greatest originality. While others were shaping their canvases towards a solid geometry, he kept his own rectangular, contriving to push bits of them out in a non-geometrical way by simply padding them. His large, unprimed planes of cotton are stitched collages of plain and patterned pieces, some of whose shapes fill out into organic bumps and ridges to create a variety of soft and roundly contoured swellings. The smooth tactility of this upholstery is, of course, extremely sensual and highly charged with emotive suggestion; and its patchwork is often contrastingly reticent – a consideration of tensioned elements balancing each other across defined spaces, of subtly restrained hues and scattered oddments of rhythmic pattern, either drawn from 'found' material or deliberately painted to order. The best of Donald is that which is aimed to please the senses, and the final images are usually haunting enough to linger in the mind's eye as a fine lyric set to music remains echoing in one's head; or as the sound of a

[73]

strathspey might flow from his own violin – because he is a keen amateur fiddle player.

Curiously enough, the medium of boxed reliefs, which you will remember is the exclusive vehicle in Fred Stiven's art, has been used for its different purposes by other, younger artists besides George Donald. **William Maclean** (b1941), for instance, has quite recently moved his own imagery into three dimensions by this means of expression; and the character of his vision now takes us away from abstraction once more because Maclean is someone who is not content merely to intellectualise about language or convey aesthetic pleasure. To him, a work of art must also carry or symbolise ideas and, in his case, these are usually admonitory in tone, messages to be read as warning lights about man's ambivalent attitudes towards the natural world – the realisation of his dependence upon it and the ways in which he selfishly abuses it. Here he makes special reference to the fisherman's cruel struggle to harvest the ocean; like Bellany, he has a birthright that lies close to the sea, for he was born in Inverness and his first choice of career was as a sailor.

Maclean left school to join the Naval Officers' training ship, *HMS Conway*, and afterwards served in the Merchant Navy, sailing as a Midshipman with the Blue Funnel Line from 1959 to 1961. He then quit the service and began studying at Gray's School of Art where he won numerous awards, one to Hospitalfield and several for post-graduate and travelling scholarships. Now living and working in Fife, he teaches at Bell Baxter High School in Cupar. Maclean's imagination operates poetically, dauntlessly pursuing and calculating the telling metaphor or symbol; he has much to say from personal experience, of course, and makes excellent capital out of his sea-faring background. His arrival as a painter of promise occurred in a group exhibition at the Richard Demarco Gallery in 1969 ("Four Figurative Artists") when his inventiveness as a designer was very apparent. It was interesting to see him, for example, contrast formal themes of flowering or explosive forces with plant systems that were severely geometrical.

As Bellany's themes have an aura hovering around them, so does Maclean's work hold similar suggestions of ritual drama, of menace, bloodshed and death. However, whereas Bellany's totems are often aggressively emotive (Expressionist), Maclean's are less sinister but potent, nevertheless, in that more classical or spiritual attitude which seeks to crystallise narrative or feeling in a symbolic device.

At one time, a central symbol of his was a fish on a spike planted vertically on the strand and enclosed in a bathing tent or a canvas shelter that suggests, perhaps, a temporary theatre. Its wings, (a visual pun?) are indicated by cascading planes of forms seemingly composed of seagulls shredded and torn to pieces; his images are not without their Surrealist implications. In *Coastal Dream* of the same period, a tragic narrative is hauntingly whispered in an empty stillness. From a strange room full of museum showcases, a door in the centre opens on to sunlit dune and sea while, in the middle of the floor, stands a chair cluttered with hastily-divested garments.

The concept of the shrine that is inevitably suggested by the disturbing, primitive and magical symbolism in the spiked fish paintings appears to have combined with the museum display cabinets from the interior of the latter picture to find expression in the boxed reliefs which most lately have been the subject of his investigations. The character of these is certainly a poetic mixture of ritual object and didactic showcase. But there was an intermediate stage between the painted and the boxed image, in

[74]

fact, because in March, 1975, within an Arts Council show called a "Choice Selection" at the Fruitmarket Gallery, he exhibited a number of mixed media pieces in wood and metal where, for example, painted fish are seen imprisoned behind the doors of a wire cage *(Trap Image No 3)*. The boxes contain a similar symbolism of forces and make use of found objects like the bones and skulls of animals or birds (it is worth remarking that Dallas Brown – who hails from the same region – has also constructed boxes in which such skulls play a role) as well as forms especially carved and painted. The refined quality of his craftsmanship in materials like wood contributes greatly to the aesthetic value of these reliefs, which are really collaged environments in miniature and thus dependent for their communication on the emotive juxtaposition or convincing realisation of the solid elements of which they are comprised. One image, a *Spirit Boat* with an amusingly three-dimensional reflection, formally reminds one of Bellany's vision; another is a nostalgic dream of the romantic days of sail locked in a cupboard. The most exciting of them is not at all illustrative, however, but a beautifully fashioned portable cabinet originally designed to contain his version of the *"Symbols of Survival"*.

With the last two – and youngest – artists in this survey, we find ourselves back in reality, or rather with two quite different means of transposing or capturing the essence of a particular reality – that of landscape. The subject, of course, is not only one of the great traditional themes in European art and pertinent to British tastes, but brings us back, tidily enough I hope, to our starting point; the larger part of Sir William Gillies' *oeuvre*, with which we began, is based on the interpretation of this thematic material. It is also an added and happy coincidence that the work of the first of these two, while not being in any way superficially similar to that of Gillies, does share certain characteristics in matters of lyrical atmosphere and emphatic linear rhythm. Like Gillies too, the artist in question does not paint landscape alone; in his case this means that the subject is not alive for him without the presence of some focal incident.

James Fairgrieve (b1944) comes from Prestonpans – along the coast from the capital just by Port Seton, Bellany's birthplace – and began a successful student career at Edinburgh College of Art in 1962. After a year of post-graduate study, he spent six months on a travelling scholarship to Italy – mainly on the Adriatic coast as far South as Bari. In early one-man events at the New 57 Gallery, the odd palm tree and other souvenirs of this experience were evident – along with the peculiarly calm and lucid aspects of his youthful talent. His vision of the world is always clean as a whistle and gladly accepts the point of realism, while superimposing on it, nonetheless, a high degree of selectivity and formality. His gaze is sympathetic and one is never left in doubt either of his emotional reactions as a human being or his attitude as a painter.

He may be said to have arrived safely and properly in a one-man show at The Scottish Gallery in November, 1974. Then it was obvious that this quiet East Lothian man, who now lives on the edge of the Lammermuirs, was one of the most consistent, dedicated and poetic of the younger painters; and that his message spoke of a peace and resolution which seem precious in the violence of present times. Fairgrieve's subject matter embraces simple facts of existence that most urban-dwellers tend to forget, if indeed, they ever knew the joys to be discovered in a communion with nature, with her seasons, elements and creatures; the balletic

movements in a strong wind; the warmth of a rabbit's fur; the magic of a starry night –unadulterated by artificial afterglow. In his celebratory art, many of the observations made are, in fact, nocturnal, so that spectators have been temporarily discomfited by the predominantly dark backgrounds appearing (or disappearing) in a number of paintings.

In translating such material – which could seem altogether too hackneyed or even sentimental – his conclusion remains intimate and personal but still detached enough to admit cool analysis and structural invention where the occasion demands it. His gentle love of life is tempered by an exceptionally observant eye. His brand of realism, therefore, is often literal but stops short of *trompe l'oeil* effects, as he is never one for relying on deceit. The integrity of the painted surface is continually preserved. The real source of his art lies in two creative directions – in the classical formality of his pictorial arrangement (which is often almost austere); and in the poetic notion underlying his choice of subject, making of every appearance, incident, movement or character a charming and sometimes witty illumination of the quality of life. A small self-portrait made wintry and memorable by snowflakes; a desolate, rolling hillside humanised by a column of smoke; spent matches on the patterned floor of an empty room; all provide the evidence with which to trace the artist's own presence.

Smooth without being mechanical, his immaculate technique and precise draughtsmanship are only part of a larger repertoire of assets which he employs to please our senses; he takes great pains with the business of presentation. A fine sense of space and its dramatic or atmospheric possibilities, is also active in the best of his larger images. Where the lyrical note is absent, of course, painting like this – as I suggested when reviewing the work of Barbara Balmer – will tend to revert to the category of *de luxe* illustration; with Fairgrieve, perhaps, it is Allison Uttley's *Wandering Hedgehog* that I sometimes feel may be around the corner. But it happens seldom and recently he has taken out an insurance against the risk by moving the nature of his images more closely towards abstract solutions. One may now appreciate the design more clearly on two separate levels – firstly, the symbolic and emotive aspects resident in the sight of a lonely feather stuck on top of a post among the rolling moonlit hillsides, or the passage of a bird above a woman walking in the snow by a cottage wall; and second, the recognition of the creative intelligence behind the appearance, behind the interlocking relationship of planes whose edges are fairly hard and of how this may produce an aesthetic pleasure of a very different and classical kind. Fairgrieve lectures at the College in Edinburgh and is an active member of the New 57 Gallery.

It is fitting that the last artist in this list should represent an entirely novel point of view towards the elements of landscape. **Glen Onwin** (b1947) is a native of Edinburgh and studied painting at the College there, eventually finishing a postgraduate year in 1971 and gaining a travelling scholarship which he took the following year in Tunisia. Since leaving College, he has worked as a school teacher. Onwin first attracted notice with a series of bound canvas and wax constructions entitled *Sled 1972*, which seemed to owe some of its inspiration to the example of the man in the survival waistcoat, Joseph Beuys. This was first shown in the S.S.A. and later included in the "Choice Selection" at the Fruitmarket in 1975. But the first major indication of his arrival was the ambitiously large and complex *Saltmarsh*

piece which he installed in the Scottish Arts Council Gallery, Charlotte Square, in January, 1975.

Though its concept is valid enough, a great deal of what, for want of a term less vague, has come to be called Land Art, is often visually boring in the extreme – a few undistinguished photographs, a box of rubble or weeds, a slice of Ordnance Survey. As far as conveying mood or feeling, it can seldom be a satisfactory alternative to painting, but there are aesthetic merits in the way it records and analyses landscape. Its quasi-scientific procedures and geological museum-specimen type of presentation need not, in fact be all dull logic or pedantry, but may temper the intellectual sampling with juxtapositions, commentaries or conclusions that are poetic in their amalgamation. In a way, too, this phenomenon is merely a new signal of that old desire to get "back to nature". Its aim is to present and interpret rather than represent, because it is not at all second-hand or concerned with illusion but with the tangible facts of the elements themselves. With the assistance of their physical presence, the artist may re-phrase the truth or sense of a place. Thus, the most significant factor in Onwin's *Saltmarsh* was the manner in which he recycled the material of the particular area under his review. The language he used is an international one – Edinburgh had seen Dutch versions of it only a few months previously at the Festival – and though its grammar is difficult to master, he spoke it with unusual authority. He also had something personal to say.

The theme of the piece involved experiences in a number of different media, including some of his own devising, and was, in fact, a ten-acre salt marsh or merse near Dunbar where tides have driven a long, flat wedge into the mainland. Its lower reaches, of course, are washed twice daily while the upper ones are submerged only occasionally; but the action or evaporation of salt water has everywhere inhibited plant growth so that it is a blighted and desolate spot composed of ditches, pools and hummocks or islands of stunted grass garnished with traces of decaying matter. Natural profusion makes selection difficult, so these reduced circumstances were ideal for Onwin's purposes. He had been making observations and taking samples there since March 1973 and the fruits of his researches were contained in four main groups.

Where he had manipulated found material, forms were arrived at mostly by chance; though he had often drawn underlying circles to symbolise the cyclical nature of the environment. While his medium is anti-traditional, Onwin still cares about the physical appearance of all his images and does not close his painter's eye when the other is pressed to the microscope or the viewfinder of a camera. There were several suites of photographs – some were in colour and most were better than one usually finds in such exercises – which either set the scene with general views or examined detail like the pattern of dry mud cracks, worm casts, bird's claws on the sand, the texture of short grasses and reflections or slicks on the surface of the water. Six big pencil drawings also suggested very subtly that they were traces of similar liquid vagaries. But the finest and most exciting pieces were organic abstracts made with the stuff of the place itself – mud and other deposits which had been ground down and applied to flat planes as if they were pigment. Media and subject, therefore, became one and their animation was suspended and cocooned. Already dead, they might be the instrument of their own immortality, while the artist has played the role of God with the proper elements.

In one mode, the matter was affixed to transparent glass plates and viewed from the other side – a long series of little squares looking like fresh specimens of dirt on water; a huge and magnificent single plate that has trapped a dark mosaic of mud and leafy compost as if beneath a sheet of ice. In a second, the matter was arranged on canvas and covered with uneven layers of semi-opaque wax (a favourite agent of his). There was a suite of sixteen small squares, a solitary large rectangle and other collections of big rectangles whose presence was quite beautiful as they had the dull sheen, the warm colour, the staining and veining of alabaster or some rare marble.

Leading from this, certain recent work has explored man's links with his origins in the ocean by documenting some of the process of brine evaporation involved in obtaining salt from the sea. Onwin's contribution to "Inscape", Paul Overy's exhibition of selected Scottish contemporaries at the Fruitmarket in December, 1976, consisted of some visual realisation of another natural process whereby our solid fuels have been compressed and compounded from vegetable matter over aeons of time. Here he measured coal and peat and, with a felt-tip pen on tracing paper, described time graphically to a recipe suggested by Charles Darwin in *The Origin of the Species* in 1859.

There have been other important environmental experiments which, although they do not come strictly within the 'painterly' scope of this survey, do demand some descriptive reference. Firstly, there are the series of "Journeys to the surface of the Earth" made by the Glasgow 'artist-philosopher', Mark Boyle (b1935). With admirable craftmanship, patience and reticence, Boyle is content to let the commonplace speak for itself and so disprove apparent banality. It comes as a surprise to find that its design never seems prosaic and often assumes that authority of structure and restrained pattern to be found in all true visual poetry. In the chance encounters with the environment, Boyle brings back six foot square slices of its surface moulded in *repoussé* by some mysterious alchemy of resin. Locations are selected by the simple method of throwing darts at a large-scale map. When the journey has been made to an area, the site of the exact slice to be recorded is pin-pointed by hurling a right-angle iron into the air and marking where it comes to rest.

By isolating large fragments in this way and presenting them hung vertically as if they were relief sculpture, unusual associations, qualities and constructions are brought to light, so that we are persuaded to re-assess them and contemplate the curious coincidences which have brought them together. What is interesting are the romantic feelings these pieces invoke and the beautiful arrangements of design, texture and colour they encapsulate – railway sleepers embedded in cinders, rocks and sand newly tide-washed, an old tiled roof patched with bitumen, a mosaic of tile, red tarmac and low coping stone. But best of all is the amazing detail and the mystery of manufacture that is part of the creative equation – once more we see man playing at God.

Boyle is equally well-known furth of Scotland. Ian Hamilton Finlay (b1925) is widely acclaimed abroad but, unfortunately, less well recognised in his own country. He is, however, a 'visual-poet' of a very illuminating kind whose own patch of land and water, "Stonypath", in the Pentland Hills South-West of Edinburgh, is a magical garden retreat quickened with tangible metaphors and signals of considerable poetic intelligence. Though Finlay feels strongly that his work should not be cate-

gorised simply as a brand of Concrete Poetry, the term must serve as an indication of the area he explores. At a time when Conceptual Art – with its frequently po-faced self-indulgence, mystification and meagre substance – has become fashionable, it is worth observing that, while Concrete Poetry shares the same reverence for the idea itself, the similarity must end there. Because the latter is witty, it insists on the idea being clarified and condensed as economically as possible, and it expects to be universally understood. In this delicate territory, this narrow borderland where the word and the image may be fused, good ideas are easily debased by poor work-manship. But, in matters of presentation, Finlay is as admirably fastidious as elsewhere and careful only to collaborate with the better typographers, calligra-phers, draughtsmen, printmakers, sculptors and other craftsmen. As a result, his ideas avoid the ephemeral and become fixed in symbols that are well made and look memorable and interesting enough to withstand the rigours of both time and familiarity.

Many of his poems are about ships, the sea, the wind, the sun and the seasons generally; and in them his mystical marriage of word and image produces meta-phors and puns (both visual and verbal) which are clairvoyant and haunting. Sometimes he dispenses with words altogether – as he has done in a series of mina-ture aircraft carriers carved in stone or cast in bronze. Their very presence is faintly Surreal, but that is not enough to explain why they should seem so delightful or embody a symbolism which is so memorably and quietly catalytic. Their solid dimension, of course, contains poetic insight and the clue lies in how they are named; the naming of things is one of the basic functions of the bard. Finlay calls one of these aircraft carriers a Bird-Bath, a second a Bird-Table, another a Fountain; and they are each constructed to fulfill the purposes suggested by the titles. It would be a dull fellow indeed who did not welcome the wit and style of such an elegant conceit; appreciate the skein of serious and didactic thought radiating from such a brilliant little metamorphosis; and marvel at the way the author invites the birds themselves to take part in an improvised drama. This high standard of creative and poetic thought, which draws illuminating verbal analogies and revels in making an aesthetic virtue of a visual pun, remains a constant and spiritually uplifting factor in all the messages he causes to be put on paper, wood, glass, canvas, or stone.

Other younger painters have also exhibited concern for aspects of the environ-ment; namely James McGlade, whose interest in symbolising the mysterious forces in dowsing or the riddle of the megalithic standing stones has an obvious relation-ship with the Demarco pilgrimages; Michael Docherty, who is now involved in creating small environments to symbolise personal concepts; and Ainslie Yule, whose imaginative constructions also inhabit a mixed area between painting and sculpture.

To bring matters up to date, I must refer again to the New 57 Gallery whose ex-ample of corporate action prompted a group of young painters in the West to form a Glasgow League of Artists. The League, in effect, is another artists' cooperative and, since its founding in 1971, has established a large communal studio workshop in the centre of the city and a healthy programme of sponsored exhibitions.

Ronald Forbes and Gregor Smith were among the founders and membership includes other distinguished young talents like Kate Whiteford and Calum Mac-

kenzie. This short list, in turn, reminds me that there are also several other names which have been connected with the New 57 Gallery and deserve to be mentioned here – painters like Barbara Rae, Ann Ross, Eileen Lawrence, John Mooney and Kirkland Main.

Though the Glasgow League of Artists has no gallery of its own, the city of Glasgow has recently acquired a rather different type of premises in Sauchiehall Street which not only carries exhibitions, but is also designed to play an active role in fostering community interest in the arts. The Third Eye Centre was set up by the Scottish Arts Council and opened in May 1975 with a retrospective show of Joan Eardley paintings. It is now run independently by a Glasgow board of management.

This account can have no real end and only take us to another series of beginnings. It is not my intention to sum up these three decades against which my nose was so closely pressed, but I will venture one heartening comparison between art in Scotland in 1945 and it position as I write now. Then the situation was largely closed and there appeared to be only a very few options available to the young artist, today the situation is wide open and the options appear to be legion.

1. William Johnstone *Embryonic* (from Genesis, a series of plaster reliefs) 1973, 48″ × 36″ Private Collection.

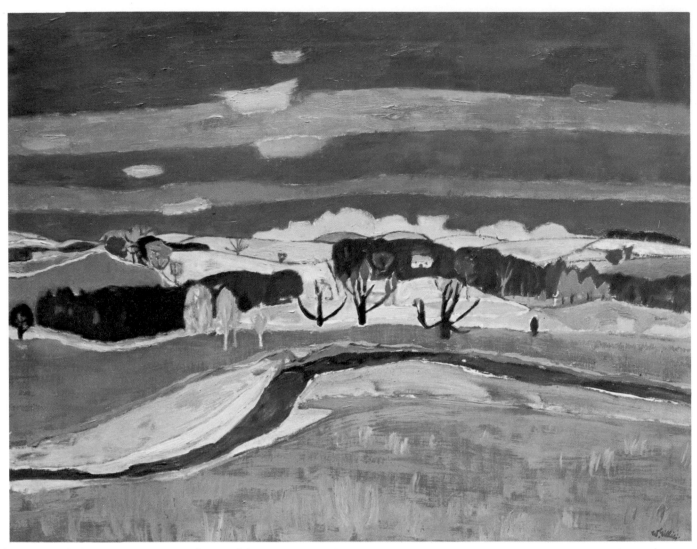

2. William Gillies *Dusk* 1959, 28″ × 36″, Aberdeen Art Gallery.

3. *right* John Maxwell *Two Figures (Clowns)* 1954, 23″ × 16″, Private Collection.

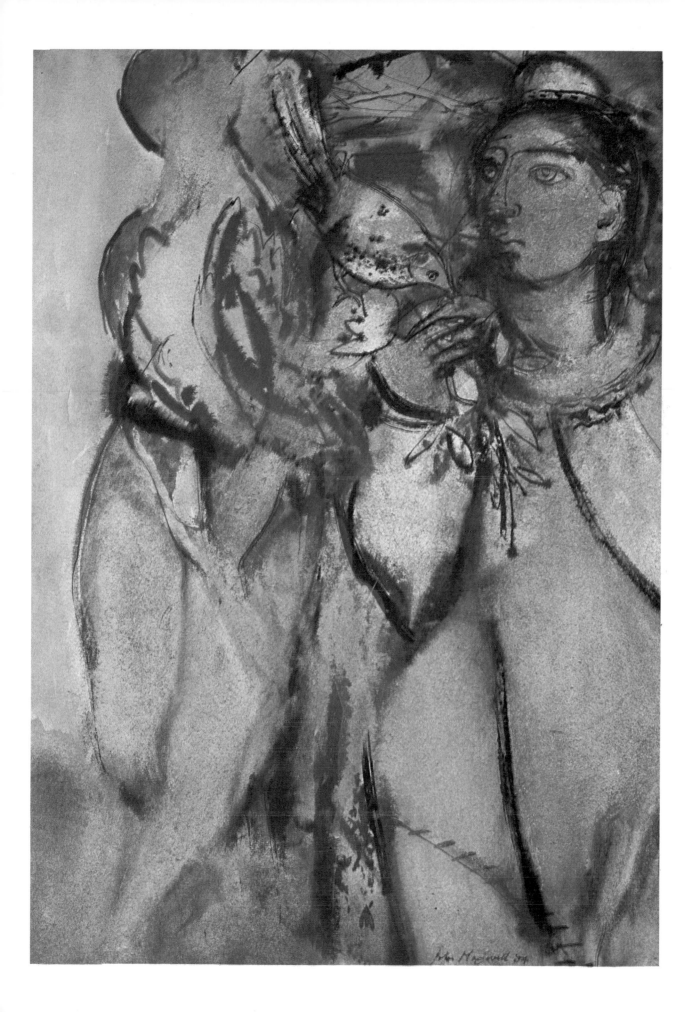

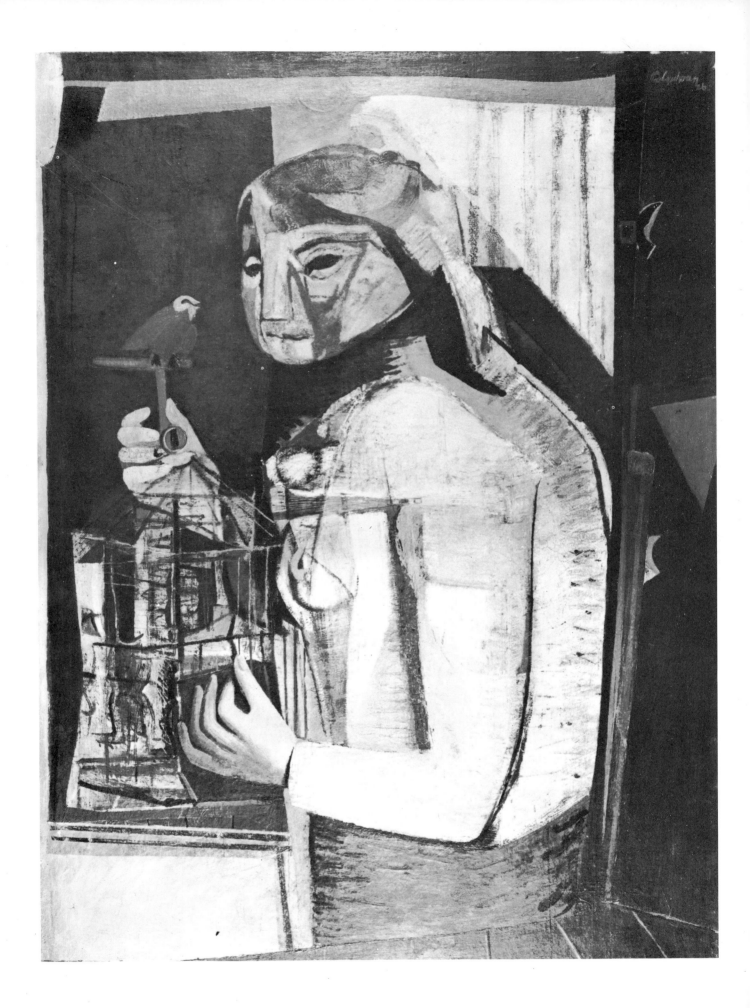

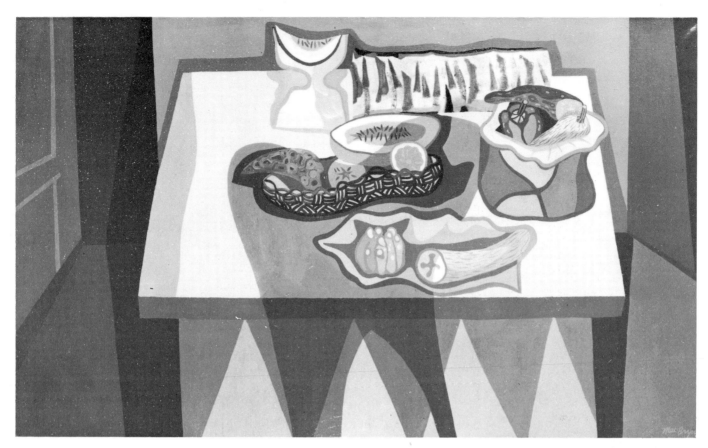

5. *above* Robert MacBryde *Still Life with Fruit and Vegetables* (or Large Still life) 35″ × 57½″, The Mayor Gallery.

6. *right* Alexander Zyw *Olivier* 1964, 79″ × 56″, the Artist.

4. *left* Robert Colquhoun *Woman with Birdcage* 41″ × 29″, Bradford City Art Gallery.

7. William MacTaggart *Starry Night, the New Town* 1955, 42″ × 52″, Private Collection.

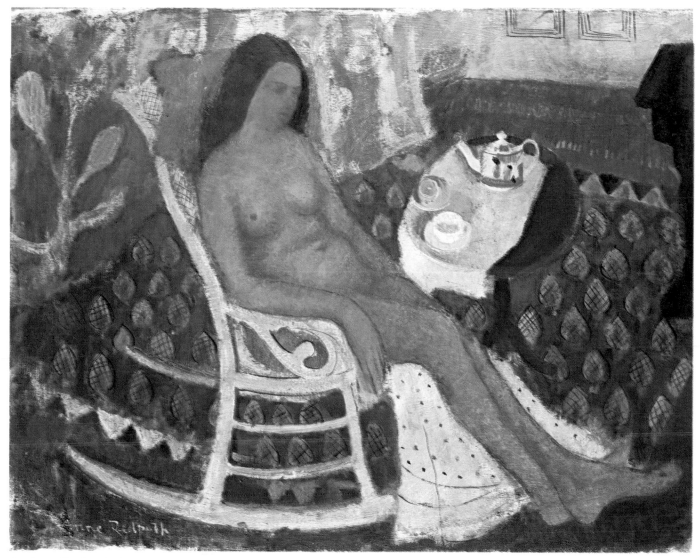

8. Anne Redpath *Girl in a Rocking Chair* 1949, 29″ × 36″, Private Collection.

9. *above* Wilhelmina Barns-Graham *Black and White on Terra Cotta* 1971, 13″ × 15″, the Artist.

10. *left* Charles Pulsford *Yellow Landscape with Figures* 1953, 32″ × 40″, Private Collection.

11. *right* William Gear *Spiked Landscape* 1966, 60″ × 40″, Private Collection.

12. David Donaldson *Joan Dickson* 60″ × 60″, Commissioned by the Scottish Arts Council.

13. *right* Denis Peploe *Tanscraig*
25″ × 38″, the Artist.

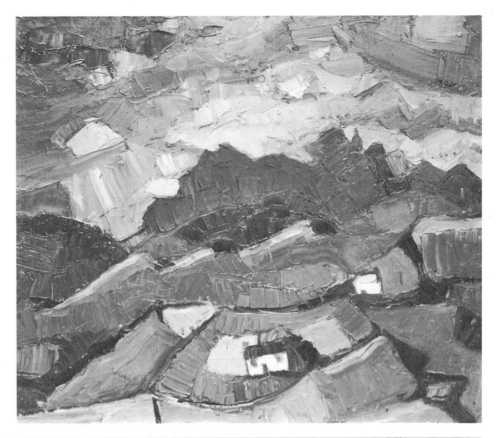

14. *below* Alberto Morrocco *Self Portrait with wife and daughter and Conde, Duc de Olivares* 1974, 70″ × 96″, the Artist.

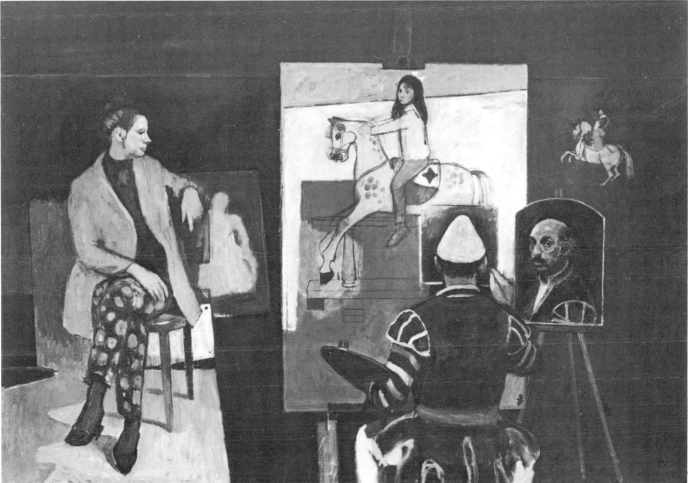

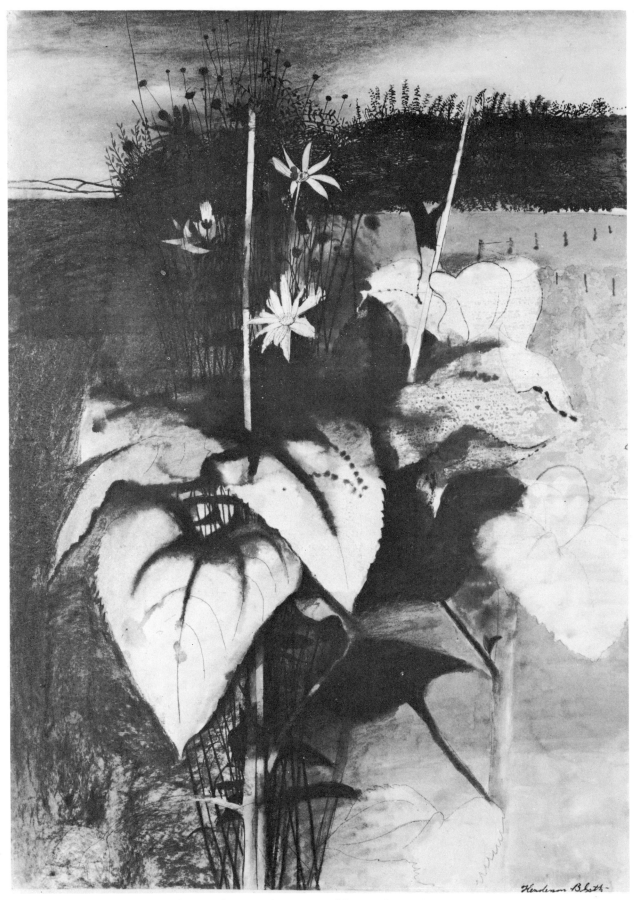

15. Robert Henderson Blyth *Leaves of a Sunflower* 1961, 19¾″ × 27″, Aberdeen Art Gallery.

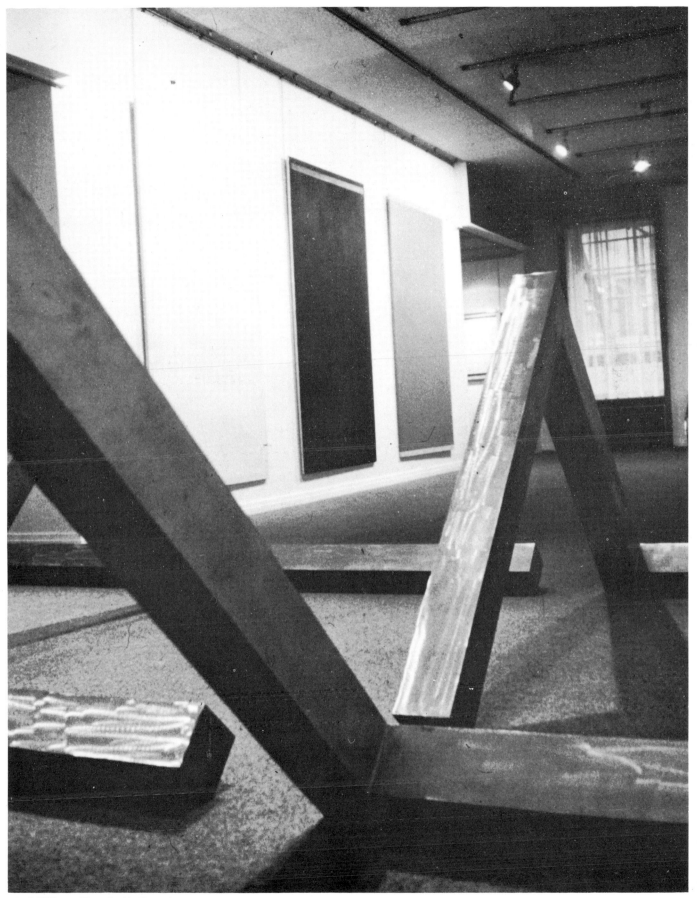

16. William Turnbull *Installation Shot of Exhibition at the Scottish Arts Council Gallery* March 1974.

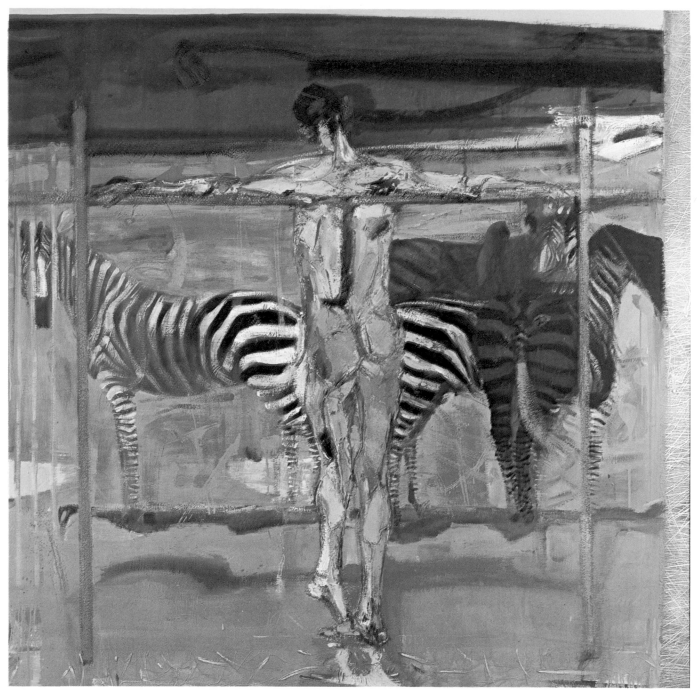

17. Robin Philipson *Zebra* (right-hand panel of triptych) 1974, 60″ × 60″, Private Collection.

18. Joan Eardley *Summer Sea* c 1962, 48″ × 72″, Royal Scottish Academy (Diploma Collection) by permission of the National Gallery of Scotland.

19. David McClure *Black Studio – Interior* 1969,
39½″ × 49½″, Scottish Arts Council.

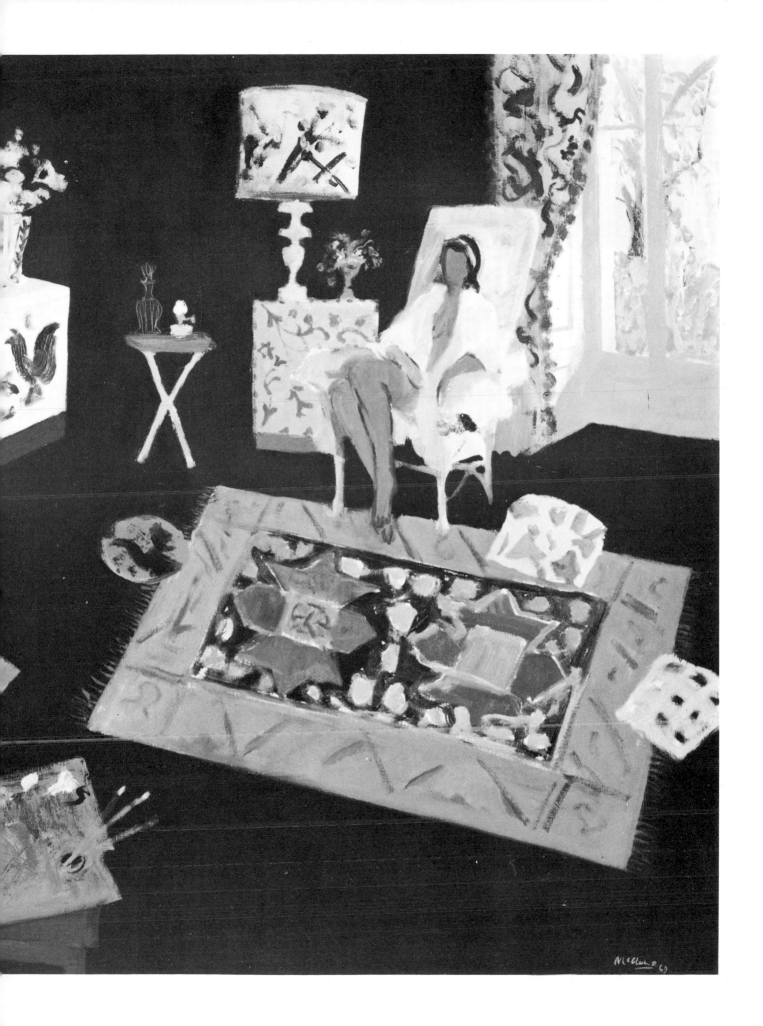

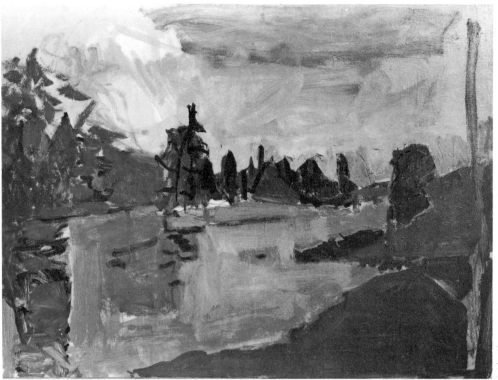

20. *left* The Earl Haig *The Tweed at Mertoun* 1968, $34\frac{1}{2}'' \times 44\frac{1}{8}''$, Scottish National Gallery of Modern Art.

21. *below* Edward Gage *The Road to Vitalades* 1976, $22'' \times 38''$, Private Collection.

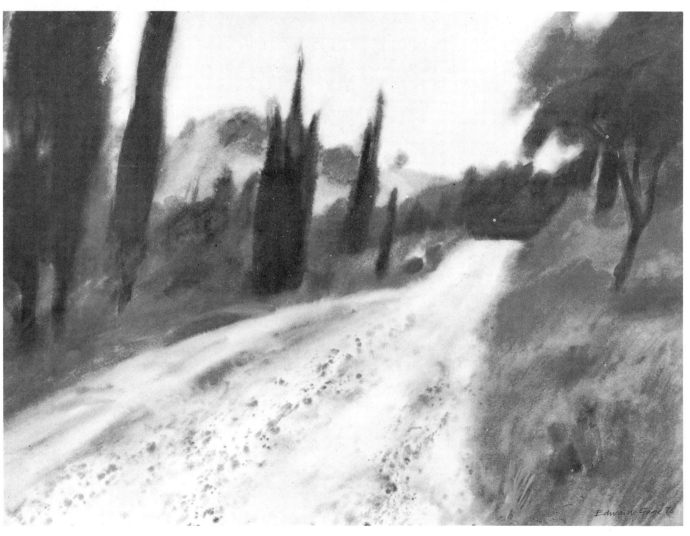

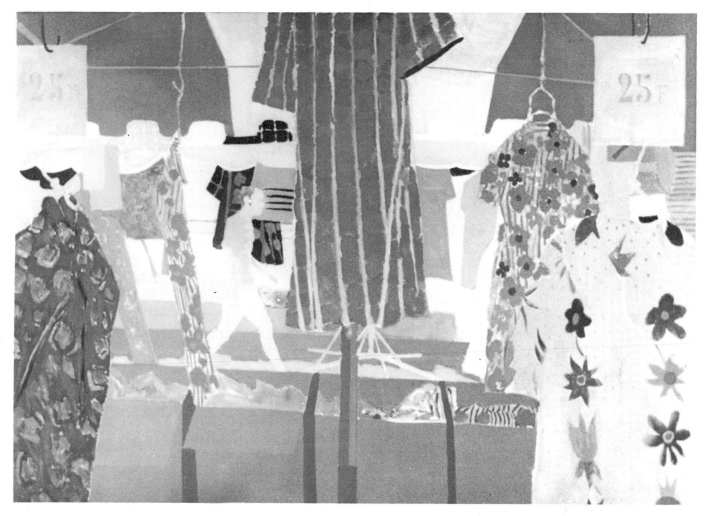

22. *above* David Michie *Man in the Market* 1974, 36″ × 50″, Yorkshire Education Authority.

23. *right* John Busby *Sky Canticle* 1973, 40″ × 40″, the Artist.

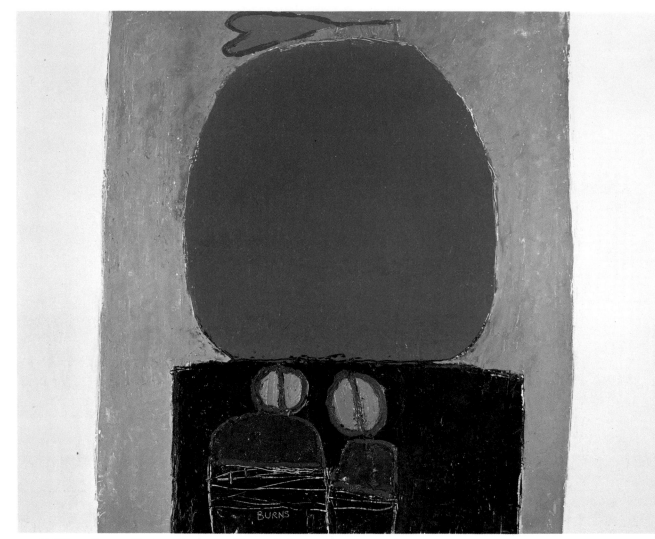

24. William Burns *Harbour Shape 4* 30″ × 40″, Royal Scottish Academy.

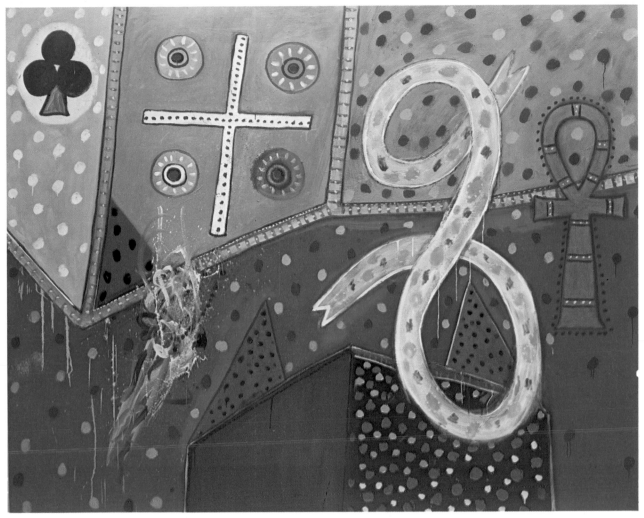

25. Alan Davie *Magic Serpent No 2* 1971, 48″ × 68″, Private Collection.

26. Barbara Balmer *Downhill Olive Grove*
1976, 48″ × 40″, Scottish Arts Council.

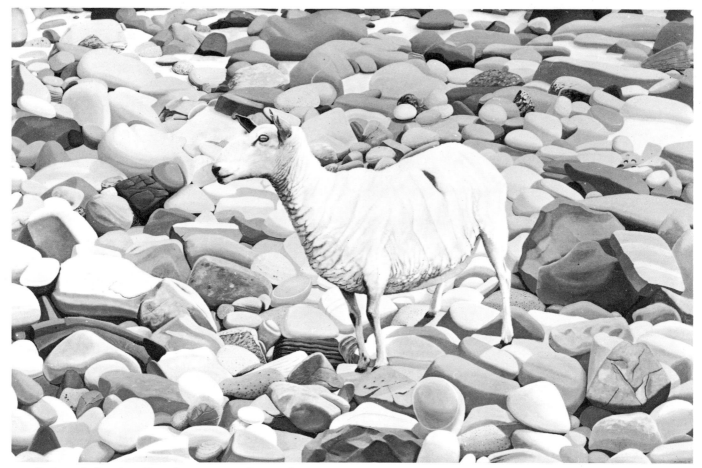

27. Robert Callender *Short Cut* 1974, 84″ × 66″,
the Artist.

28. *right* Fred Stiven *Winter Shelf* 18″ high, the Artist.

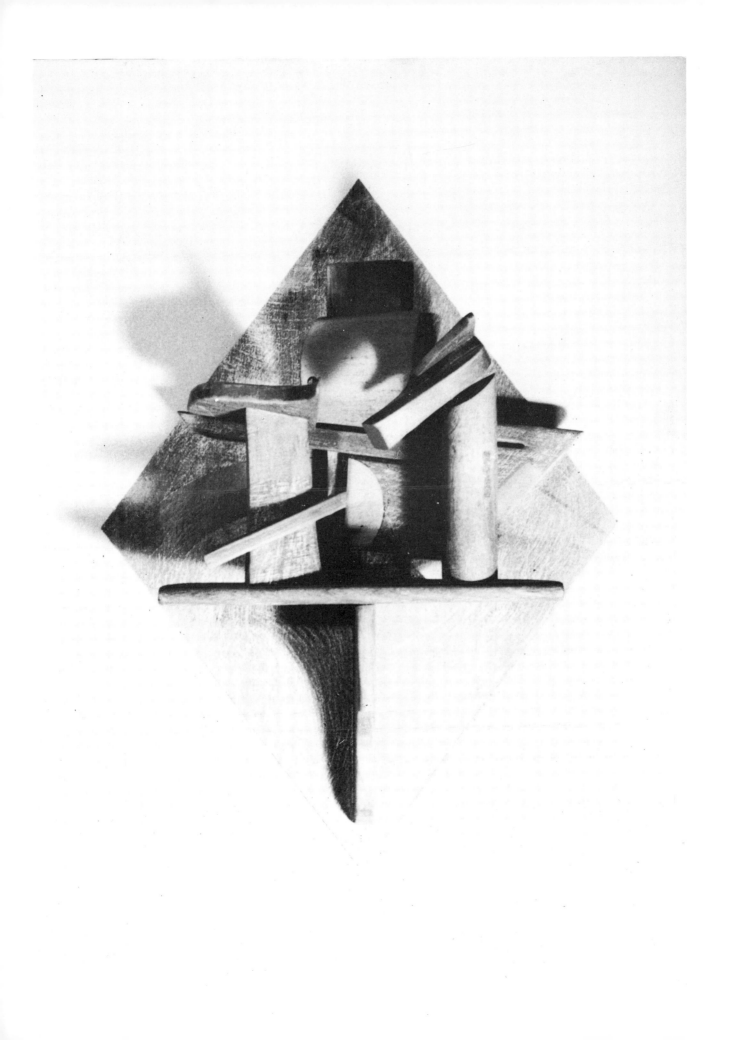

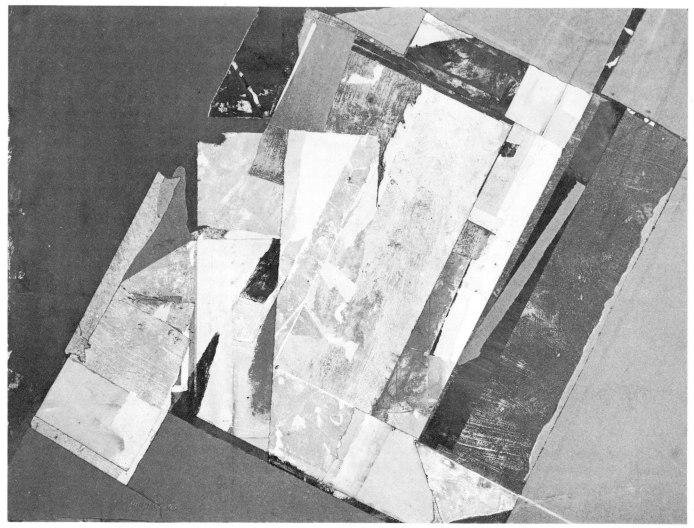

29. Philip Reeves *Hillside, Shap* 1973/4, 32″ × 40″, the Artist.

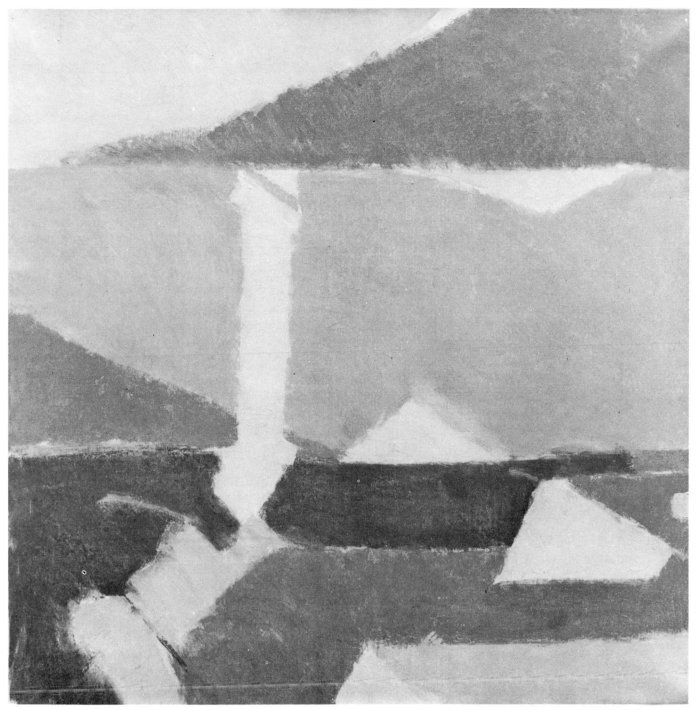

30 Ian McKenzie Smith *Morning* 1973, 36″ × 36″, Private Collection.

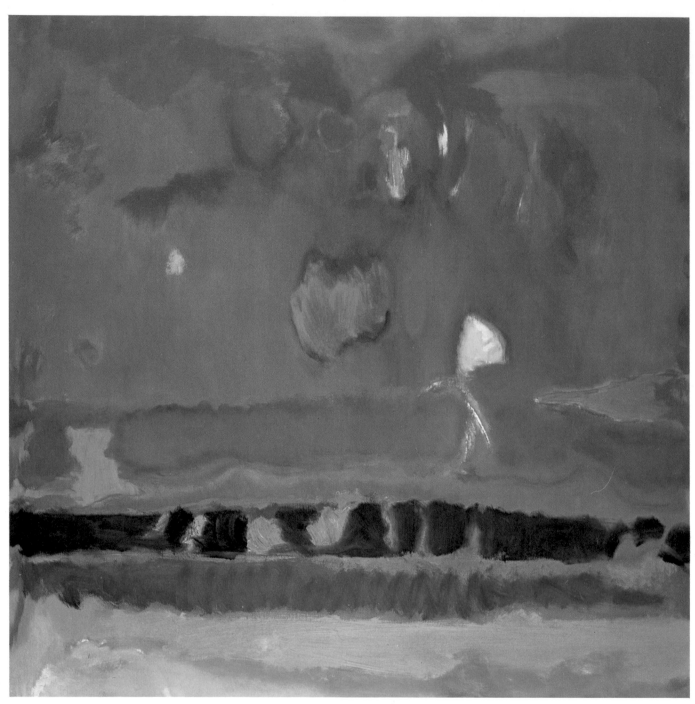

31. John Houston *Lake Owen* 1971, 60″ × 60″, Private Collection.

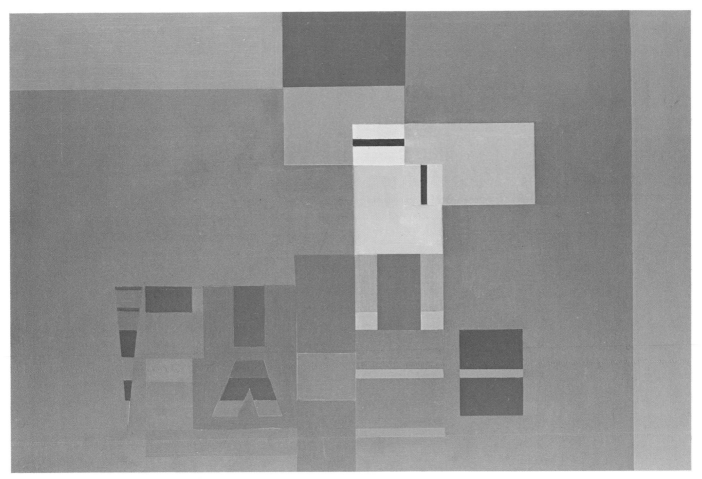

32. James Cumming *The Heart of the Matter* 1972/3, 25″ × 38″, the Artist.

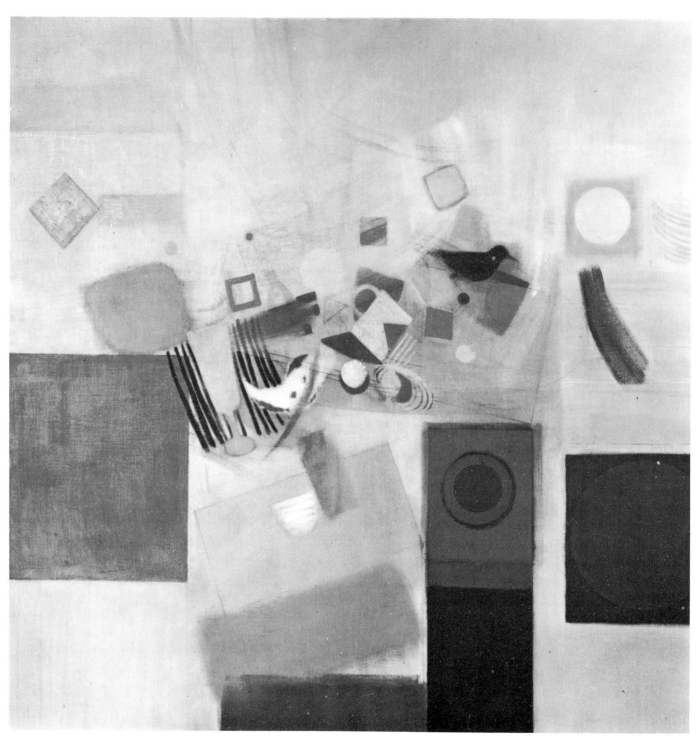

33. William Littlejohn *Still Life – Harbour and Bird* 1964, 50″ × 50″, Scottish National Gallery of Modern Art.

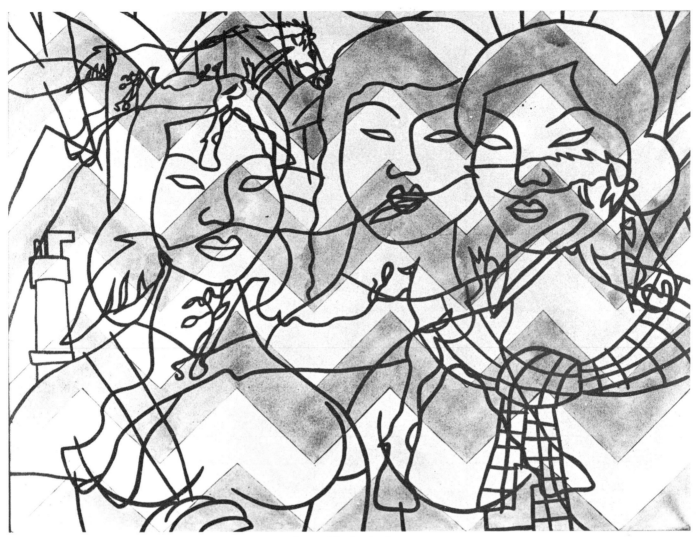

34. Ian McCulloch *Three Girls, Vietnam* 1972, 28″ × 56″, the Artist.

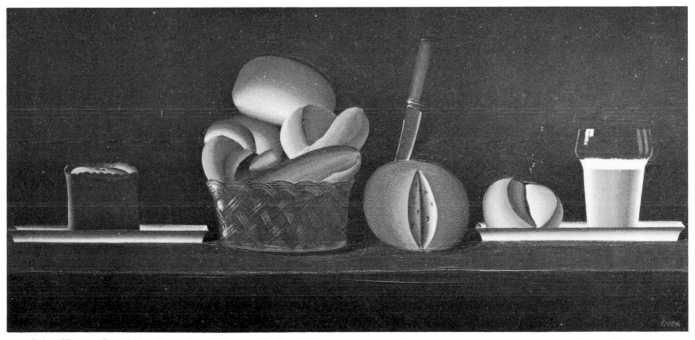

35. John Knox *Dutch Snack* 1976, 16″ × 35″, the Artist.

36. Denis Buchan *Sounds and Figure in a Studio near the North Sea* 50″ × 50″, the Artist.

37. William Crozier *West Garden* 1969, 48″ × 48″, Scottish Arts Council.

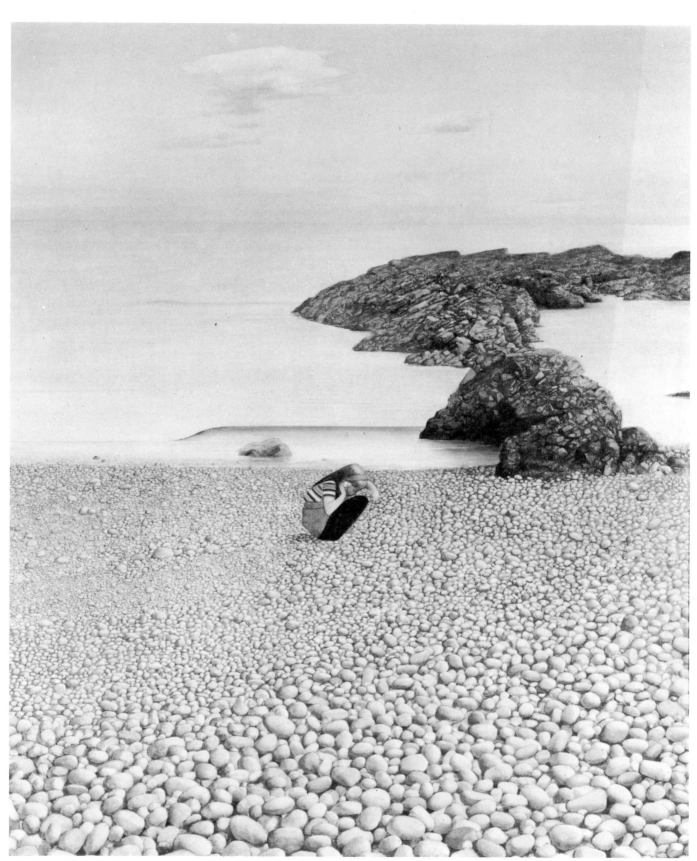

38. Peter Collins *Petra Listens* 1973, 35½″ × 29¼″, Scottish Arts Council.

39. *right* Neil Dallas Brown *Figure and Cat in Dark Pool* 1973, 48″ × 34½″, the Artist.

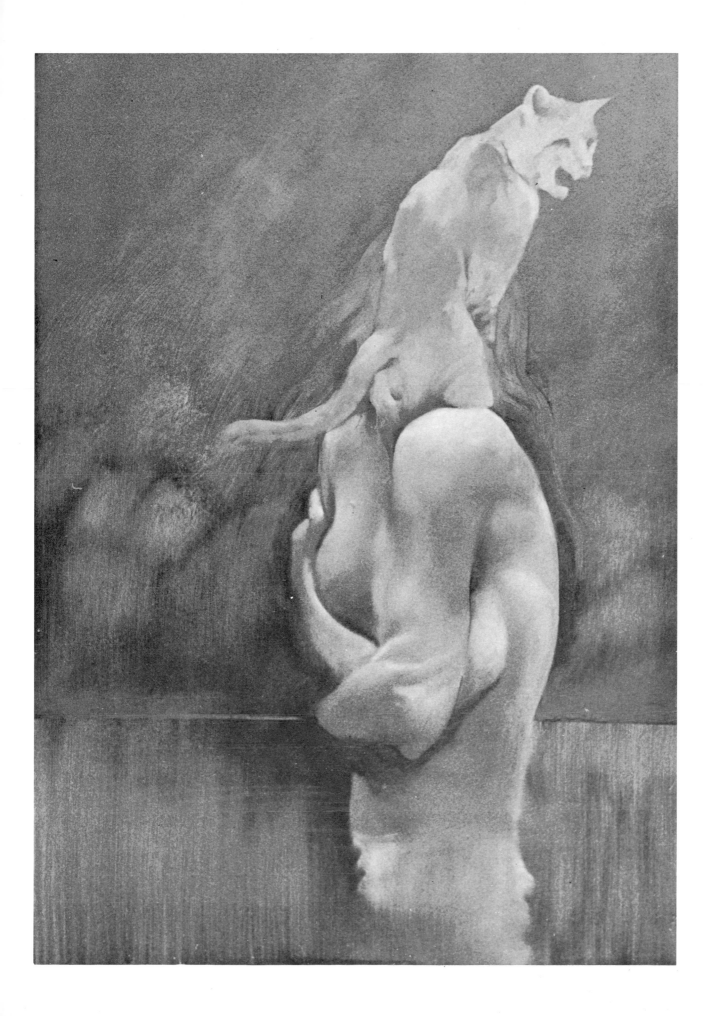

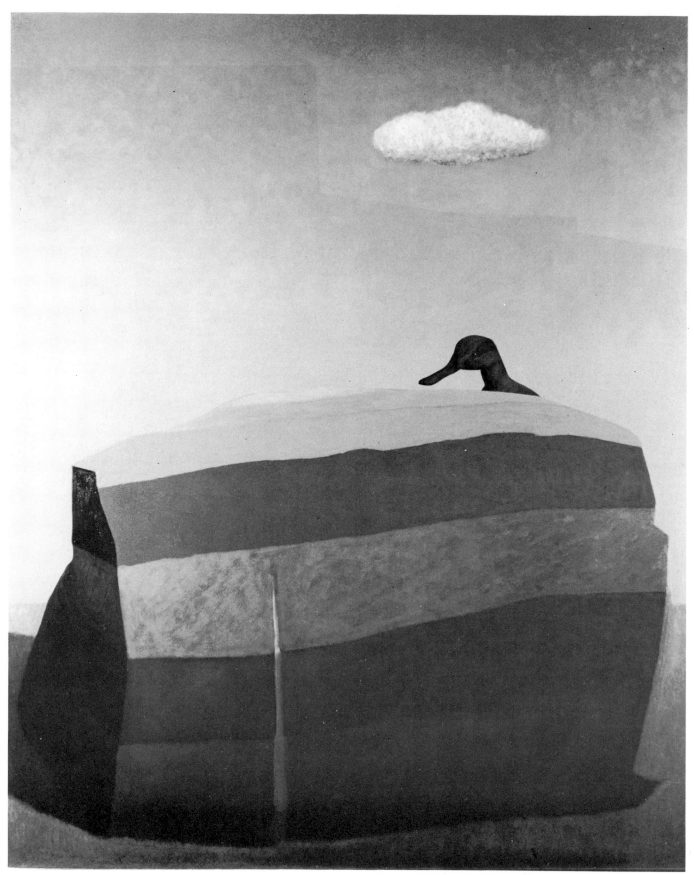

40. John Johnstone *Rock Bird* 1970/3, 60″ × 48″, Private Collection.

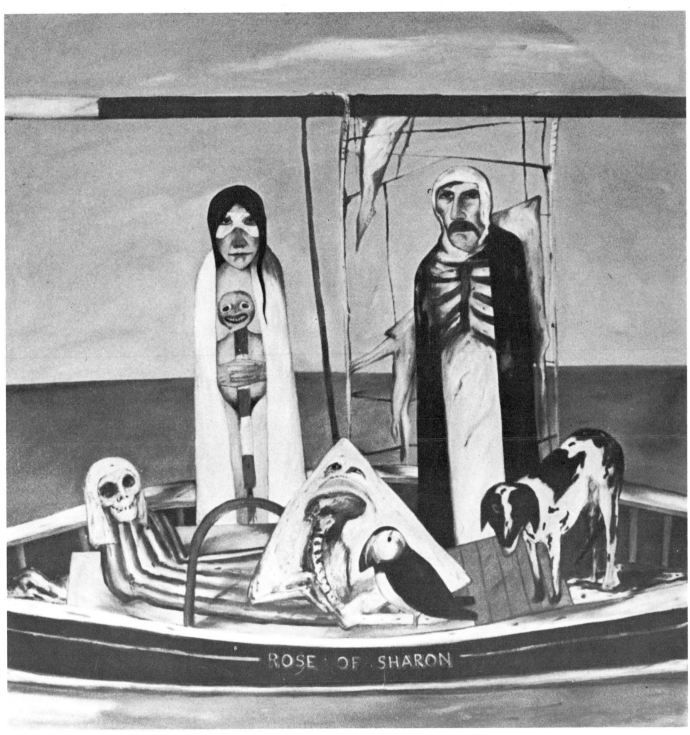

41. John Bellany *Rose of Sharon* 1974, 72″ × 74″, the Artist.

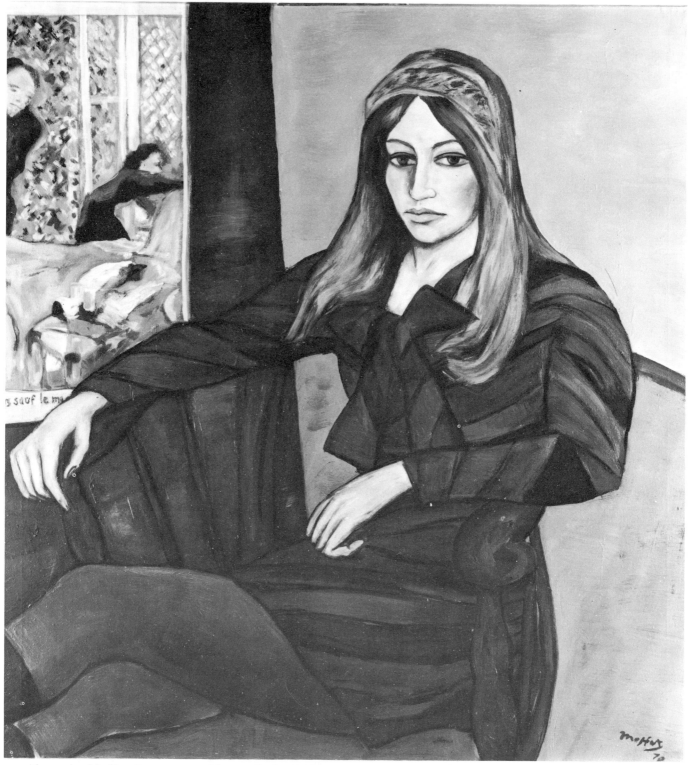

42. Alexander Moffat *Susan* 1970, 36″ × 34″, the Artist.

43. *above* David
Evans *The Guest* 1975,
40″ × 50″, the
Artist.

44. *right* Colin Cina
Homage to the N-Gram
1974, 84″ × 126″,
Angela Flowers
Gallery.

45. Elizabeth Blackadder *Objects on White* 1968, $25\frac{1}{2}''$ × $35\frac{1}{2}''$, Scottish Arts Council.

46. Patricia Douthwaite *Amy Johnson with Goggles* 1976, 48″ × 48″, the Artist.

47. George Donald *Rothiemurchus and Beyond – a Strathspey* 1976, 30″ × 36″, the Artist.

48. Kenneth Dingwall *Drawing* 1974, $8\frac{2}{3}''\times14\frac{1}{2}''$, the Artist.

49. James Fairgrieve *Winter Image* 1976, 48″ × 72″, the Artist.

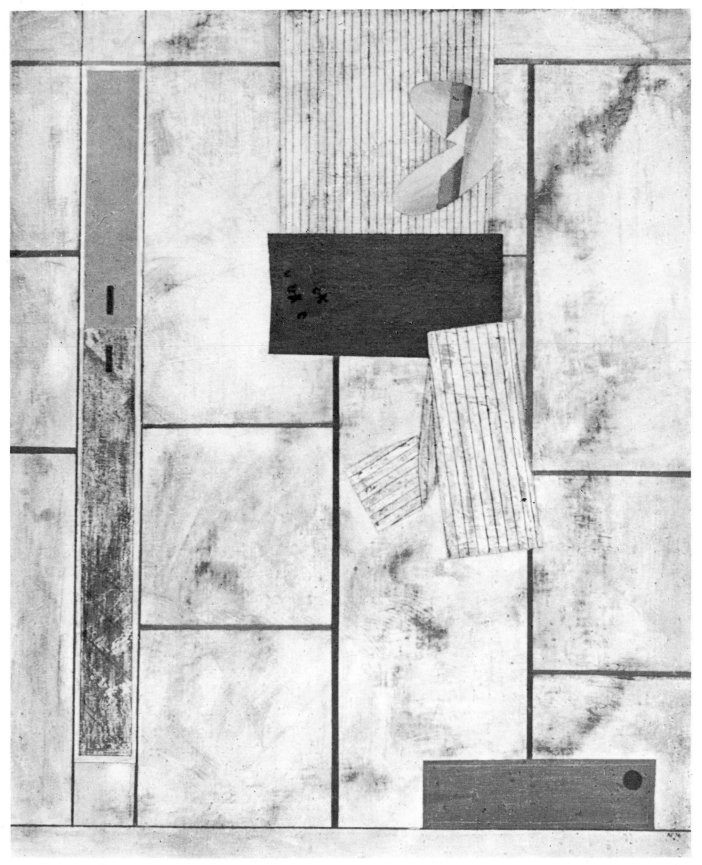

50. Alexander Fraser *Stonehaven* 1975, 30″ × 24″, Scottish Arts Council.

51. William Maclean *Trap Image No 3* 1974,
18″ × 24″, Scottish Arts Council.

52. Glen Onwin *Four Units* 1974, (each unit) 24″ × 24″, the Artist.

BARBARA BALMER A.R.S.A. R.S.W.

Born Birmingham 1926. Spent two years Coventry School of Art. One year as Display Artist for Rowntrees of Scarborough. Andrew Grant Scholarship to Edinburgh College of Art for two years. Awarded Post Diploma and Travelling Scholarship to Spain and France. Elected R.S.W. 1966. Elected A.R.S.A. 1973. Lecturer at Grays School of Art. Married to George Mackie. Lives in Aberdeen.

ONE-MAN EXHIBITIONS
1965 Traverse Theatre Art Gallery, Edinburgh. 1970 Demarco Gallery, Edinburgh. 1970 Aberdeen University Staff Club. 1970 Restrospective, University of Aberdeen, Senior Common Room. 1975 Scottish Gallery, Edinburgh. 1975–6 Royal Edinburgh Hospital.

GROUP EXHIBITIONS
1963, 65 John Moores, Liverpool. 1966 Bradford Spring Exhibition. 1966 Demarco Gallery Inaugural Exhibition; 1969 Glasgow Group. 1973 Loomshop Gallery, Lower Largo. 1973 Loomshop Gallery, Lower Largo Festival Exhibition. 1973 Sheffield University. 1971 Art Spectrum, Scotland. 1973 Nine Scottish Painters, University of Sheffield.

COLLECTIONS
H.M. The Queen. Scottish Arts Council. R.S.A. Collection. Glasgow Art Gallery. Aberdeen Art Gallery. Greater London Council. Dunbarton Education Trust. Edinburgh Corporation Education Department. Save & Prosper Group. University of Stirling. John Moore.

W. BARNS-GRAHAM

1912 Born St. Andrews, Fife. 1931–6 Studied Edinburgh College of Art. 1940 Moved to Cornwall. 1949 A founder member of the Penwith Society of Arts in Cornwall. 1956–7 Taught at Leeds School of Art. Works in Cornwall and Fife.
Awards: 1932–4 Two Year Maintenance Scholarship, Edinburgh College of Art. 1937 Post Graduate travelling scholarship. 1951 Painting prize St. Ives Festival work purchased for Borough of St. Ives. 1955 Travelling scholarship from the Italian Government through the British Council.

ONE-MAN EXHIBITIONS
1947 & 49 St. Ives, Downings Gallery. 1948 & 52 Redfern Gallery, London. 1954 Roland Browse & Delbanco, London. 1956 The Scottish Gallery, Edinburgh. 1957 Wakefield City Art Gallery. 1960 The Scottish Gallery, Edinburgh. 1968 The Richard Demarco Gallery, Edinburgh. 1968 The Bear Lane, Oxford. 1970 Leeds Park Square Gallery. 1970 Sheviock Gallery, Cornwall. 1971 Marjorie Parr Gallery, London.

GROUP EXHIBITIONS
1947 & 48 Crypt Group, St. Ives. 1951 British Abstract Art, London. Mirror & Square, London. 1953 Contemporary Water Colours Exhibition, Brooklyn, U.S.A. 1955 Seven Scottish Artists Arts Council Travelling Scotland. 1962 International Gouache Exhibition, New York; Contemporary Scottish Artists Arts Council, Canada (Toronto). 1962–63 Waddington Gallery, Mixed Shows. 1962 British Water Colours Exhibition, Sweden, arranged by Waddington Gallery. 1964 Pictures for Schools Exhibition, Royal College of Art Galleries.

JOHN BELLANY

Born Port Seton 1942. Studied at Edinburgh College of Art from 1960–1965. 1962 won an Andrew Grant Scholarship. Post Graduate Travelling Scholarship in Holland and Belgium in 1965 and was at the Royal College of Art, London from 1965–1968. Lecturer in Painting, Croydon College of Art.

EXHIBITIONS
1965 Dromidaris Gallery, Holland. 1968 Edinburgh College of Art. 1969 Winchester School of Art.

1970 Drian Gallery, London. 1970 Hendrix Gallery, Dublin. 1971 New 57 Gallery Dublin. Print-makers Workshop, Edinburgh. Drian Gallery, London. 1972 R.C.A. Galleries, London. 1973 Triad Arts Centre, Bishops' Stortford, Herts. Edinburgh City Arts Centre.

GROUP EXHIBITIONS

Edinburgh Festival Exhibition 1963/64/65. Young Contemporaries 1964/66/67. John Moore's Exhibition Liverpool 1966/67. London Group 1968. '20 × 57' Edinburgh Festival 1969/70/71/72. Scottish Realism, Arts Council Touring Exhibition 1971. British Figurative Art, Nova London Gallery, Copenhagen 1972. Nicholas Treadwell Gallery 1972. Fanfare for Europe, Drian Gallery, London 1973. Figures in the Landscape (Arts Council Touring Exhibition) 1973.

COLLECTIONS

Scottish Arts Council. Edinburgh Corporation. Royal College of Art. Zuider Zee Museum, Holland. Murals, Chesser House, Edinburgh.

ELIZABETH BLACKADDER R.A., R.S.A., R.S.W.

Born 1931 at Falkirk and studied at the University of Edinburgh and at Edinburgh College of Art where she now teaches. Travelling Scholarship to Italy in 1955 and 1956, and has since worked in France and Portugal. Member of the Royal Scottish Society of Painters in watercolour. A.R.S.A. 1963. R.S.A. 1972. A.R.A. 1971. R.A. 1976.

ONE-MAN EXHIBITIONS

1959 57 Gallery, Edinburgh. 1961 Scottish Gallery, Edinburgh. 1965 Mercury Gallery. 1966 Scottish Gallery, Edinburgh. Thames Gallery, Eton. 1967 Mercury Gallery, Art Gallery, Reading. 1969 Mercury Gallery. 1970 Vaccarino Gallery, Florence. 1971 Mercury Gallery. 1971 Loomshop Gallery, Largo. 1972 Scottish Gallery, Edinburgh, Royal Glasgow Institute Invitation Exhibition. 1976 Stirling Gallery.

COLLECTIONS

Museum of Modern Art, New York. Tate Gallery, London. Scottish National Gallery of Modern Art. Scottish Arts Council. Glasgow Art Gallery. Aberdeen Art Gallery. Graves Art Gallery, Sheffield. Art Gallery and Museum, Reading. Carlisle Art Gallery. Nuffield Foundation. Teeside Museum and Art Gallery. Greater London Council. County Council of Argyll. County Council of Nottingham-shire. County Council of West Riding. Ministry of Public Works. Paintings in Hospitals. Stirling University. Paisley Art Gallery. Doncaster Art Gallery. Kettles Yard, Cambridge.

R. HENDERSON BLYTH

Born 1919 Glasgow. Educated in Glasgow. 1934 First exhibited at R.S.A. and principal Glasgow Salons. 1934–39 Studied Glasgow School of Art. 1937 First exhibited at Royal Academy. 1940 Post Diploma year Hospitalfield. Arbroath. 1941 Joined Royal Army Medical Corps. Continued to paint while serving in France, Belgium, Holland and Germany. 1945 Guthrie Award. 1946 Joined staff at Edinburgh College of Art as assistant to W. G. Gillies. Elected Member of S.S.A. 1949 Elected Associate of R.S.A. Elected Member of Royal Scottish Society of Painters in Watercolour. 1954 Joined staff of Gray's School of Art, Aberdeen. Elected a member of R.S.A. 1960 Appointed Head of Drawing and Painting, Gray's School of Art. 1970 Died May 18th, Aberdeen.

GROUP EXHIBITIONS

1942 New English Art Club, London. 1944 Army Exhibition of Handcrafts, Dundee. 1948 C.E.M.A. Tour. 1950 The Scottish Scene (Scottish Arts Council). 1951 Britain in Watercolours (Art Exhibitions Bureau). 1952 Young Contemporary British Painters (Scottish Arts Council). 1954 Fifty Years of British Art 1904–1954 (Bradford City Art Gallery). 1954 Some Edinburgh Painters (National Gallery of Canada). 1956 The Scottish Scene (circulated by the Art Exhibitions Bureau). 1963 Fourteen Scottish Painters (The Commonwealth Institute and The Scottish Arts Council). 1964 Contemporary Scottish Art, Reading Museum and Art Gallery. 1964 Four Scottish Artists (Scottish

Arts Council), Edinburgh International Festival Exhibition. 1965 Seven Scottish Painters, IBM Gallery, New York.

COLLECTIONS
Aberdeen Art Gallery. Aberdeen: Gray's School of Art. Aberdeen University. Craigie College of Education, Ayr. Dumbartonshire County Council. Dundee Art Gallery. Department of the Environment. Edinburgh Schools Collection. Edinburgh College of Art. The Scottish National Gallery of Modern Art, Edinburgh. Royal Scottish Academy, Edinburgh. City of Edinburgh Art Centre. Glasgow Museums and Art Gallery. The McLean Museum & Greenock Art Gallery. Art Gallery of Hamilton, Canada. Imperial War Museum. Nottingham Art Gallery. Nuffield Foundation. Paisley Museum and Art Gallery. Perth Art Gallery. Scottish Arts Council. West Riding County Council.

NEIL DALLAS BROWN

Born in Elgin 1938. Studied at Dundee College of Art, Hospitalfield, Arbroath and the Royal Academy Schools, London. Won a Travelling Scholarship which enabled him to visit France, Italy and Spain. Won David Murray Scholarships in 1959 and 1961; Leverhulme Grant Award in 1960 and a Chalmers Bursary in 1962. 1967 received a Scottish Arts Council Award and went to New York. 1970 was awarded the major purchase prize in the Arts Council of Northern Ireland Open Painting Exhibition, Belfast. Teaches part-time at Duncan of Jordanstone College of Art, Dundee. Married with two children and lives and works in Newport on Tay.

EXHIBITIONS
1959 Duncan Institute Cupar. 1960 Duncan of Jordanstone College of Art. 1964 '57 Gallery, Edinburgh. 1965/67 Tib Lane Gallery, Manchester. 1976/68/69/71/72 Piccadilly Gallery, London. 1968 Scottish Gallery, Edinburgh. 1969 Richard Demarco Gallery, Edinburgh. 1971 Compass Gallery, Glasgow. 1972 University of York. 1973 Galerie Schreiner, Basle.

GROUP EXHIBITIONS
1961 Five Dundee Painters, Dundee City Museum. 1963 Young Scottish Contemporaries, Arts Council, Edinburgh. 1964 Four Painters, New Charing Cross Gallery, Glasgow. 1965 Seven Scottish Painters, IBM Gallery, New York City. Four Young Scottish Painters, Piccadilly Gallery, London. Contemporary Scottish Painters, Glyn Vivian Gallery, Swansea. 1967 The Surrealists, Copenhagen. The Edinburgh Open 100. 1968 Scottish Painting '68. Richard Demarco Gallery, Edinburgh. Four Fife Artists, Carnegie Festival, Dunfermile. Mostra Mercato d'Arte Contemporanea, Florence. 1968/70 Open Painting Exhibition, Belfast. 1969 Fine Art for Industry, R.C.A., London. Three Scottish Artists, Durham University. 1970 Seven Painters in Dundee, Scottish National Gallery of Modern Art. Twelve Scottish Painters (Touring U.S.A.). Narrative Painting in Britain in the 20th Century, London. Scottish Painting, Park Square Gallery, Leeds. Painting '70, Aberdeen City Art Gallery. 1971 Three Scottish Artists, Gallery Edward Harvane, London. Art Spectrum, Scotland. 1972 Aspects of Surrealism, British Art 1930–72, Gallery Edward Harvane, London. 1973 Contemporary British Art, Rochdale Municipal Art Gallery. "Figures in the Landscape" toured by South Western Arts Association. "Drawings by Scottish Artists", Stirling Gallery, Stirling.

COLLECTIONS
Scottish Arts Council. Dundee City Museum. Skopje Museum, Yugoslavia. Nottingham City Art Gallery. Vincent Price Collection, U.S.A. Scunthorpe Education Committee. Fife Education Committee Hertfordshire County Council. Schools Collection, Walker Art Gallery, Liverpool. Kingsway Technical College, Dundee. College of Commerce, Dundee. Arts Council of Northern Ireland. Dumbarton Education Authority. Provincial Insurance Ltd. Scottish Television. University of York. College of Education, Dundee. West Riding of Yorkshire Education Committee. Clackmannan County Council. Pitlochry Festival Collection. College of Education, Dundee.

DENIS BUCHAN A.R.S.A.

Born 1937 in Arbroath, Angus. 1954–58 Studied Duncan of Jordanstone College of Art. 1958–9 Post Diploma year. 1959 R.S.A. Award. 1959 Hospitalfield Arbroath (Summer). 1960–62 National

Service (Army). Also attended part-time classes in Shrewsbury College of Art. 1961 Elected Member of S.S.A. 1962–65 Part-time teacher Duncan of Jordanstone College of Art. 1962 Keith Prize R.S.A. 1963 Latimer Award R.S.A. Since 1965 Full time teacher Duncan of Jordanstone College of Art. Lives in St. Vigars, Angus. 1968 Married. 1975 A.R.S.A.

ONE-MAN EXHIBITIONS
1959 Malcolms Furnishing Store, Dundee. 1965 Douglas & Foulis, Edinburgh.

GROUP EXHIBITIONS
1961 Five Dundee Painters Dundee Art Gallery. 1962 Rawinsky Gallery, London. 1963 Scottish Young Contemporaries, Scottish Arts Council. 1963 New Charing Cross, Glasgow. 1963/64 Bradford Spring Festival, Yorks. 1964 Plus or Minus 30, Glasgow University. 1964 About Around Exhibition, Leicester University. 1965 Scottish Artists, Glasgow School of Art. 1965/6/7 Montrose Festival, Angus. 1966/7/8 Glasgow Group. 1967 Scottish Contemporaries, S.T.V. House, Edinburgh. 1968 Art Across the Tay, Dundee Art Gallery. 1968 Painters and Printmakers of Dundee, New Charing Cross Gallery Glasgow. 1969 Dundee Art Society. 1969 New Tendencies in Scottish Painting, Richard Demarco Gallery, Edinburgh. 1970 7 Painters in Dundee, Glasgow. 1974/75 Saltire Society Edinburgh. 1975 Compass Gallery, Glasgow.

COLLECTIONS
R.S.A. and S.S.A. Scottish Arts Council. Dundee College of Education. Leicester University, Vincent Price Collection U.S.A.

WILLIAM BURNS R.S.A. R.S.W. (1921–1972)

1921 Born 31st May at Newton Mearns, Renfrewshire. Educated in Glasgow. 1939–42 Royal Air Force. 1944–48 Studied at Glasgow School of Art. 1947–48–49 Studied at Hospitalfield College of Art, Arbroath. 1952 Awarded the Royal Glasgow Institute of the Fine Arts Torrance Award. Elected a Member of Society of Scottish Artists. 1953 Elected a Member of Royal Glasgow Institute of the Fine Arts. Awarded the Royal Scottish Academy Guthrie Award. 1955 Appointed Lecturer in Art, Aberdeen College of Education. Elected an Associate of the Royal Scottish Academy. 1958 Elected a Member of Royal Scottish Society of Painters in Watercolours. 1967 Appointed Principal Lecturer in Art, Aberdeen College of Education. 1970 Elected a Member of the Royal Scottish Academy. Resigned from Principal Lectureship at Aberdeen College of Education to concentrate full time on painting. 1972 Died 14th October on return solo flight from Dundee to Aberdeen.

ONE-MAN EXHIBITIONS
1964 The Scottish Gallery, Edinburgh. 1965 'Scottish Paintings by William Burns' College of Art, Manchester. 1966 The Scottish Gallery, Edinburgh. 1968 'William Burns Paintings' Festival Exhibition at the Scottish Gallery, Edinburgh. 1973 Memorial Exhibition, Aberdeen Art Gallery, Edinburgh Art Centre, Collins' Memorial Gallery, Strathclyde University.

GROUP EXHIBITIONS
1950 'A Selection from the Royal Scottish Academy' (Scottish Arts Council). 1955 'Contemporary Scottish Paintings' (Scottish Arts Council). 1955 Festival Exhibition, The Scottish Gallery, Edinburgh. 1958–59 'The Scottish Scene' (Art Exhibitions Bureau). 1959–60 'Scottish Painters' (Greenock Art Gallery). 1962 Stone Art Gallery, Newcastle. 1964 'Contemporary Scottish Art' (Reading Art Gallery). 1966 The Scottish Gallery, Edinburgh. 1968 'Three Centuries of Scottish Painting' (National Gallery of Canada). 1968 'Art Across the Tay' Dundee Art Group (Dundee Art Gallery). 1969 Inaugural Exhibition (Compass Gallery, Glasgow). 1970 'Colour in Scottish Painting' (Glasgow Art Gallery). 1970 'Artists of the North East' (Compass Gallery, Glasgow).

COLLECTIONS
Aberdeen Art Gallery; Aberdeen College of Education. Aberdeen University. Bishops Otter College, Chichester. Department of the Environment (Collection of British Embassies). Dumbarton Education Authority. Dundee Art Gallery. Edinburgh Corporation (Jean Watson Bequest). Edinburgh University (Talbot Rice Memorial Collection). Glasgow Art Gallery. Nottinghamshire Education

Authority. Nuffield Foundation. Paisley Art Gallery. Royal Scottish Academy (Thorburn Ross Collection. Thomas and Christina Forbes Hutchinson Memorial Fund. David Muirhead Memorial Fund). Scottish Arts Council. West Riding Education Committee. University of York.

JOHN P BUSBY

Born 1928. 1946–48 Served in R.A.F. 1948–52 Studied Sculpture and painting at Leeds Art College. 1954–55 Post Graduate Scholarship Edinburgh College of Art. 1952–55 Painted in Edinburgh. 1955–56 Travelling Scholarship Edinburgh College of Art (France and Italy). 1958–67 Served on '57 Gallery Committee. 1970 Elected member of Royal Society of Arts. 1971–73 Council member of S.S.A. 1971–73 Founder member of Society of Wild-life Artists. 1972 Elected member of Glasgow Group. Married to singer Joan Busby. Mural "Christ in Majesty" (St. Columba's by the Castle).

ONE-MAN EXHIBITIONS
1961 '57 Gallery Edinburgh. 1964 York University. 1964, 67, 69 Lane Gallery, Bradford. 1965 Cliffe Castle, Keighley. 1967 The Scottish Gallery (with Derek Hyatt). 1969, 70, 73 Goosewell Gallery, Menston, Yorkshire. 1970 Compass Gallery (with Derek Hyatt). 1971 People's Theatre Arts Centre, Newcastle. 1972 Saltire Society, Edinburgh (Festival). 1972 Richard Demarco Gallery, Edinburgh. 1973 Abbot Hall, Kendal.

GROUP EXHIBITIONS
Young Contemporaries 1955. Wakefield Art Gallery, Bradford Art Gallery. Reading Art Gallery. The Glasgow Group. Stone Gallery, Newcastle. Grundy House, Blackpool. Demarco Gallery, Edinburgh. Marjorie Parr Gallery. Halifax Arts Festival. Leeds Art Gallery. '57 Gallery, Edinburgh. Edinburgh Festival. Art Spectrum Scotland.

COLLECTIONS
Abbot Hall Kendal. Belfast Art Gallery. Bradford Art Gallery. Glasgow Art Gallery. Wakefield Art Gallery. West Riding & Edinburgh Education Departments. Edinburgh Corporation. Scottish Arts Council Yorkshire Arts Association. Royal Society for the Protection of Birds.

ROBERT CALLENDER

Born Mottingham, Kent 1932. Studied at South Shields Art School, Edinburgh University, Edinburgh College of Art 1954–1958, Post-graduate 1958–1959. Andrew Grant Travelling Scholarship. Lived in France. British School in Rome Travel Scholarship, Italy, Spain. Lecturer Institute for American Universities, Aix-En-Provence. Latimer Award R.S.A. 1964. Guthrie Award R.S.A. 1965. Elected A.R.S.A. 1966, Resigned 1969. President Society of Scottish Artists 1970–1973. Arts Council Major Award 1972. Prize Winner at First International Drawing Biennale Middlesbrough. Currently a lecturer at Edinburgh College of Art. Chairman of the 57 Gallery in the 1960's.

ONE-MAN EXHIBITIONS
1956, 1958 57 Gallery. 1970 Lane Gallery Bradford, Billingham Arts Centre, Edinburgh University. 1970 Lower Largo. 1973 Edinburgh City Hospital Festival. 1974 Scottish Gallery. 1976 The Scottish Gallery.

GROUP EXHIBITIONS
Scottish Gallery. Langholm Reading. Douglas and Foulis. Durham Fine Art Society. Scottish Arts Council Touring Exhibition. Spectrum. Demarco Gallery. Piccadilly Gallery. Marjorie Parr Gallery. Glasgow School of Art. Felixstowe Festival. Edinburgh Festival 20 × 57. 57 Gallery. Nude, Still Life, Portrait, Postcard, Walls and Landscape Exhibitions. First Exhibition Stirling Gallery (Drawing). Elizabeth Ogilvie, R Callender at Stirling Gallery 1973. 57 Gallery Festival 75 (Drawings). The Need to Draw, Scottish Arts Council.

COLLECTIONS
Edinburgh Schools. Scottish Arts Council. Edinburgh Corporation. East Lothian Hospital Board. Nuffield Foundation. West Riding Education Authority. American Institute Aix. Stirling University. Edinburgh City Hospital. Teeside Museum and Art Gallery. Bank of Scotland.

COLIN CINA

1943 Born Glasgow, Scotland. 1961–63 studied at Glasgow School of Art. 1963–66 studied at Central School at Art, London. 1966 awarded Peter Stuyvesant Foundation Travel Bursary for U.S.A. 1967 obtained studio in London and has painted and taught in London since then. Teaches at Central and Winbledon Schools of Art.

EXHIBITIONS
1967 Arnolfini Gallery, Bristol. 1969 Arnolfini Gallery, Bristol. 1970 Serpentine Gallery, London. 1971 Hatton Gallery, University of Newcastle. 1972 Demarco Gallery, Edinburgh. 1972 Angela Flowers, London. 1973 Arnolfini Gallery, Bristol. 1974 Galerie Wellman, Dusseldorf. 1974 Angela Flowers, London. 1975 Scottish Arts Council Gallery, Glasgow. 1975 Cina Paintings 1966–75.

GROUP EXHIBITIONS
1965 Clare College, Cambridge. 1966 Young Contemporaries, London. Young Britain, Altam & Co., New York New Generation, Whitechapel Gallery, London. 1967 John Moores Liverpool Exhibition, Walker Art Gallery. 1968 Leicestershire Collection 2, Whitechapel Gallery London New Generation Interim, Whitechapel Gallery. British Painting '67–'68, Arts Council. 1969 Art in the Making, Goldberg/Demarco, Edinburgh.
1970 Celtic Triangle, Regional Arts Councils Colour Extensions, Central Library, Camden. 1971 London Group, Royal Academy Galleries, London Art Spectrum London, Alexandra Palace. 1972 British Drawings '52–'72 Angela Flowers London & Wolverhampton City Art Gallery. Serpentine Directions, Arts Council. 1973 Ung Engelsk Konst, Konsthallen Goteborg. Warehouse Gallery, London. Critic's Choice, Gulbenkian Theater Gallery, Newcastle Summer Studio, Institute of Contemporary Arts, London. 1974 John Moores Liverpool Exhibition, Walker Art Gallery.

COLLECTIONS
Victoria & Albert Museum, Arts Council of Gt. Britain, Scottish National Gallery of Modern Art, Stuyvesant Foundation, Israel Museum Jerusalem, Scottish Arts Council, Konsthallen Goteborg, Leicestershire Education Authority, Bristol City Art Gallery, Laing Art Gallery Newcastle upon Tyne, East Midlands Art Association, London Press Exchange, University of Stirling.

PETER COLLINS R.S.A.

Born Inverness 1935. Studied Edinburgh College of Art 1952–56. Awarded Post-Diploma 1956–57. 1957 Travelling Scholarship. 1957–58 Studied in Italy. 1959 Elected S.S.A. 1962 Latimer Award R.S.A. 1966 Elected A.R.S.A. 1965 Lecturer at Duncan of Jordanstone College of Art. 1974 Elected R.S.A. Lives in Dundee.

ONE-MAN EXHIBITIONS
1968 The Scottish Gallery.

GROUP EXHIBITIONS
1968 "Art Across the Tay" Dundee. 1968 Scottish Painting Demarco Gallery. Painters and Printers in Dundee. New Charing Cross Gallery, Glasgow. 1969 S.T.V. Young Scottish Painters, Edinburgh Festival. 1970 Seven Painters in Dundee. Scottish Arts Council touring exhibition "12 Scottish Painters". Maine State Commission on the Arts & Humanities Touring U.S.A. 1971 Art Spectrum.

COLLECTIONS
Aberdeen Art Gallery. Edinburgh Education Authority. Glasgow Art Gallery and Museum. Scottish Arts Council. Dundee City Art Gallery.

ROBERT COLQUHOUN

Born Kilmarnock 1914. 1933 Scholarship to Glasgow School of Art. Studied with Hugh Adam Crawford and Ian Fleming. Won an Art prize for Drawing with Robert MacBryde. Post Diploma from the Glasgow College of Art which he spent at Hospitalfield. 1938 Travelling Scholarship to France and

Italy. 1939 Returned to Ayrshire. 1940 Joined Royal Army Medical Corps. 1941 Invalided out of Army went to London. Shared Studio with MacBryde, Minton, Ayrton, Vaughan, John Craxton, and knew Dylan Thomas. Joined Civil Defence Corps as ambulance driver until 1944. Painted at night because of day and night shifts. 1951 Production of "Donald of the Burthens" at Covent Garden Choreography by Leonide Massine, decor and costumes by Colquhoun and MacBryde. Designs for costumes and set exhibited at the Redfern Gallery. 1953 Production of "Lear" at Stratford by George Devine, decor and costumes by Colquhoun. Died 1962 in London.

ONE-MAN EXHIBITIONS
1943 Lefevre Gallery, London. 1944 Lefevre Gallery, London. 1946 Lefevre Gallery, London. 1947 Lefevre Gallery, London. 1950 Redfern Gallery, Drawings, Watercolours and Monotypes. 1951 Lefevre Gallery, London. 1957 David Archers Parton Gallery, London. 1958 Whitechapel Art Gallery, London. 1962 Robert Colquhoun "His Person and His Times" at the Establishment Club, London.

GROUP EXHIBITIONS
1942 Lefevre Gallery, London "Six Scottish Painters". 1948 Small Group of paintings at Lefevre. 1951 "60 Paintings for 1951". 1956 Contemporary Arts Society (Seasons Exhibition) Winter Group. 1959 Kaplan Gallery, London, (with MacBryde).

COLLECTIONS
Arts Council of Great Britain. Bradford City Art Gallery. Bristol City Art Gallery. British Council. Contemporary Art Society. Glasgow City Art Gallery. Manchester City Art Gallery. Junior Common Room, Jesus College, Oxford. Tate Gallery. Victoria & Albert Museum. Dundee Art Gallery. Aberdeen Art Gallery. Sydney Art Gallery, Australia. National Gallery of Canada. Vancouver Art Gallery. Albright Art Gallery, Buffalo. Michigan Art Gallery. Museum of Modern Art, New York; and many private collections.

WILLIAM CROZIER

Born Yoker 1933. Studied Glasgow School of Art 1949–53. Has since lived in Paris, Dublin, Malaga and London. Head of Fine Art Department Winchester College of Art.

ONE-MAN EXHIBITIONS since 1957
I.C.A. London. Arthur Tooths, London. Drian Gallery, London. Madaleine Gallery, Paris. Gallery Blu, Milan. New Charing Cross Gallery, Glasgow. Demarco Gallery, Edinburgh. Compass Gallery, Glasgow 1969. Compass Gallery, Glasgow 1975. Gallery Stern, Cologne, 1975.

COLLECTIONS
Victoria and Albert Museum. Walker Art Gallery, Liverpool. Birmingham Art Gallery. Glasgow Art Gallery. Aberdeen Art Gallery. Scottish National Gallery of Modern Art, Edinburgh. Museum of Modern Art, Dallas, U.S.A. National Gallery of Canada. National Gallery of Australia. Scottish Arts Council. Contemporary Art Society.

JAMES CUMMING R.S.A. R.S.W.

1922 Born Dunfermline. 1939 Awarded Scholarship, Edinburgh College of Art. 1941–46 R.A.F.V.R. 1950 Appointed Lecturer in Painting, Edinburgh College of Art. 1951 Royal Scottish Academy Award. 1958–61 President of Society of Scottish Artists. 1962 Elected Associate of Royal Scottish Academy and Member of Royal Scottish Society of Painters in Watercolour. 1964 International Scholarship to Harvard University. 1966 Retrospective Exhibition arranged by Carnegie Trust. 1970 Elected Academician. 1973 Elected Treasurer R.S.A. 1974 Appointed Member of Council for National Academic Awards.

ONE-MAN EXHIBITIONS
1955 Gallery One, London. 1957/59 57 Gallery, Edinburgh. 1962/71 The Scottish Gallery, Edinburgh. 1965/66 Reid and Taylor Gallery, Langholm. 1966 First Retrospective Exhibition (1951–66)

Carnegie Trust, Dunfermline. 1967/70/73/74 Loomshop Gallery, Largo. 1969/71/73 Marjorie Parr Gallery, London. 1971 New Ulster Gallery, Ireland. 1972 The Scottish Gallery, Edinburgh International Festival. 1973, Marjorie Parr Gallery, London. 1973 University of Sheffield. 1973 University of Durham. 1973 Second Retrospective Exhibition (1959–73) Leith Festival. 1974 Loomshop Gallery, Lower Largo. 1975 Marjorie Parr Gallery, London. 1976 Marjorie Parr Gallery, London.

GROUP EXHIBITIONS

1958 Scottish Painters, Nice, France. 1961 Commonwealth Painters, Ottawa, Canada. 1963 14 Scottish Artists, Commonwealth Institute, London. 1964 Contemporary Painters, Reading. 1966 The Edinburgh School, Galerie Des Ponchettes, Nice, France. 1973 Scottish Painters, English Speaking Union, Edinburgh. 1975 Ten Edinburgh Artists, Royal Cambrian Academy, Conway and Cardiff Art Gallery.

COLLECTIONS

H.R.H. Prince Philip Duke of Edinburgh. Aberdeen Art Gallery. Argyll Education Trust. Arts Council. British Steel Corporation. Caird Art Bequest. City of London. Carnegie Trust Civic Collection. Danish Embassy. Dumbartonshire Education Trust. Edinburgh Corporation (Watson Trust). Edinburgh Education Trust. Edinburgh University. Fife Education Trust. Glasgow Art Gallery and Museum. Kirkcaldy Art Gallery. Liverpool University. Loomshop Gallery, Lower Largo. Maurice Villency Gallery, New York. Nuffield Foundation. Perth Art Gallery. Royal Scottish Academy. Royal Ontario Museum, Toronto, Canada. Scottish Arts Council. Scottish National Gallery of Modern Art. Towner Art Gallery, Eastbourne.

ALAN DAVIE

1920 Born Grangemouth. 1937–40 Edinburgh College of Art. 1940–46 Royal Artillery. 1942 Guthrie Award R.S.A. 1947 Travelling Scholarships from Edinburgh College of Art in France, Switzerland, Italy, Sicily and Spain. 1953–56 Taught art to adolescent children. 1956–57 Prix Guggenheim Exhibition, Museum of Modern Art, Paris. Guggenheim Museum, New York. 1956–58 Lectured and broadcast in London, Oxford, Leeds, Liverpool, Nottingham. 1956–59 Gregory Fellow, Leeds University. 1959–60 Taught art at the L.C.C. Central School. 1963 Prize for the best foreign painter at the one-man show at the VII Bienal de Sao Paulo.

ONE-MAN SHOWS

1946 Edinburgh. 1948 Florence and Venice. 1950, 52 Gimpel Fils Gallery, London. 1954–56 Three one-man shows at the Gimpel Fils Gallery, London. Catherine Viviano Gallery, New York. 1957 Catherine Viviano Gallery, New York. 1960 Gimpel Fils Gallery, London. Charles Lienhard Gallery, Zurich; 1961 Naviglio Gallery, Milan. Carnegie Institute, Pittsburgh. Galerie Rive Droite, Paris. Martha Jackson Gallery, New York. Gimpel Fils Gallery, London. 1961–62 Esther Robles Gallery, Los Angeles. 1962–63 F.B.A. Galleries, London. Stedlijk Museum, Amsterdam. Kunstnernes Hus, Oslo. Kunsthalle, Baden-Baden. Kunstgewerbeverein Pforzheim, Germany. Kunsthalle, Berne. 1963 Gimpel Fils Gallery, London. Brazilian Embassy, London. La Medusa Gallery, Rome. Visioni Colori Palazzo Grassi, Venice. S.S.A. Galleries, Edinburgh. 1964 Gimpel-Hamover Gallery, Zurich. 1965 Martha Jackson Gallery, New York. Gallery Zwirner, Cologne. Court Gallery, Denmark. Gallery Bleue, Stockholm. Gallerie d'Aujourd'hui Une Groupe at Museum of Modern Art, Paris. Gimpel Fils Gallery, London. 1966 Gallery Haaken, Oslo. Gimpel Fils Gallery, London. Rotterdamische Kuntskring. Rotterdam. 1967 Galerie de France, Paris. Gimpel and Hanover Gallery, Zurich. Kestner-Gesellschaft, Hanover. The Arts Club, Chicago and Minnesota. Gimpel Gallery, London. 1968 Kunstverein Fur Die Rhineland und Westfalen, Dusseldorf and Overbeck-Gesellschaft, Lubeck. Richard Demarco Gallery, Edinburgh. The Hudson Gallery, Detroit. 1969 Gimpel Gallery, London and New York. 1970 Gimpel Fils London. La Medusa Gallery, Rome. Galerie Stangl Munich. 1971 2nd Triennale of world art, Delphi, Indiz. Dimpel Fils Gallery, London. Galerie Lambert, Monet, Geneva. Gimpel and Hanover, Zurich. 1972 Gimpel Gallery, New York.

GROUP EXHIBITIONS

1956 Critic's Choice Exhibition, Tooth's Gallery, London. 1956–57 Prix Guggenheim Exhibition, Museum of Modern Art, Paris. Guggenheim Museum, New York. 1957 Fourth International Art Exhibition, Japan. 1957/58 New Trends in British Art Exhibition, Rome, New York Art Foundation Gallery, Rome. 1958 Retrospective Exhibitions Wakefield, Nottingham, London, Liverpool. Critic's Choice Exhibition, Tooth's Gallery, London. 50 Years of Modern Art Exhibition at the Brussels International Fair. Young Artists Exhibition in the Central Pavilion, 29th Biennale, Venice. 1958/59 Pittsburgh International Exhibition, Carnegie Institute. 1960 British Painting 1700–1960 in Moscow and Leningrad. Critic's Choice, Tooth's Gallery, London. Galerie Rive Droite, Paris. Martha Jackson Gallery, New York. 1964 54–64 Exhibition at the Tate Gallery, London. Salon de Mai, Paris, Documenta III Kassel. 1964/65 The Peggy Guggenheim Collection organised by the Arts Council in the Tate Gallery, London. 1965 Lithographs, Zurich improvisations Gimpel Fils, London. 1965 Retrospective Exhibition Graves Art Gallery, Sheffield. 1966 Retrospective Exhibition Usher Gallery, Lincoln. Retrospective Exhibition, Queen's Gallery, Leeds. 1966 Exhibition arranged by the Scottish Committee of the Arts Council with William Gear Commonwealth Institute Gallery, Edinburgh. Exhibition organised by the Norfolk Contemporary Arts Society, Castle Museum, Norwich. Salon de Mai, Paris and Belgrade. 1967 Salon de Mai, Paris, R.O.S.C. Dublin. Peter Stuyvesant Collection, Tate Gallery, London. 1968. Magic in Art Exhibition Gimpel Fils London. Salon de Mai, Paris. Drawings Exhibition, Kuntsmuseum, Basle. 1970 Mixed Exhibition, Cologne Fair. Retrospective U.S.A. Texas, California and Montreal, Canada. Mixed Exhibition Italy, Franco Castelli Milan. British Painting and Sculpture 1960–70 National Gallery of Art, Washington D.C. 1971 Mixed Exhibition, Kunst Markt Basel. Prints and Gouaches exhibition, Galerie de Varenne Paris. Scottish Television Festival Exhibition, Edinburgh. Exhibition at Lancaster University. III Bienal de Arte Coltejer, Medellin Colombia S.A. British Paintings 1945–1970 Norway and Poland. Salon de Mai, Paris. Retrospective Edinburgh Festival Scotland. Braunschweig Kunstverein und Badischer. Kunstverein Karlsruhe, Germany.

COLLECTIONS

National Gallery of South Australia, Adelaide. Stedlijk Museum, Amsterdam, Staatliche Kunsthalle, Baden-Baden. Art Gallery, Bedford. The Arts Council of Northern Ireland, Belfast. Kunsthalle, Berne. Stadtische Kunstgalerie, Bochum. Bristol Museum. Albright Museum, Buffalo. Institute of Art, Detroit. Trinity College, Dublin. Durham University. Towner Art Gallery, Eastbourne. Scottish National Gallery of Modern Art, Arts Council – Scottish Committee, Edinburgh. Eindhoven Museum. Glasgow University. Wadsworth Atheneum, Connecticut, Hartford. Ferens Art Gallery, Hull. City Art Gallery, Leeds. Arts Council of Great Britain, London. British Council, London. Gulbenkian Foundation, London. Peter Stuyvesant Foundation, London. Tate Gallery, London. Victoria and Albert Museum, London. City Art Gallery, Manchester. Museum of Modern Art, New York. Norfolk Contemporary Art Society, Norwich. Kunstnernes Hus, Oslo. National Gallery of Baden-Baden. Art Gallery, Bedford. The Arts Council of Northern Ireland, Belfast. Kunsthalle, Berne. Stadtische Kunstgalerie, Bochum. Bristol Museum. Albright Museum, Buffalo. Institute of of New South Wales, Sydney. National Gallery, Tel Aviv. Gemeente Museum, The Hague. Peggy Guggenheim Collection, Venice. Museum of the 20th Century, Vienna. City Art Gallery, Wakefield. Yale University, U.S.A.

KENNETH DINGWALL

Born 1938 in Clackmannanshire. Trained at Edinburgh College of Art 1955/59. Andrew Grant Post-Graduate Scholar 1959/60. Athens School of Art, Greece 1961/62. Worked in Morayshire at Elgin Academy and in Clackmannanshire with primary school and mentally handicapped children. Appointment to National Museum of Antiquities of Scotland, resigned to live and work in Greece. Taught English in a Strategahki Language School in Athens. Since 1963, two-year contract, part-time, and full-time lecturer Edinburgh College of Art. 1968/72 Conducted Worker's Adult Education art classes, also Edinburgh Festival Summer School lectures for W.E.A. and University of Wisconsin Extension students. 1972 Scottish Arts Council Painting Award. 1973/4 Visiting Professor, Minneapolis College of Art and Design, Minneapolis, Minnesota, U.S.A. Also Visiting Artist, Yale University Summer School of Music and Art, 1974.

The Gallery, Hydra, Greece 1963. The Scottish Gallery, Edinburgh 1969. The Steven's Gallery, Minneapolis, U.S.A. 1974. Scottish Arts Council Gallery 1977.

COLLECTIONS
Aberdeen Art Gallery and Museum. Edinburgh College of Art. Lillie Gallery, Milngavie. Minneapolis Art Institute, U.S.A. Royal Edinburgh Hospital Board. Scottish Arts Council. University of Aberdeen. University of Arizona, Tuscon, U.S.A.

GROUP EXHIBITIONS
"The Need to Draw" Scottish Arts Council 1975. "Contemporary Scottish Art" Stirling University 1974. "Awards to Artists" S.A.C. Gallery, Edinburgh 1972. "Spectrum", Scottish Arts Council 1971. "The Edinburgh School", Edinburgh Festival E.C.A. 1971 "Painting 70" Aberdeen Museum and Art Gallery 1970. "Edinburgh College of Art" Marjorie Parr Gallery, London 1968. "Commonwealth Festival Exhibition", McLellan Galleries, Glasgow 1964.

GEORGE DONALD A.R.S.A.

Born Ootacamund, South India, 1942. Early years in Madras and Cochin. Grew up in Aberdeen, entered Edinburgh Art College 1962. Hospitalfield, Arbroath, Summer 1965. D.A. 1966. Postgraduate year in drawing and painting awarded 1966. Travelled through Turkey and Iran to Afghanistan, Pakistan and India. Spent time in Nepal, Kashmir and Bengal. Studied at Benares Hindu University, 1968. Hornsey College of Art/London University Institute of Education 1969. A.T.C. (London) 1969. Commenced teaching Edinburgh College of Art – Painting, drawing, printmaking 1970. Professional member of S.S.A.

EXHIBITIONS
French Institute, Edinburgh Festival, 1966. Drawings and Prints, Strasbourg 1967. Pernod (Print Prize), Edinburgh 1967. International Exchange, Tokyo, Japan, 1968. Marjorie Parr Galleries, Chelsea, 1968. Exhibitions of Maths/Art/Education project, Hornsey, London 1969. "Fort Knox" Edinburgh Festival, 1970. "Scottish Graphics" Edinburgh Festival. 1970 57 Gallery, Edinburgh (One-man) 1971. The Edinburgh School E.C.A. 1971. Scottish Printmakers Travelling Exhibition, 1971. International Graphics, Carnegie Festival of Arts, Dunfermline, 1971. Goosewell Gallery, Menston, Yorkshire, 1971. "Original Print" Printmakers' Workshop, 1972, 73, 74. Pool Theatre (One-man), Edinburgh 1972. Richard Demarco Gallery, Edinburgh 1972. "100 – 57" Edinburgh Festival 1972. Richard Demarco Gallery, Edinburgh, 1973. "Among the Quiet Fibres", Weavers' Workshop, Edinburgh 1974. The Glasgow Group, Glasgow 1974.

COLLECTIONS
Aberdeen Art Gallery. Edinburgh Corporation. Scottish Arts Council. Nuffield Foundation. And work in private collections in United Kingdom, U.S.A., Canada, Europe, Puerto Rico, Pakistan.

DAVID DONALDSON R.S.A.

1916 Born Chryston, Glasgow. 1931–38 Student, Glasgow School of Art. 1941 Assistant Lecturer, Glasgow School of Art. 1951 A.R.S.A. 1962 R.S.A. 1964 Royal Society of Portrait Painters. Currently Head of Drawing and Painting, Glasgow School of Art. Honorary Doctorate, University of Strathclyde.

ONE-MAN SHOWS
1973 The Scottish Gallery (Edinburgh Festival Exhibition). Regular Exhibitor at R.S.A.

WORK IN THE FOLLOWING PUBLIC COLLECTIONS
Aberdeen Art Gallery. Glasgow Art Gallery. Edinburgh City Collections. Scottish Arts Council, Paisley Museum and Art Galleries; and in many other private collections.

MURAL COMMISSIONS
Dalereoch Primary School, Dunbarton. St Teresa's School, Glasgow.

PATRICIA DOUTHWAITE

Born Glasgow 1939. Studied with Margaret Morris (Dancing and Mime). 1960 Married Paul Hogarth. 1968 Returned to Scotland. Intermittently lived in Paisley, Cambridge and Majorca. Phyllis Calvert Award for Mime. Set Designer at several theatres. Designed entire production of "Salome" for Lindsay Kemp.

ONE-MAN EXHIBITIONS

1957 British Council Gallery, Glasgow. 1958 57 Gallery, Edinburgh. 1963 Grabowski Gallery, London. 1964 Ipswich College of Art. 1967 Clare College, Cambridge. 1969 Demarco Gallery, Edinburgh. 1970 Stirling University. 1970 Festival Show, Demarco Gallery. 1970 Serpentine Gallery, London British Arts Council. 1972 Hanover Gallery, London. 1972 Demarco Gallery, Edinburgh. 1973 St. Andrew University. 1973 The Motiv Gallery, London. 1977 The Scottish Gallery, Edinburgh.

GROUP EXHIBITIONS

1960 Redfern Gallery, London "Ten Young Painters". 1960 Lords Gallery, London. 1964 Cambridge Artc Council. 1967 Fantasy & Figuration, Institute of Contemporary Art London. 1968 Axiom Gallery, London. 1969 New Tendencies in Scottish Art, Adinburgh.

COLLECTIONS

Scottish Arts Council. Scottish National Gallery of Modern Art. Stirling University. St. Andrew University.

JOAN EARDLEY R.S.A. (1921–1963)

Born Warnham, Sussex, 1921. Educated in Blackheath. Moved to Glasgow. 1939 Entered Glasgow School of Art. 1939–43 Studied Glasgow College of Art. 1943 Awarded Post Diploma Scholarship. 1946 Studied at Hospitalfield Arbroath. 1948 Elected S.S.A. 1948 Took Post Diploma at Glasgow School of Art. Awarded two travelling scholarships. Part time teacher at Glasgow School of Art. 1950 She discovered Catterline Village. 1955 Elected Associate of Royal Scottish Academy. 1963 Elected Academician R.S.A. 1963 Honorary Membership of the Glasgow Society of Lady Artists. Died August 1963.

ONE-MAN EXHIBITIONS

1949 September, The Glasgow School of Art. 1950 7–28 April Gaumont Gallery, Gaumont Cinema, Aberdeen (19 paintings, 17 drawings). 1955 From 21 June St. George's Gallery, London (25 Oils, 12 gouaches). 1959 22 August–17 September 1957 Gallery, Edinburgh (13 Oils, 4 drawings) 1961 29 May–10 June Scottish Gallery, Edinburgh (55 Oils, 13 pastels) 1963 May–June Roland Browse & Delbanco, London (35 Oils) 1964 Memorial Exhibition, Art Gallery and Museum, Glasgow, R.S.A., Edinburgh.

GROUP EXHIBITIONS

1947 West of Scotland Artists, Skelmorlic. 1948 Drawings and Watercolours by Contemporary Scottish Artists. 1952 Eight Young Contemporary British Painters, Touring Exhibition, Arts Council–Scottish Committee. 1954 February Six Young Painters, Parson's Gallery, London. 1954 A Selection of Paintings from the S.S.A. 1954 Touring exhibition, Arts Council – Scottish Committee. 1955 Contemporary Scottish Painting, Art Exhibitions Bureau, London. Scottish Gallery, Edinburgh. 1956 Paintings by Four Glasgow Artists, Helensburgh. 1957 The French Institute, Edinburgh. Bradford City Art Gallery. 1958 Scottish Gallery, Edinburgh. 1959 Critic's Choice, Tooth's London Selection by Terence Mullaly. 1961 Contemporary British Landscape, Touring Exhibition, Arts Council. 1963 20th Century Scottish Painting, Abbot Hall Art Gallery, Kendal and subsequent tour in England by the Arts Council. 1963 Four Scottish Painters, Arts Council. 1963 14 Scottish Painters, The Commonwealth Institute, London and subsequent showing in the Glasgow Art Gallery.

Art Gallery and Industrial Museum, Aberdeen. County Council, Argyll. City Museum and Art Gallery, Birmingham. Herbert Art Gallery and Museum, Coventry. Gracefield Arts Centre, Dumfries. Arts Council, Scottish Committee, Edinburgh. Edinburgh Corporation. Royal Scottish Academy, Edinburgh. Scottish National Gallery of Modern Art. Edinburgh University. Art Gallery and Museum, Glasgow. Central Hotel, Glasgow. St Enoch Hotel, Glasgow. Glasgow University. Art Gallery, Huddersfield. Abbot Hall Art Gallery, Kendal. Alfred East Art Gallery, Kettering. Arts Council of Great Britain, London. Contemporary Art Society. London. Ministry of Works, London. South London Fine Art Gallery, London. Education Trust, Stirling; and in many other private collections.

DAVID EVANS A.R.S.A.

Born Llanfrechfa, Monmouthshire 1942. Studied Newport College of Art 1959–62. Studied Royal College of Art 1962–65. Royal College of Art. Silver Medal for painting and Travelling Scholarships to Spain and Morocco 1965. Taught at Edinburgh College of Art 1965–68. Granada Arts Fellow University of York 1968–69. Currently teaching at Edinburgh College of Art. Elected Associate Royal Scottish Academy 1974.

ONE-MAN EXHIBITIONS
Welsh Arts Council, R.C.A. Galleries, London, Pictures for Welsh Schools. Brighton City Arts Centre. Royal Academy London. Royal Scottish Academy. Society of Scottish Artists. Marjorie Parr, London. New 57 Gallery, Edinburgh, 20 — 57 University of Edinburgh, University of Stirling. York Festival of the Arts.

COLLECTIONS
Essex & Leicester Education Authorities, University of York, Ministry of works, Royal Burgh of Arbroath. Carlisle City Art Gallery. Jean Watson Trust, Edinburgh. Scottish Arts Council. Coventry Training College. St. Catherine's College, Oxford.

JAMES FAIRGRIEVE A.R.S.A.

1944 Born Prestonpans, East Lothian. 1962–68 Attended Edinburgh College of Art. 1963–64 Andrew Grant Open Scholarship. 1967–68 Post Graduate study. 1968 David Murray Landscape Award 1969 Travelling Scholarship. 1970 Elected Professional Member of S.S.A. 1976 A.R.S.A. Teaches Drawing and Painting at Edinburgh College of Art.

ONE-MAN EXHIBITIONS
1969 New 57 Gallery. 1971 New 57 Gallery. 1973 Scottish Arts Club. 1974 Scottish Gallery.

GROUP EXHIBITIONS
1966. Reeves Bi-Centenary. 1966–67 Edinburgh Festival. 1967 Drawings and Prints in Strasburg. 1968 Glasgow Institute of Fine Art. 1968 Marjorie Parr Galleries. 1969 20 57 Festival Exhibitions. Group Shows in the New 57 Gallery 1969–73. 1971 The Edinburgh School. Annual S.S.A. Exhibition since 1970. 1973 Richard Demarco Gallery. 1974 Triad Arts Centre. 1974 Haworth Art Gallery Accrington.

COLLECTIONS
Edinburgh Corporation. Edinburgh Schools. Scottish Arts Council. Argyll Schools.

ALEXANDER FRASER A.R.S.A.

Born 1940, Aberdeen. Studied at Gray's School of Art, Aberdeen 1958–62. Post Graduate year 1962–63. Travelling Scholarship to France and Italy 1964. Latimer award 1964 and Guthrie award 1969, Royal Scottish Academy. Elected Associate of Royal Scottish Academy 1971. Lecturer at Gray's School of Art, Aberdeen since 1966. Arts Council award 1971. Lives at Muchalls, Kincardineshire.

1964 The 57 Gallery, Edinburgh. 1965 Drawings, Former Art College, Aberdeen. 1970 The Arts Tower, Sheffield University. 1972. The Demarco Gallery, Edinburgh. 1974 The Compass Gallery, Glasgow.

GROUP EXHIBITIONS

1964 Seven Scottish Painters, Durham University. 1967 3 Man Group Show, Demarco Gallery, Edinburgh. 1968 Scottish Painting, Demarco Gallery, Edinburgh. 1968–71 Glasgow Group, McLellan Galleries, Glasgow. 1969 New Tendencies in Scottish Art, Demarco Gallery, Edinburgh. 1969 Modern Scottish Paintings, Travers Gallery, London. 1969 Inaugural Exhibition, Compass Gallery, Glasgow. 1970 Painting 70, Aberdeen Art Gallery. 1970 Artists of North East, Compass Gallery, Glasgow. 1970 12 Scottish Painters, The Maine State Commission on the Arts and Humanities, Touring U.S.A. and Canada. 1971 Art Spectrum, Scotland. 1972 Awards to Artists Exhibition, Arts Council Touring Exhibition. 1973 9 Scottish Painters, Durham and Sheffield Universities, 1973 1st Exhibition, Drawings, The Stirling Gallery, Stirling.

COLLECTIONS

Scottish Arts Council, Contemporary Art Society, London. Aberdeen Art Gallery. Dundee Art Gallery. Glasgow Art Gallery. Sheffield City Art Galleries. Edinburgh Civic Collection. Sheffield University.

EDWARD GAGE R.S.W.

1925 Born Gullane, East Lothian. 1933–41 Educated The Royal High School of Edinburgh. 1941–42 Studied at Edinburgh College of Art. 1942–47 Guardsman in the Scots Guards, commissioned in The Royal Scots, served in Ulster and as a Staff Captain in India and Malaya. 1947–50 Studied at the Edinburgh College of Art. 1950–51 Post-Graduate Scholarship. 1951–52 Travelling Scholarship spent in Deya, Majorca. 1952–68 Art Master, Fettes College. 1952–56 Free-lance stage set designer; work for the Gateway and Citizen's Theatres. 1952 Began working as free-lance illustrator–drawing for Radio Times, B.B.C. Publications, Bodley Head, Cassel, Michael Joseph, Longmans. 1958 First began as a Part-time Lecturer at the Edinburgh College of Art. 1960–64 President of the Society of Scottish Artists. 1963 Elected Member of the Royal Scottish Society of Painters in Water-colours. 1966 Appointed Art Critic for The Scotsman newspaper. 1968 Senior Lecturer, Department of Design, Napier College of Commerce and Technology.

ONE-MAN SHOWS

1964 The Scottish Gallery. 1971 The Scottish Gallery. 1974 The Scottish Gallery.

GROUP SHOWS

1956 The French Institute, Edinburgh. 1958 The French Institute, Edinburgh. 1960 The 57 Gallery. Exhibits regularly at the R.S.A., R.S.W. and Royal Glasgow Institute.

COLLECTIONS

Works in the following collections – Glasgow Art Gallery, Scottish Arts Council, Edinburgh City Collection (Jean Watson Trust), Edinburgh Trust, Aberdeen University, Edinburgh University, Education Trusts of Argyll and Dumbarton; Shell, Ethicon.

WILLIAM GEAR

Born Methil, Fife, 1915. Studied Edinburgh College of Art and University. In 1937–38 studied in Paris with Fernand Leger. Travelled in France, Italy, Yugoslavia, Albania, Greece, Turkey. 1940–45 Army service in the Middle East, Italy, Germany. 1946–47 in Germany with Monuments, Fine Arts Section, Central Commission. 1947–50 lived in Paris. Met Hartung, De Stael, Padkine, Pignon, Poliakoff, etc. Married in 1949 and moved to England 1950. 1951 Festival of Britain Purchase Award. 1953 Elected Member of London Group. Designed textiles for Edinburgh Weavers. 1957 visited New York. 1958 appointed Curator Tower Art Gallery, Eastbourne. 1959 revisited New York. 1960

Fellow International Institute of Arts and Letters. 1964 appointed Head of Fine Art, Birmingham College of Art. 1967 Cargill Award, Glasgow Institute of Fine Arts. 1968 appointed Member of Fine Art Panel, National Council for Diplomas in Art and Design.

EXHIBITIONS

1944 Siena and Florence. 1948 Galerie Arc en Ciel, Paris. Gimpels Fils, London, Salon des Realities. 1949 Betty Parsons, Gallery, New York; 1952 Frankfurt, Oxford, One Man Tour English Provinces. 1953 Canterbury. 1954 Retrospective Exhibition South London Gallery. 1956 Gimpels Fils, London. 1957 Saidenberg Gallery, New York. 1958 Gimpels Fils, London. 1960 Hastings and Edinburgh. 1960 Stone Gallery, Newcastle. 1961 Retrospective, Gimpels. 1963 Douglas and Foulis, Edinburgh. 1964 Bear Lane Gallery, Oxford. 1965 Birmingham and Nottingham. 1967 Gimpels Fils and Adelaide, Melbourne, Sydney. 1969 Arts Council N. Ireland and Scottish Arts Council, Belfast, Londonderry, Glasgow.

GROUP EXHIBITIONS

1940–45 Jerusalem, Tel Aviv, Cairo. 1949 Mannheim, New York, Paris, Cobra Group Amsterdam, Copenhagen. 1952 Contemporary British Artists, British Council, France. 17 Collectors, Tate Gallery. 1st International Art Exhibition, Japan. Cincinatti Print Bienalle. 1953 Five Contemporary British Painters, Canada. International Water Colour Exhibition, Brooklyn Museum. Galerie de France, Paris. Sao Paulo Biennale, Brazil. British Painting and Sculpture, Whitechapel Art Gallery. 10 British Painters, Stockholm. Venice Biennale. 1955 Seven Scottish Painters, Arts Council, Edinburgh. 10 Years of English Landscape Painting, South London Gallery. 145–55 I.C.A. Contemporary Prints, Milan. 3rd International Art Exhibition, Japan. International Exhibition, Venezuela. 1956 Contemporary British Art, Oslo. British Art 1900–1955, Copenhagen. Contemporary British Art, New York. 1957 Premio Lissone, Italy. International Bericht, Dusseldorf. British Lithographs, Denmark. Dimensions, O'Hana Gallery, London. Contemporary British Art, Lisbon. Paris, North Carolina. 1958 British Abstract Painting, New Zealand. John Moores Exhibition, Liverpool. Contemporary British Art, Brussels. 1959 Seven British Artists, Australian Tour. British Artists, Australian Tour. British Printmakers, Bogota, Jerusalem. Guggenheim Award Exhibition R.W.S. Galleries. 1960 Six British Painters, Latin American Tour. 1961 Kenya, Rhodesia. 1962 British Art Today, San Francisco, Dallas, Santa Barbara. Europe '62, New Vision Centre, London. 10 British Painters, Denmark, Norway. 1963 Gimpel-Hanover Gallery, Zurich. British Painters and Sculptors, Stuttgart. 1964 London Group Jubilee Exhibition, Tate Gallery. Open Exhibition Belfast. Commonwealth Biennale of Abstract Art, Edinburgh. International Art 1965–66, Denmark. 1966 Joint Exhibition with Alan Davie, Edinburgh Festival (Arts Council). 1968 Carnegie Arts Festival, Dunfermline. 3 Centuries of Scottish Painting, Canada. Art Across the Tay, Dundee Art Gallery. Painting '64–'67 Arts Council Tour. Artists for Czechoslovakia, Camben Arts Centre. 1969 British Painting since 1900, Commonwealth Institute, London. Gimpels Fils Gallery, New York.

COLLECTIONS

Arts Council, Gt. Britian. Scottish Arts Council. Contemporary Art Society. Tate Gallery. National Gallery of Canada. British Council. Albright Art Gallery, Buffalo. Scottish National Gallery of Modern Art. National Gallery, New South Wales, Sydney. Arts Council of N. Ireland. Institute of Contemporary Art, Lima, Peru. Musee Des Bezux Arts, Liege. Art Gallery, Nelson, New Zealand. City Art Galleries of Brighton, Manchester, Eastbourne, Southampton, Toronto, Toledo, Ohio. Museum of Modern Art, New York. (Print). Victoria & Albert Museum. Tel Aviv Museum of Art. Laing Art Gallery, Newcastle. Abbot Hall Gallery, Kendal. Whitworth Gallery, Manchester. Glasgow University. Oxford New College. Cambridge Pembroke College. Birmingham University. Financial Times. Reeves.

SIR WILLIAM GILLIES C.B.E. D.Litt. R.A. R.S.A. P.P.R.S.W. (1898–1973)

1898 Born Haddington East Lothian. 1916 Studied for 2 terms at Edinburgh College of Art. Called up for war service in Spring 1917. 1919 Resumed studies at Edinburgh College of Art. 1922 Founder member of 1922 Group. 1923 Post Graduate Scholarship. 1924 Travelling Scholarship in Paris to

study under Andre L'Hote. Then to Italy. 1925 Taught art for 1 year at Inverness Academy. 1926 Small part-time appointment to Edinburgh College of Art. 1932 Elected to the Society of Eight. 1937 Became Member of S.S.A. 1939 Gillies family moved to Temple. 1940 Elected A.R.S.A. First Assistant on the staff at Edinburgh College of Art. 1946 Head of School of Painting at Edinburgh College of Art. 1947 Elected R.S.A. 1950 Elected R.S.W. 1957 Awarded C.B.E. 1960 Became Principal of Edinburgh College of Art. 1963 Elected President R.S.W. 1964 Elected Associate of the Royal Academy. 1966 Edinburgh University conferred Doctor of Letters. (D. Litt.). Elected Fellow of the Educational Institute of Scotland. Retired from Edinburgh College of Art. 1969 Elected to the Board of Edinburgh College of Art as Representative of R.S.A. 1970 Knighted in recognition of his services to Art in Scotland. 1971 Elected Academician of R.A. in London. 1973 Died Temple on April 15th.

ONE-MAN EXHIBITIONS

1948 French Institute, Edinburgh. 1949 Scottish Gallery, Edinburgh. 1950 International House, Edinburgh. 1952 The Scottish Gallery, Edinburgh. 1953 "The Scottish Scene", National Trust, Edinburgh (Collection Dr. Lillie). 1960 The Stone Gallery, Newcastle. 1963/68 The Scottish Gallery, Edinburgh. 1968 The Loomshop Gallery, Lower Largo.

GROUP EXHIBITIONS

1923, 25, 26, 27, 28, 29, 22 Group. 1927 St. George's Gallery, Grosvenor Street, London. 1932, 33, 34, 35, 36, 37, 38, Society of Eight. 1938 Reid & Lefevre, London. 1942 "Art for the People" Miners Institute, Cowdenbeath. 1942 Paintings and Drawings by British Artists, C.E.M.A. Touring Exhibition. 1942 "Six Scottish Painters" Reid & Lefevre. 1945 Paintings by 7 Scottish Artists, Annans Ltd., Glasgow. 1947 Group Show, Scottish Gallery, Edinburgh. 1949 "Paintings by Present Day Scotts", Annans Ltd., Glasgow. 1951 Festival of Britain Exhibition, London. "Britain in Watercolours", R.W.S. Galleries, London. British Painting 1925–50, Arts Council. "Contemporary Scottish Painting" Arts Council Scottish Committee. 1952 Festival Exhibition Group Show. 1954 Scottish Painters, National Gallery of Canada, Ottowa. Paintings, Watercolours and Drawings by Gillies and Maxwell, New Burlington Galleries, London. "Three Scottish Painters", Crane Gallery, Manchester. Festival Group Show, Scottish Gallery, Edinburgh. 1957 Contemporary British Painting, The British Council.

COLLECTIONS

Aberdeen Art Gallery. Gracefield Arts Centre, Dumfries. Dundee City Art Gallery. Edinburgh Corporation. R.S.A. Scottish Arts Council. Scottish National Gallery of Modern Art. Edinburgh University. Glasgow Art Gallery. Glasgow University. Greenock Art Gallery. Kirkcaldy Art Gallery. Arts Council of Great Britain, London. Department of the Environment. Royal Academy of Arts, Nuffield Foundation. Tate Gallery. Lillie Art Gallery, Milngavie. Laing Art Gallery, Newcastle upon Tyne. Paisley Art Galleries. Perth Art Gallery. Preston Art Gallery. Reading Art Gallery.

GEORGE ALEXANDER EUGENE DOUGLAS,
The Earl HAIG O.B.E., D.L., M.A., F.R.S.A.

Born Kingston Hill 1918. Stowe School 1931–35, Christ Church, Oxford 1936–39. Moved to Bemersyde from Kingston Hill 1924. Served M.E.F. with Royal Scots Greys 1939–42. P.O.W. Italy and Germany 1942–45. Camberwell School of Art 1945–47, where he studied under William Johnstone, Pasmore, Gowing, Coldstream and Rogers. During vacations he worked with Paul Maze. Since 1947 has lived and worked at Bemersyde. 1948 S.S.A. Served as a member of Royal Fine Art Commission 1958–61. Served as member of Board of Trustees of the National Galleries of Scotland 1963–1973. Member of Council of the Scottish Arts Council since 1969.

ONE-MAN EXHIBITIONS

1949, 52, 55 Redfern Gallery, London. Leicester Gallery, 1959. 1962 Fifty-seven Gallery, Edinburgh. O'Hana Gallery, London, 1966. 1968 Richard Demarco Gallery, Edinburgh. 1945, 49, 52, 56, 61, 73, The Scottish Gallery, Edinburgh. Haddington House, 1973. The Scottish Gallery 1976.

GROUP EXHIBITIONS

Poland, Demarco Exhibition 1967. Scottish Painting, Wales. Scottish Painting, Reading. Three

Centuries of Scottish Paintings, Canada 1968. Oirtach Tas Exhibition, Dublin Municipal Gallery 1968. John Moores Exhibition. 1973 Lamp of Lothian Gallery. Galerie Vallombreuse, Biarritz 1974.

COLLECTIONS
H.M. The Queen. H.M. The Queen Mother. H.R.H. The Duke of Edinburgh. Scottish National Gallery of Modern Art, and Scott Hay Collection. Arts Council of Great Britain. Arts Council, Scottish Committee. Ministry of Works. Scottish Modern Arts Association. British Railways. Edinburgh University. Leicester, Banff, Argyll County Council Education Authorities. Abbot Hall Gallery, Kendal. Imperial War Museum. Joseph Pulitzer.

JOHN HOUSTON R.S.A. R.S.W.

Born Buckhaven, Fife 1930. Studied Edinburgh College of Art 1948–54. Teaches Edinburgh College of Art. Married to Elizabeth Blackadder. Elected an academician of the Royal Scottish Academy 1972. Member of the Royal Scottish Society of Painters in Watercolour. Member of the Society of Scottish Artists. Guthrie Award, Royal Scottish Academy 1964. Cargill Prize, Royal Glasgow Institute 1965.

ONE-MAN EXHIBITIONS
1958 57 Gallery, Edinburgh. 1960 Scottish Gallery, Edinburgh. 1962 Scottish Gallery, Edinburgh, Festival Exhibition. 1965 Scottish Gallery, Edinburgh. 1966 Mercury Gallery, London. 1967 Scottish Gallery Edinburgh Festival Exhibition. 1967 Lane Gallery, Bradford. 1968 Mercury Gallery, London. 1969 Wustum Museum of Fine Arts, Racine, Wisconsin. 1969 Johnson Foundation, Racine, Wisconsin. 1970 Cerberus Gallery, New York. 1970 Mercury Gallery, London. 1970 Loomshop Gallery, Lower Largo. 1971 Scottish Gallery, Edinburgh Festival Exhibition. 1972 Mercury Gallery London. 1972 Loomshop Gallery, Lower Largo. 1974 Oban Art Society. 1974 Retrospective Exhibition, Dunfermline. 1974 Loomshop Gallery, Lower Largo. 1975 Mercury Gallery, London.

GROUP EXHIBITIONS
1958 Edinburgh Painters and Craftsmen, Nice. 1960 Scottish Gallery. 1962 Scottish Gallery. 1961 Contemporary Scottish Painting, Toronto. 1963 14 Scottish Painters, Commonwealth Institute, London. 1965 7 Scottish Painters, IBM Gallery, New York. 1965 Scottish Gallery. 1966 Mercury Gallery, London. 1967 15 Artists, Demarco Gallery, Museum of Modern Art, Warsaw. 1967 Scottish Gallery. 1967 Lane Gallery, Bradford. 1968 Three Centuries of Scottish Painting, National Gallery of Canada, Ottowa. 1968 Mercury Gallery, London. 1969 Wustrom Museum of Fine Arts, Racine, Wisconsin, U.S.A. 1969 Johnston Foundation, Racine, Wisconsin. 1970 12 Scottish Painters, Maine State Commission on the Arts and Humanities, Touring U.S.A. 1970 Cerbans Gallery, New York. 1970 Mercury Gallery, London. 1970 Loomshop Gallery, Lower Largo. 1971 Art Spectrum, Aberdeen Art Gallery. 1971 The Edinburgh School, Edinburgh College of Art. 1971 Scottish Gallery, Festival Exhibition. 1972 Mercury London. 1974 Glen Pavilion Dunfermline. 1975 Scottish Gallery. 1975 Mercury Gallery, London.

COLLECTIONS
Argyll County Council. Aberdeen Art Gallery. Bradford Art Gallery. British Transport Hotels. Carlisle Education Authority. Carnegie Trust. Contemporary Art Society. Copenhagen Tuborg Breweries Collection. Department of the Environment. Dumfries, Gracefield Arts Centre. Dunbartonshire Education Authority, Edinburgh Education Authority, Edinburgh Ethicon, College of Domestic Science, Jean Watson Bequest, Scottish Arts Council, Scottish National Gallery of Modern Art, The Royal Bank of Scotland, The Royal Edinburgh Hospital, The Royal Scottish Academy, Scottish Television, The University. Fife Education Authority. Glasgow Art Gallery and Museum. I.B.M. I.C.I. Kirkcaldy Art Gallery and Museum. Abbothall Art Gallery, Kendal. Financial Times, London. Nottinghamshire Education Authority. St. Anne's College, Oxford. Perth Art Gallery and Museum. Portsmouth City Art Gallery. Prairie School Racine, Wisconsin. Nuffield Foundation. Shell Petroleum Company. Strathclyde University. Tyneside Museum Services. Vincent Price Collection, U.S.A. Walker Art Gallery, Liverpool. East Riding County Council, Yorkshire. West Riding County Council, Yorkshire.

JOHN JOHNSTONE A.R.S.A.

Born Falkirk, Stirlingshire 1937. 1956–60 College of Art. 1960–61 Post graduate. 1961–62 Travelling Scholar to West Indies, Columbia, Equador and Peru. Lecturer Edinburgh College of Art. Since 1963 member S.S.A. Lives in Edinburgh. Latimer Award 1967. Arbroath Arts Award 1968. Arts Council Award 1970. A.R.S.A. 1972.

ONE-MAN EXHIBITIONS
1961 El. Calle-jon Bogota, South America. 1964 57 Gallery Edinburgh. 1970 Scottish Gallery, Edinburgh. 1970 Goosewell Gallery, Menston, Yorkshire. 1970 Mercury Gallery, London. 1975 Compass Gallery, Glasgow.

GROUP EXHIBITIONS
Young Scottish Contemporaries. Scottish Committee Touring Exhibition. Contemporary Scottish Painters. Scottish Arts Council. New Symbolists, Piccadilly Gallery, 1966/68. Marjorie Parr Gallery, 1967/68/69. Three Centuries Scottish Paintings, National Gallery, Canada. Art Spectrum, Aberdeen Art Gallery. 20 57, Edinburgh University, 57 Gallery. 12 Scottish Painters, Portland Maine State Commission United States of America. Glasgow Group, McLellan Gallery, Glasgow. R.S.A. and S.S.A.

COLLECTIONS
Scottish Arts Council. Arts Council of Great Britain. Hamilton Art Gallery, Canada. Olinda Museum Sao Paulo, Brazil. Aberdeen Art Gallery. Liverpool University. Watson Trust, Edinburgh. Campden Borough Council, London.

WILLIAM JOHNSTONE O.B.E.

Born 1897 June. Studied Edinburgh College of Art, Studio of Andre Lhote, Paris, Colorossi. Studied in Art Galleries of Italy, Holland, Spain and France. Diploma Edinburgh College of Art. Carnegie Travelling Scholarship. Stuart Prize. Keith Award. Maclaine-Watters Medal. Fulbright Scholarship to U.S.A. Leverhulme Award, O.B.E. Taught Basic and Industrial Design at Regent Street Polytechnic. Taught Design at Royal School of Needlework. Principal of Camberwell School of Arts and Crafts. After the War, Principal Central School of Arts and Crafts. Director Summer School Colorado Springs 1949–50. 1961 Survey of Art Education in Israel. Member of Council on Council of Industrial Design. Member of Council for Royal Society of Arts.

ONE-MAN EXHIBITIONS
Wertheim Gallery, 1934. Scottish Gallery 1934. Gimpel Fils, 1949. Colorado Springs 1950. Reid & Lefevre, 1953. Reid & Lefevre 1958. Bear Lane Oxford 1959. Reid Gallery, Cork Street, 1960. Stone Gallery, Newcastle 1961. Stone Gallery, Newcastle 1963. Reid Gallery, 1964. Decor Gallery Newcastle. 1969. Decor Gallery Newcastle, 1969. Scottish Arts Council Retrospective, 1970. Compass Gallery, 1970. University of Stirling. Dundee, Kendal Lancaster 1972. Scottish National Gallery of Modern Art, 1973. Festival Exhibition 1976 at Talbot Rice Art Centre, Edinburgh.

GROUP EXHIBITIONS
Reid & Lefevre 1939. Reid & Lefevre, 1942. Hanover Gallery, 1953. Leicester Gallery, 1958. Pittsburgh International 1958. Brussels International 1958. Bradford Spring Exhibition 1965/66. National Gallery of Wales, "Scottish Painters" 1966. 3 Centuries of Scottish Painting, Canada, 1968.

COLLECTIONS
Scottish Gallery of Modern Art. Portrait Gallery, Edinburgh. Kelvingrove Civic Collection. Aberdeen Civic Collection. Dundee Civic Collection. Abbott Hall Art Gallery. Kendall Art Gallery, Pitlochry Art Gallery. Victoria and Albert Museum. East London Art Gallery. Mrs Hope Mantagu-Douglas-Scott. Colorado Springs Fine Art Centre. Mrs Winard. Nuffield College, Oxford. Scottish Arts Council Collections.

JOHN KNOX A.R.S.A.

Born 1936 Kirkintilloch. Studied Glasgow School of Art, Andre Lhote Atelier, Paris. Lecturer at Dundee College of Art 1957 Haldane Scholarship & Craig Bequest – Glasgow School of Art. 1958 Haldane Scholarship – Glasgow School of Art. 1957 Stuart Prize – R.S.A. 1958 Carnegie Scholarship – R.S.A. 1963 Elected Professional Member of S.S.A. 1966 Latimer Award – R.S.A. 1968 Guthrie Award – R.S.A. 1969 Resident Artist – Hospitalfield College of Art, Arbroath. 1970 Resident Artist – Hospitalfield College of Art, Arbroath. 1971 Arts Council Award. 1972 A.R.S.A. 1974 Member of the Scottish Arts Council.

ONE-MAN EXHIBITIONS
1966 The Scottish Gallery, Edinburgh. 1969 Richard Demarco Gallery, Edinburgh. 1971 Serpentine Gallery, London. 1972 Buckingham Gallery, London. Aberdeen Civic Arts Centre. 1974 Galleria Tinoghelfi – Vincenza, Italy.

GROUP EXHIBITIONS
1962 Glasgow Group – A.I.A. Gallery, London. 1963 Twentieth Century Scottish Painting – Arts Council. Young Scottish Contemporaries – Arts Council. 1964 Scottish Painters Plus or Minus Thirty – Scottish National Gallery of Modern Art & Glasgow University. Knox & McCulloch New Charing Cross Art Gallery, Glasgow. Scottish Painting Enterprise '64 – Glasgow. 1965 Contemporary Scottish Painting – Glynn Vivian Gallery, Swansea. Young Scottish Painters – Commonwealth Arts Festival, Glasgow. 1966 Four Scottish Painters – Piccadilly Gallery, London. Scottish Painting 1866–1966 – Links House, Glasgow. Ten Scottish Painters, Irish Arts Council Irish Open Painting Competition. 1967 Fifteen British Painters, Polish National Gallery of Modern Art, Warsaw. Edinburgh Open 100, Festival Exhibition. 1968 Three Centuries of Scottish Painting, National Gallery of Canada. New Symbolists, Piccadilly Gallery, London. Scottish Painting '68m Demarco Festival Exhibition. Felixtowe Arts Festival. Art Across The Tay, Dundee Art Gallery. 1969 Acireale International Arts Festival, Italy. Compass Gallery Glasgow. Three Scottish Painters, Durham University. Painters from the Demarco Gallery, Travers Gallery, London. 1970 Scottish Painting, (touring U.S.A.); Celtic Triangle, (touring U.K.); S.T.V. Festival Exhibition, Edinburgh. Seven Painters in Dundee, National Gallery of Modern Art, Arts Council. New Multiple Art, Whitechapel Gallery, London. Multiples, Arts Council. Painting '70, Aberdeen Art Gallery. 1971 Art Spectrum, Arts Council. Arts Council Award Winners Exhibition, Pitlochry Festival Exhibition. 1972 '57 Festival Exhibition. 9 Dundee Painters, Edinburgh Arts Centre. Demarco Gallery. 1973 Dusseldorf International Art Market, Steiger Galerie. Stirling Gallery. Compass Gallery, Glasgow. Sheffield University. 1974 Galleria d'Arte del Cavallino, Venice. Stirling Gallery.

COLLECTIONS
Otis Art Institute, Los Angeles, U.S.A. Olinda Museum, Sao Paulo, Brazil. Scottish National Gallery of Modern Art. Scottish Arts Council. Contemporary Arts Society. Manchester City Art Gallery. Aberdeen Art Gallery. Dundee Art Gallery. Edinburgh Civic Collection. R.S.A. Collection. Dumfries Education Authority. Edinburgh Education Committee. Camden Collection, London. Nuffield Foundation. Kingsway Technical College. Strathclyde University. St. Andrew's University. Aberdeen University. Stirling University.

WILLIAM LITTLEJOHN R.S.A.

Born 1929. Studied Dundee College of Art 1946–51. D.A. 1962 R.S.A. Award. Teaching Posts in Angus 1953–66. 1966 David Cargill Award, Royal Glasgow Institute of Fine Arts. 1966 A.R.S.A. 1966–70 Assistant Head of Drawing and Painting, Grays School of Art. Aberdeen, now now Head. 1973 R.S.A. Lives in Aberdeen and Arbroath.

ONE-MAN EXHIBITIONS
The Scottish Gallery, 1961, 63, 67.

GROUP EXHIBITIONS
1960 Arbroath Art Gallery. 1961 Scottish Painting, Toronto. 1963 Twentieth Century Scottish

Painting, Arts Council Touring Exhibition. 1964 Contemporary Scottish Painting, Art Gallery, Reading. 1964 Plus or Minus 30 Glasgow University. 1965 Wales, Scottish Painting. 1968 Art Across the Tay, Dundee Art Gallery. 1970 Painters of the North East, Compass Gallery, Glasgow. 1970 Painting 70, Aberdeen Art Gallery. 1969 300 Years of Scottish Painting, Canada. 1970 12 Scottish Artists, Maine and Eastern U.S.A. 1971 Art Spectrum, Scotland.

COLLECTIONS
Aberdeen Art Gallery. Abbot Hall Gallery, Kendal. Arbroath Art Gallery. Arts Council. Edinburgh Civic Collection. Edinburgh Education Authority. Edinburgh University. National Gallery of Modern Art. Paisley Art Gallery. R.S.A. Collection. Tower Art Gallery, Eastbourne.

ROBERT MACBRIDE (MACBRYDE) (1913–1966)

Born Maybole Ayrshire 1913. Left school at 14. Worked for 5 years in a local shoe factory. 1932–37 Studied at Glasgow School of Art. Met Robert Colquhoun. 1937–39 Studied in France. Returned to Scotland at outbreak of war. 1941 Left for London. 1941–46 Shared a house with John Minton and (from 1943) Jankel Adler. 1943 First one-man show at the Lefevre. Numerous other shows followed in London and Europe. Worked as a stage designer. Designed the sets and costumes with Colquhoun for 1951 Massine's Scottish Ballet "Donald of the Burthens", produced by Sadlers Wells Ballet at Covent Garden. Worked mainly in London, East Anglia, Cornwall and Ireland and only returned to Scotland for short visits to his family house in Maybole. 1966 He died after being knocked down by a bus in Dublin Street.

DAVID McCLURE R.S.A., R.S.W.

Born Lochwinnoch, 1926. Educated Queen's Park School, Glasgow, and at Glasgow University 1943–44. Edinburgh University 1947–49 and at Edinburgh College of Art 1947–52. Travelling Scholarship in Spain and Italy, 1952–53. Taught at Edinburgh College of Art 1953–55. Fellow of the College 1955–57. Now teaching at Duncan of Jordanstone College of Art, Dundee. Elected S.S.A. 1951, A.R.S.A. 1963, R.S.W. 1965. R.S.A. 1971.

ONE-MAN EXHIBITIONS
1957 Circola di Cultura, Palermo, Italy. Scottish Gallery, Edinburgh. 1961 Saltire Society, Edinburgh. 1962 Scottish Gallery, Edinburgh. 1966 Scottish Gallery, Edinburgh. 1969 Scottish Gallery, Edinburgh. 1977 Loom Shop Gallery, Lower Largo.

COLLECTIONS
Art Gallery, Aberdeen. Airlie Hall, Queen's College, City Museum and Art Galleries, Dundee. Arts Council, Scottish National Gallery of Modern Art. The University Staff Club, Education Committee, R.S.A. (Thorburn Ross Collection), Edinburgh. The University Staff Club St. Andrews. Art Gallery Museum, Glasgow. Art Gallery and Museum, Perth. Shell Petroleum Company. British Railways. Towner Art Gallery, Eastbourne. Staff House, The University, Birmingham. Caird Trust, Greenock. County Council Education Committee, Argyll.

IAN McCULLOCH

Born Glasgow 1935. Studied Glasgow School of Art 1953–57 & Hospitalfield House, Arbroath. R.S.A. Travelling Scholarship 1957. Arts Council Awards 1967–68, 1972–73 Major Award. Professional Member S.S.A. Founder Member Glasgow Group. At present teaching in University of Strathclyde. Lecturer in Fine Arts Dept. of Architecture since 1967.

EXHIBITIONS
1959 Blythswood Gallery, Glasgow. 1960 '57 Gallery, Edinburgh. 1962 Citizens Theatre, Glasgow. 1967 Charing Cross Gallery, Glasgow. 1969/71 University of Strathclyde, Glasgow. 1973 Arts Council organised one-man Exhibition after Award. 1974 Collins Exhibition Hall, University of Strathclyde. Perth Art Gallery. Dundee Art Gallery.

1960 West of Scotland Painters, Edinburgh Festival. 1961 Count Down Exhibition, Glasgow. 1962 A.I.A. Gallery, London. Four Glasgow Painters, Print Room, University of Glasgow. McCulloch & Knox '57 Gallery, Edinburgh. 1963 English Speaking Union, Edinburgh.
1963/64 Tweintieth Century Scottish Painting, Abbot Hall Art Gallery, Kendal. 1964 McCulloch & Knox. New Charing Cross Gallery, Glasgow. Scottish Painting, Stirling Festival. Scottish Painters 30, Scottish National Gallery of Modern Art, University of Glasgow. 1965 Commonwealth Arts Festival, Glasgow. 1965 Contemporary Scottish Painters, Glynn Vivian Art Gallery, Swansea. 1966 Structure '66, National Museum of Wales. The West of Scotland Painters, Belfast. 1967 Grosvenor Gallery, London. 1968 Scottish Painting 1968, Richard Demarco Gallery, Edinburgh. Oirtach Tas. Municipal Gallery, Dublin. 1968/69 Three Centuries of Scottish Painting, National Gallery of Canada. 1969 New Tendencies in Scottish Paiting, Richard Demarco Gallery, Edinburgh. 1971 Art Spectrum, Scottish Arts Council. 1972/73 '57 Gallery Exhibitions.

WILLIAM MACLEAN

Born Inverness 1941. Inverness Royal Academy and H.M.S. Conway, Angelsea, N. Wales. 1959–61 Midshipman, Merchant Navy, Blue Funnel Line, Liverpool. 1961 Grays School of Art, Aberdeen. 1961 Rowney Paint Prize. 1964 Scholarship to Hospitalfield Art School, Arbroath. 1965 Post Graduate Scholarship Drawing and Painting. 1966 George Davidson Memorial Scholarship. 1967 Scottish Education Department, travel scholarship. Lives and works in Fife.

ONE-MAN EXHIBITIONS
New 57 Gallery, Edinburgh, 1968. Dundee University Staff Club. 1971. Loomshop Studio, Largo, Fife, 1971, 1973.

GROUP EXHIBITIONS
Two-man Show with Steve Lawson, Sculptor, Cummings Hotel, Inverness, 1964. Mixed Exhibition Hopetoun House, Edinburgh, 1968. S.S.A. R.S.A. Exhibitions, Pernod Exhibition, 1968. "8 Artists" Kirkcaldy Art Gallery. With 3 other artists, designed and constructed large Exhibition "Colour" for Wiggins Teape Ltd. Tilly-Coultry, Clackmannanshire. Younger Scottish Artists. S.T.V. Richard Demarco Festival Exhibition – Water Colours – George Street, Edinburgh. "Works on Paper" New 57 Art Gallery, Edinburgh. 1969 R.S.A. and S.S.A. Exhibitions. "Portraits" New 57 Gallery. Four Figurative Painters, Richard Demarco Gallery. Kirkcaldy Art Gallery. Invited Artist – "Hamlet" – Exhibition Demarco Gallery. Mixed Exhibition New 57 Gallery, 1971. R.S.W. Annual Exhibition 1971. Arts Group Exhibition Richard Demarco Gallery Edinburgh. 4 Artists, Studio Nine, Culross, Fife. McCoig, Stiven, Evans, Maclean. 2-man show with Ian Macleod New 57 Gallery, Edinburgh. S.S.A. Travelling Exhibition selected from Annual Exhibition, 1971. Colin Jellico Gallery, Manchester. Summer Exhibition Edward Harvane Gallery, London. Pernod Exhibition and Arbroath Exhibition 1973. Group Show, Studio Nine, Culross 1973. Scottish International Educational Trust. Major award to collect material for an Exhibition on the history and development of ring net herring fishing on the west coast of Scotland. The Exhibition to consist of drawings and paintings and photographs. S.S.A. Travelling Exhibition 1973. Opening Exhibition of Drawing, Stirling Gallery. Crowsteps Exhibition, Blairlogie. 2-man show with Neil Dallas Brown, Stirling Gallery. S.S.A. Exhibition 1974.

COLLECTIONS
Aberdeen Art Gallery, Scottish Arts Council, Fife Education Authority, Perth Town Council, Seaforth Maritime Scottish Collection, British Transport, School collections in Fife and Inverness.

SIR WILLIAM MACTAGGART P.P.R.S.A. H.R.A. H.R.S.W. L.L.D.
F.R.S.E. A.R.A. H.F.R.I.A.S. Chevalier de la Legion d'Honneur

Born Loanhead 15th May 1903. Through ill health educated at home. 1918–21 Attended part-time Edinburgh College of Art. 1922 Elected Member of S.S.A. Foundation Member of the 1922 Group.

1922–29 Annual Visits to France. Painted at Cannes, Le Cannet, Cassis, Bormes, Grimaud. 1927 Elected to Society of 8. Lavery, Peploe and Cadell were members. 1933 Elected President of the Society of Scottish Artists until 1936. Taught part-time at Edinburgh College of Art. 1937 Married to Fanny Aavatsmark. Elected A.R.S.A. 1939–45 Honorary Exhibition Organiser for C.E.M.A. 1948 Elected Academician of R.S.A. and Member of the Festival Society Council. 1955 Elected Secretary of R.S.A. 1957 Appointed Member of the Scottish Advisory Committee of Independent Television Authority until 1964. 1959 Elected President R.S.A. Hon. R.H.A. Honorary Member Royal Scottish Society of Painters in Watercolour. 1960 Appointed Trustee of the National Museum of Antiquities. 1961 Honorary Doctor of Laws of Edinburgh University. 1962 Knighted. 1965 Freeman of the Burgh of Loanhead. 1967 Elected Fellow of the Royal Society of Edinburgh. 1968 Elected Associate of the Royal Academy. Chevalier de la Legion d'Honneur. 1969 Honorary Fellowship of the Royal Incorporation of Architects in Scotland. 1973 Elected R.A.

ONE-MAN EXHIBITIONS

1924 Church of St. Andrew, Cannes. 1929 The Scottish Gallery, Edinburgh. 1932 Mac-Taggart House, Hillwood, Loanhead. 1938 Connells Gallery, Glasgow. 1945, 47 T & C Annan Ltd., Glasgow. 1953 The Scottish Gallery. 1955 Kunstnerforbundet, Oslo. 1959 Festival Exhibition at Scottish Gallery. 1960, 62, 64, Stone Gallery, Newcastle upon Tyne. 1966 Festival Exhibition Scottish Gallery. 1971 Loomshop Gallery, Lower Largo.

GROUP EXHIBITIONS

1963 "Four Scottish Painters" Arts Council Scottish Committee (Festival). 1964 "14 Scottish Painters", Commonwealth Institute, London.

COLLECTIONS

Aberdeen Art Gallery. Argyll County Council. Bradford City Art Gallery. Dumfries, Gracefield Arts Centre. Dundee City Art Gallery. Durham County Council. Edinburgh Corporation. R.S.A. Scottish Arts Council. Scottish National Gallery of Modern Art. Edinburgh University. Glasgow Art Gallery. McLean Museum and Art Gallery, Greenock. Arts Council of Great Britain, London. Tate Gallery. Middlesbrough Municipal Art Gallery. Laing Art Gallery, Newcastle upon Tyne. Stirling University.

JOHN MAXWELL R.S.A. (1905–1962)

Born Dalbeattie 1905. In 1921 he enrolled as a student at Edinburgh College of Art. Diploma Edinburgh College of Art 1926. Post Graduate Scholarship 1927. 1928 Travelling Scholarship in France, Spain, and Italy. Attended the Academe Moderne run by Ozenfant and Leger. Large scale mural at St. Cuthberts Church. First Fellow under the Andrew Grant Scholarship Bequest. Executed fine mural at Craigmillar, Niddrie. Works appeared in travelling C.E.M.A. Exhibitions. Assistant at Edinburgh College of Art to Penelope Beaton until 1943. Went back to Dalbeattie till 1947 when he returned to Edinburgh College of Art as Senior Lecturer in charge of Composition. Elected A.R.S.A. 1945. Elected R.S.A. 1949. Died 3rd June 1962.

ONE-MAN EXHIBITIONS

1948 French Institute. 1951 Aberdeen Art Gallery. 1954 Arts Council Gallery. 1960 Arts Council.

GROUP EXHIBITIONS

London Group, 1935–37. 1939 40 British Council Touring Exhibition Toledo, U.S.A., and Ottowa 1939–40. Edinburgh University Arts Society 1949. Arts Council Touring Exhibition 1954. British Council Oslo and Copenhagen 1956. Arts Council Touring Exhibition 1958. Nottingham 1959. Stirling Gallery 1959. Arts Council Touring Exhibition 1960. British Council in U.S.S.R. 1960. Kendal & Arts Council Touring Exhibition 1963. "20th Century British Landscape" North Western Museum and Art Gallery Service Touring Exhibition 1963–64. Regular Exhibitor at S.S.A., R.S.A.

COLLECTIONS

Aberdeen Art Gallery. Arts Council. Gracefield Arts Centre, Dumfries. Edinburgh College of Art. Glasgow Museums and Art Galleries. New South Wales Gallery. Royal Scottish Academy. Scottish Modern Arts Association. Scottish Gallery of Modern Art. Tate Gallery. Whitworth Art Gallery, Manchester.

DAVID MICHIE R.S.A.

Born St. Raphael, France, 1928. Educated at Hawick High School and the Edinburgh College of Art, taking a Post-Graduate Scholarship there in 1932–3. In 1953–4 he had a Travelling Scholarship in Italy. Taught Drawing and Painting at Gray's School of Art, Aberdeen from 1957–61. Guthrie Award 1960. He has been on the staff of Edinburgh College of Art since 1961 and is now Vice-Principal of the College. President of the Society of Scottish Artists from 1961–63 and in 1964 elected Associate of the Royal Scottish Academy; a Full Member in 1972. He lives in Edinburgh and is married with two daughters.

ONE-MAN EXHIBITIONS
Mercury Gallery, London, November 1966, January 1969, November 1971, November 1974.

GROUP EXHIBITIONS
Regular Exhibitor in R.S.A., S.S.A. etc.

COLLECTIONS
H.M. The Queen. Argyll County Council. Aberdeen Art Gallery and Industrial Museum. Banffshire Education Authority Edinburgh Corporation, Jean Watson Trust. Edinburgh Education Authority. Ethicon. Glasgow Art Gallery and Museum. Gracefield Arts Centre, Dumfries. Liverpool University. Nottinghamshire County Council. Nuffield Foundation. Queen Elizabeth College, London. Royal Scottish Academy. Scottish Arts Council. Scottish National Gallery of Modern Art. Shell Petroleum Company.

ALEXANDER MOFFAT

Born Dunfermline, Fife, 1943. Edinburgh College of Art, 1960–1964. Worked in Engineering Factory Edinburgh, 1964–1966. Visited Berlin, Dresden, Weimar, Leipzig and Halle 1967. Professional Member of Society of Scottish Artists, 1968. Elected Chairman of New 57 Gallery, 1968. Elected to Council of Society of Scottish Artists, 1973. Worked as a Photographer with the Scottish Central Library, 1966–1974. 2 Films directed by W. Gordon Smith for B.B.C. T.V. Scotland, 1971 and 1973. 2 Murals for A.U.E.W. Building, Morrison Street, Edinburgh, 1973.

EXHIBITIONS
Open-air Festival exhibitions with John Bellany, 1963, 64, 65. Young Contemporaries (London) 1964. One-man show, New 57 Gallery, 1970. Scottish Realism, Scottish Arts Council, 1971. Glasgow Group, 1971. A View of the Portrait, Scottish National Portrait Gallery, Festival 1973.

ALBERTO MORROCCO R.S.A. R.S.W.

Born Aberdeen 1917 of Italian parents. Studied Gray's School of Art, Aberdeen 1932–38. Won Brough Travelling Scholarship and Carnegie Travelling Scholarship, and studied in France and Switzerland. Army service 1940–46. After war returned to Aberdeen and did some part time teaching at the Gray's School of Art. Founder member of the "47 Group". Head of School of Painting, 1950, at Duncan of Jordanstone, College of Art. In 1951 made Associate of Royal Scottish Academy. 1959 won the San Vito prize for Landscape. Elected to R.S.A. in 1963. 1962 Mural commissioned St. Columba's Church, Glenrothes. 1963 and 1965 Mural commissioned at Dundee Royal Mental Hospital.

ONE-MAN EXHIBITIONS
1949 British Council, Aberdeen – paintings and drawings. 1955 Roseangle Gallery, Dundee – paintings. 1957 Scottish Gallery, Edinburgh – paintings and drawings. 1962 Saltine Society Gallery, Edinburgh – paintings. 1966 University of Dundee, Dundee – paintings. 1969 Compass Gallery, Glasgow – constructions and paintings. 1973 Roseangle Gallery, Dundee – paintings and drawings. 1973 Scottish Gallery, Edinburgh – paintings.

GROUP EXHIBITIONS

1947 "47 Group" Art Gallery, Aberdeen. 1948 "47 Group" Art Gallery, Aberdeen. 1949 "47 Group" Art Gallery, Aberdeen. 1950 "47 Group" Art Gallery, Aberdeen. 1963 "Artists of Anticoli" Rome. 1964 "14 Scottish Painters", Commonwealth Gallery, London. 1964 "4 Scottish Artists" Arts Council Gallery, Edinburgh Festival Exhibition. 1972 "5 Dundee Painters" Art Centre, Edinburgh.

COLLECTIONS

Scottish National Gallery of Modern Art. Paisley Art Gallery. Aberdeen Art Gallery. Bristol Art Gallery. Dumfries, Gracefield Art Centre. Dundee Art Gallery. Edinburgh Arts Council. Edinburgh Corporation (ex. Scottish Modern Arts Assoc.). Edinburgh R.S.A. (Thorburn Ross Collection). Glasgow Art Gallery. Newark-on-Trent Municipal Museum (presented by the Contemporary Arts Society) Perth Art Gallery. West Riding County Council.

GLEN ONWIN

1947 Born in Edinburgh. 1966-70 Studied painting at Edinburgh College of Art. 1970–71 Post-Graduate study. 1971 Peter Stuyvesant Foundation Prize. Travelling scholarship to Tunisia. 1973 Scottish Arts Council Visual Arts Bursary for travel in the U.S.A. Lives and works in Edinburgh.

ONE-MAN EXHIBITIONS

1975 "Saltmarsh" Scottish Arts Council Gallery, Edinburgh, 1976 "Salt Works" Bishop's Palace, Inverness.

GROUP EXHIIDITIONS

1969 "This is Not What we came to See" – St. Cuthbert's Hall, Edinburgh. 1971 Northern Young Contemporaries. Whitworth Art Gallery, Manchester and subsequent tour. 1972 Walls-New 57 Gallery Edinburgh. Still-Life New 57 Gallery, Edinburgh. Combat Room, Leith Festival, Leith, Edinburgh. Landscape – New 57 Gallery, Edinburgh. 1973 Landscape – Richard Demarco Gallery, Edinburgh. 1975 A choice selection -- Fruit Market Gallery, Edinburgh. The Video Show. Serpentine Gallery, London. Scottish Sculpture '75. Fruit Market Gallery, Edinburgh. Kelvin Grove Museum, Glasgow. Coal – An Industrial Sponsors Exhibition – Hobart House, London. Summer Show 3 – Serpentine Gallery, London. Video Tapes from the Scottish Arts Council Collection – Scottish Arts Council Gallery, Edinburgh. 1976 New 57 Gallery Group, Fruit Market Gallery, Edinburgh.

PUBLIC COLLECTIONS

Scottish Arts Council, Edinburgh. Contemporary Art Society, London. British Council, London.

DENIS PEPLOE R.S.A.

Born March 1914. Attended Edinburgh College of Art 1931–35 and Academie Andrew Lhote, Paris. Painter and Teacher of Drawing and Painting Edinburgh College of Art. D.A. Edinburgh. Elected A.R.S.A. 1956. R.S.A. 1966 Member of S.S.A. and R.S.A.

ONE-MAN EXHIBITIONS

Scottish Gallery 1947. Scottish Gallery 1954. The Hazlitt Gallery, London 1952. Annans Gallery, Glasgow 1953.

GROUP EXHIBITIONS

S.A.C. Gallery, 1969. Scottish Painting from Collection of Dr. Lillie.

COLLECTIONS

Kirkcaldy, Glasgow. Greenock. Modern Arts Associations.

SIR ROBIN PHILIPSON P.R.S.A., A.R.A., H.R.A., R.S.W., D.A.

Born Broughton-in-Furness, 1916. Educated Dumfries Academy and Edinburgh College of Art. 1940–46 Served in India. King's Own Scottish Borderers. 1947 Joined staff of Edinburgh College of

Art. 1948 Elected Member of the Society of Scottish Artists. 1952 Elected Associate of the Royal Scottish Academy. 1955 Elected Member of Royal Scottish Society of Painters in Watercolour. 1959 Third Prize, John Moore's Exhibition, Liverpool. 1960 Appointed Head of School of Drawing and Painting, Edinburgh College of Art. 1962 Elected Royal Scottish Academician. 1963 Visiting Professor of Painting, Summer School, University of Colorado Boulder, U.S.A. 1965 Leverhulme Travel Award. 1965 Elected Fellow of the Royal Society of Arts. Appointed Member of the Royal Fine Art Commission for Scotland. 1966 Completed Mural for Glasgow Airport. 1967 Cargill Award, Royal Glasgow Institute of the Fine Arts. Elected Member of Edinburgh Festival Society. 1969 Elected Secretary of the Royal Scottish Academy. 1971 Member of Scottish Advisory Committee, British Council. Elected Member of Council, Edinburgh Festival Society. 1973 Associate of the Royal Academy. 1973 President R.S.A. 1975 Member of Advisory Committee Lothians District Council. 1976 Knighted by H.M. The Queen.

ONE-MAN EXHIBITIONS
1954 The Scottish Gallery, Edinburgh. 1958 The Scottish Gallery, Edinburgh. 1960 Roland, Browse and Delbanco, London. 1961 The Scottish Gallery, Edinburgh (Festival). 1962 Roland, Browse and Delbanco, London. 1964 Roland, Browse and Delbanco, London. 1965 The Scottish Gallery, Edinburgh (Festival). 1967 Roland, Browse and Delbanco, London. 1968 The Scottish Gallery, Edinburgh. 1969 The Loomshop, Lower Largo, Fife. 1970 Scottish Gallery, Festival. 1971 Roland, Browse and Delbanco, London. 1973 The Scottish Gallery, Edinburgh. 1975 Roland, Browse and Delbanco, London.

GROUP EXHIBITIONS
1952 Eight Young Contemporary British Painters, Arts Council, Scottish Committee. 1954 Three Scottish Artists, Crane Gallery, Manchester. 1955 Festival Exhibition, The Scottish Gallery, Edinburgh. 1958 Edinburgh-Nice Exhibition, Gallerie de Pouchettes, Nice. 1959 Six Scottish Artists, Nottingham University, Arts Council, Scottish Committee. Stirling Festival Fortnight Exhibition. 1963 Four Scottish Painters, Arts Council, Scottish Committee. Festival Exhibition. 1963-4 Fourteen Scottish Painters, Commonwealth Institute, London. Arts Council Scottish Committee. 1964 Contemporary Scottish Art, Reading Art Gallery. 1965 Seven Scottish Painters, I.B.M. Gallery, New York. 1967 Contemporary British Painting, Warsaw. 1968 Scottish Painting, The Demarco Gallery, Edinburgh. 1968 Three Centuries of Scottish Painting, National Gallery of Canada. 1974 The Bruton Gallery. 1975 Fieldbourne Gallery, London.

COLLECTIONS
Aberdeen Art Gallery. Argyll Education Trust. Arts Council, Scottish Committee. Cardiff, National Museum of Wales. Contemporary Art Society. Dumfries Educational Trust. Edinburgh Corporation. Edinburgh University. Glasgow Art Gallery. Kirkcaldy Art Gallery and Museum. Leeds City Art Gallery. Liverpool Walker Art Gallery. Manchester, Whitworth Art Gallery. Ministry of Works. Contemporary Arts Society. Scottish College of Textiles, Galashiels. Queen Margaret College Edinburgh. Middlesbrough Art Gallery. Newcastle, Laing Art Gallery. North Carolina Art Gallery and Museum, U.S.A. Nottingham Education Authority. Paisley Museum and Art Gallery. Perth Art Gallery. Scottish National Gallery of Modern Art. Scottish Television Ltd. Southport, Atkinson Art Gallery. Sunderland Museum and Art Gallery. Sutherland Education Trust. University of Colorado, Boulder, U.S.A. University of Stirling. West Riding of Yorkshire County Council. Lillie Art Gallery, Milnegavie. University of Glasgow. The Carnegie Dunfermline Trust.

CHARLES PULSFORD A.R.S.A.

Born 8th June, 1912, Leek, Staffordshire. Studied at Aberdour Junior School, Dunfermline High School, Edinburgh College of Art 1933. Hospitalfield, Arbroath, D.A. Edin.' 1937. Post Graduate year 1938. Travelling Scholarship 1938-39. Fellowship of Edinburgh College of Art 1939-47 (2 years interrupted by war service). Elected A.R.S.A. 1959. Taught Edinburgh College of Art (School of painting), 1947-52 part-time. 1952-60 full-time. Taught at Loughborough College of Art, 1960-64. Vice-Principal and then Head of Fine Art at Wolverhampton Polytechnic. Head of Fine Art and Principal Lecturer with responsibility for painting and sculpture. Visiting Lecturer with Department of Architecture, University of Edinburgh 1964-69. Retired early – August 31st, 1972.

1951 French Institute, Edinburgh. 1953 Gimpel Fils, London (with Scotty Wilson). 1956 Gimpel Fils, London (with Alan Davie). 1958 57 Gallery, Edinburgh. 1964 New Charing Cross Gallery, Glasgow. 1965 Scottish Gallery, Edinburgh. 1969 University of Stirling. 1969 Royal Hospital, Morningside, Edinburgh. 1969 The Ikon Gallery, Birmingham.

GROUP EXHIBITIONS

1947 Edinburgh College of Art (Fellowship Show). 1958 Scottish Artists (Nice, France). 1960 Zwemmer Gallery, London. 1961 Midland Group, Nottingham. 1962 Midland Group, Nottingham. 1963 "Ledlanet" (Festival). 1964 "Ledlanet" (Spring and Autumn). 1964 20 Artists, Wolverhampton. 1967 Demarco Gallery Edinburgh. 1968 Four Fife Artists, Pavilion, Dunfermline). 1968 "Art Across the Tay", Dundee. 1969 Little Festival Dundee. 1970 Group Show, Wolverhampton Polytechnic.

REGULAR EXHIBITOR

R.S.A., S.S.A. Glasgow Institute. London Group. Travelling Exhibition England (arranged by Gimpel Fils). Travelling Exhibitions in Scotland, arranged by Arts Council. The Print Club, Philadelphia. Scottish Gallery of Contemporary Art. New York (Tapestry Executed by Ronald Cruickshank).

COLLECTIONS

Mainly Arts Council and many Private Collections.

ANNE REDPATH O.B.E., R.S.A., LL.D., R.W.A., A.R.A., A.R.W.S. (1895–1965)

Born 29th March, 1895 Galashiels, daughter of Thomas Redpath, tweed designer. Educated Hawick High School. 1913 Entered Edinburgh College of Art and Moray House College of Education. 1917 Qualified as Art Teacher. 1918 Awarded Diploma and Post Graduate Year. 1919 Awarded Travelling Scholarship and visited Brussels, Bruges, Paris, Florence and Siena. 1920 Married James Beattie Michie. Lived in France and Riviera for 10 years. 1934 Returned to Scotland to live in Hawick. Elected Professional Member of S.S.A. 1939 Elected Member of Scottish Society of Women Artists. 1946 Elected Member of the Royal Society of British Artists. 1947 Elected A.R.S.A. 1948 Elected Member of Royal Institute of Oil Painters. 1949 Moved to Edinburgh. 1952 Elected R.S.A. 1955 Honorary degree of Doctor of Law, Edinburgh University. Awarded O.B.E. 1959. Elected R.W.A. 1960 Elected A.R.A. 1962 Elected A.R.W.S. 1965 Died 7 January, Edinburgh.

ONE-MAN EXHIBITIONS

1947 Gordon Small Gallery, Edinburgh. 1951 Scottish Gallery, Edinburgh. 1952 Lefevre Gallery, London. 1953 Scottish Gallery. 1956 Royal West of England Academy, Bristol. 1957 Scottish Gallery, Edinburgh. 1961 Stone Gallery, Newcastle-upon-Tyne. Lefevre Gallery, London. 1963 Scottish Gallery, Edinburgh. 1964 Lefevre Gallery, London.

COLLECTIONS

Aberdeen Art Gallery and Industrial Museum. Argyll County Council. Royal West of England Academy, Bristol. Herbert Art Gallery and Museum, Coventry. Gracefield Arts Centre, Dumfries. City Museum and Fine Art Galleries, Dundee. Arts Council, Edinburgh. Edinburgh Corporation. The Royal Scottish Academy, Edinburgh. Scottish National Gallery of Modern Art, Edinburgh. Art Gallery and Museum, Glasgow. McLean Museum and Art Gallery, Greenock. Abbot Hall Art Gallery, Kendal. Ferens Art Gallery, Kingston-upon-Hull. Art Gallery and Museum, Kirkcaldy. The Royal Academy, London. The Tate Gallery, London. City Art Galleries, Manchester. The Whitworth Art Gallery, Manchester. Laing Art Gallery and Museum, Newcastle-upon-Tyne. Art Gallery and Museum, Perth. Harris Museum and Art Gallery, Preston. Atkinson Art Gallery, Southport. Smith Art Gallery and Museum, Stirling. West Riding County Council. National Gallery of South Australia, Adelaide. Queensland Art Gallery, Queensland. Art Gallery of New South Wales, Sydney. B.C. Vancouver Art Gallery, Vancouver. National Art Gallery of New Zealand, Wellington.

PHILIP REEVES R.S.A., R.S.W., A.R.C.A.

Born 1931. Studied Cheltenham School of Art and Royal College of Art, London. A.R.S.A., 1971. Mary Marshall Brown Award. Fellow of the Royal Society of Painters and Etchers, and Engravers. R.S.W., A.R.C.A., S.S.A., R.S.A., 1976.

ONE-MAN EXHIBITIONS
1962 Douglas & Foulis, Edinburgh. Victoria Street Gallery, Edinburgh. 1970 The Scottish Gallery, Edinburgh. 1971 Compass Gallery, Glasgow. 1971 Lillie Art Gallery, Milngavie. 1973 Livingstone Tower, Strathclyde University. 1974 Rose Angle Gallery, Dundee.

GROUP EXHIBITIONS
1959 Trafford Gallery, London. 1965 57 Gallery, Edinburgh. 1965/66 New Charing Cross Gallery, Glasgow. 1966 Laing Art Gallery, Newcastle upon Tyne. 1969–72 Compass Gallery, Glasgow. 1971/4 Upper Street Gallery, London. 1968/72 Glasgow Group of Artists. 1968/72 Printmakers Workshop, Edinburgh. 1971 Art Spectrum, Scotland. 1971 Inaugural Exhibition in Stirling University. 1971 Painting for Schools Aberdeen Art Gallery. 1974 Greenock Arts Guild with James Spence. 1975 Shed 50, St. Monance.

COLLECTIONS
Scottish Arts Council. Scottish Gallery of Modern Art. Glasgow Art Gallery. Aberdeen Art Gallery. Argyll Education Committee. Links House Collection, Glasgow. Aberdeen Art Gallery. Paisley Art Gallery. Milngavie Art Gallery. Manchester City Art Gallery. Edinburgh University. Glasgow University. St. Andrew's University. Dumbartonshire Education Committee.

IAN MACKENZIE SMITH A.R.S.A.

Born Montrose 1935. Studied Gray's School of Art, 1953–58. Hospitalfield 1957 and 1958. Travelled 1958–59. Guthrie Award R.S.A. 1971. Taught in Fife 1960–63. Education Officer, Council of Industrial Design, Scottish Committee 1963–68. Director Aberdeen Art Gallery and Museums since 1968. Member Society of Scottish Artists. A.R.S.A. 1973. Associate Society of Industrial Artists and Designers. Fellow Royal Society of Arts. Fellow Society of Antiquaries (Scot). Member Scottish Arts Council.

ONE-MAN EXHIBITIONS
1959 57 Gallery, Edinburgh. 1963 57 Gallery, Edinburgh. 1965 Scottish Gallery, Edinburgh. 1967 Richard Demarco Gallery, Edinburgh. 1971 Scottish Gallery, Edinburgh. 1973 Loomshop Gallery, Lower Largo, Fife. 1975 (October) Stirling Gallery.

GROUP EXHIBITIONS
1961 Four Aberdeen Artists. Danish Institute, Edinburgh. 1962/4/6 Open Painting, Belfast. 1963 20th Century Scottish Painters, Abbot Hall Gallery, Kendal. 1964 Scottish Painters Plus or Minus 30, Glasgow University and Scottish National Gallery of Modern Art. 1964 Scottish Painters, Stirling Festival. 1964 Pictures for Schools, London. 1964, 65, 66 Bradford Spring Exhibition. 1965 Scottish Painters Under 30 Commonwealth Festival, Glasgow. 1965 Seven Scottish Painters, I.B.M. Gallery, New York. 1965 Links House, Glasgow. 1965/66 Charing Cross Gallery, Glasgow. 1965 Traverse Gallery, Edinburgh. 1965 Montrose Festival. 1966 Four Scottish Painters, Piccadilly Gallery, London. 1966 Pictures for Hospitals, London. 1970 Contemporary Scottish Artists, Maine, U.S.A. 100 Years of Scottish Painting, Canada. 1971 Celtic Triangle.

COLLECTIONS
Scottish National Gallery of Modern Art. Scottish Arts Council. Arts Council of Northern Ireland. Abbot Hall Art Gallery, Kendal. Nuffield Foundation. Royal Scottish Academy. Edinburgh Education Committee. Dumbarton Education Committee. Aberdeen Art Gallery. Carnegie Dunfermline Trust and I.B.M. Greenock.

FRED STIVEN

1929 Born in Fife. 1946–51 Graduate and Post graduate student of Edinburgh College of Art. 1951–52 Visiting Lecturer Heriot Watt Department of Typography. 1952–54 National Service, Army. 1954–58 Fife Education Authority Art Staff. 1958 to date Member of staff at Grays School of Art. At present Senior Lecturer in charge of Design and General Course. Member of The Society of Industrial Artists. Member of The Society of Scottish Artists. Member of The Glasgow Group. Co-originator, designer and builder of "Integration" (an attempt to present common ground between the scientist and the artist).

EXHIBITIONS

The Royal Scottish Academy. The Society of Scottish Artists. Aberdeen Artists Society. Modern Scottish Painting London 1969. Saltire Society Centenary Exhibition. S.T.V. Scottish Painters. The Glasgow Group. The Richard Demarco Gallery, Edinburgh. Edinburgh Arts 72. Sheffield University. Aberdeen University. Studio 9. The Loomshop. etc.

COLLECTIONS

U.K. France. Holland. Germany. Switzerland. Roumania. Scottish Arts Council. Aberdeen City Art Gallery.

WILLIAM TURNBULL

1922 Born Dundee Scotland 11 January. 1939–41 Worked in illustration department of a national periodical publishing company, Dundee. R.A.F. war service. Periods in Canada, India and Ceylon. 1946–48 Slade School of Art, London. 1948–50 Lived in Paris. 1950 Began permanent residence in London. 1957 First visit to U.S.A. 1962 First travels in Japan, Cambodia, Malaysia, etc. Married to the sculptor and print-maker Kim Lim. From 1952 to 1961 taught experimental design as a visiting artist at the Central School of Arts and Crafts, London. From 1964 to 1972 he taught sculpture at the same school.

ONE-MAN EXHIBITIONS

1950 Hanover Gallery, London. 1952 Hanover Gallery, London (Sculpture and painting). 1957 I.C.A., London (Sculpture and Painting). 1960 Molton Gallery London (Sclupture). 1961 Molton Gallery (painting). 1963 Marlborough-Gerson Gallery, New York (sculpture). Art Institute, Detroit (sculpture). 1965 Galerie Muller, Stuttgart (painting). Bennington College, Vermont, U.S.A. (painting). 1966 Pavilion Gallery, Balboa, California (sculpture and painting). 1967 IX Bienal, Sao Paola, and tour of South American countries (sculpture and painting). Waddington Galleries, London (sculpture and painting). 1968 Hayward Gallery, London (painting). 1969 Waddington Galleries (lithographs). 1970 Waddington Galleries (sculpture and painting).

COLLECTIONS

Tate Gallery. Victoria & Albert Museum. Art Council of Great Britain. Marlborough Gallery Inc. Penrose Collection. McCrory Corporation. Rutland Gallery. Waddington Galleries; and in many other private and public collections in U.K., Europe, and U.S.A.

ALEXANDER ZYW

Born 1905 in Lida, Poland. Graduated at Warsau Academy of Fine Arts. Went in 1933 to Dalmatia, Greece and Italy. Lived and worked in Paris 1934–39. 1939–45 served in the Armed Forces. Came to Britain in 1940. Permanent residence and studio in Edinburgh. First visit to Italy and France after the war was in 1949. Now returns there every summer to paint.

EXHIBITIONS

The Art Institute Warsaw, 1936. The Scottish Gallery Edinburgh 1945. The London Gallery 1948. Galleria del Milione 1949. Galerie d'Art Moderne Bale 1950. The Scottish Gallery Edinburgh 1950. Galerie Galanis, Paris 1951. Galerie Galanis, Paris 1952. Galeria del Milione, 1953. The Hanover

Gallery, London 1953. Complimentary Exhibitions in Desenzano and Brescia, Italy 1956. Galerie Henri Benezit, Paris 1957. Exhibited in the Salon de Mai, Paris, 1954, 56, 57. Retrospective Exhibition Polisy National Union of Artists, Warsau 1967. Retrospective Exhibition Scottish Gallery of Modern Art, Edinburgh 1972. "An Instant of Water" Talbot Rice Art Centre, Edinburgh Festival Exhibition 1975.

COLLECTIONS
Many works in civic and private collections in Europe, U.S.A., U.K. etc.

APPENDIX I

QUALIFICATIONS AND GENERAL ABBREVIATIONS

A.O.C.	Artists of Chelsea.
A.R.W.A.	Associate of the Royal West of England Academy.
A.R.C.A.	Associate of the Royal College of Art.
A.R.S.A.	Associate of the Royal Scottish Academy.
A.T.D.	Art Teacher's Diploma.
B.A.	Bachelor of Arts.
B.W.S.	British Water-colour Society.
C.B.E.	Commander Order of the British Empire.
C.O.I.D.	Council of Industrial Design.
D.A.	Diploma of Art.
D.Litt.	Doctor of Literature.
F.R.S.A.	Fellow of the Royal Society of Arts.
I.C.A.	Institute of Contemporary Arts.
LL.D.	Doctor of Laws.
Ph.D.	Doctor of Philosophy.
R.A.	Royal Academician (Royal Academy).
R.B.A.	Royal Society of British Artists.
R.C.A.	Royal College of Art.
R.E.	Royal Society of Painter-Etchers and Engravers.
R.G.I.	Royal Glasgow Institute.
R.H.A.	Royal Hibernian Academy.
R.I.	Royal Institute of Painters in Water-colours.
R.S.A.	Royal Scottish Academician (Royal Scottish Academy).
R.O.I.	Royal Institute of Oil Painters.
R.G.I.F.I.	Royal Glasgow Institute of Fine Art.
R.S.W.	Royal Scottish Society of Painters in Water-colours (Member).
S.S.A.	Society of Scottish Artists.
S.S.W.A.	Scottish Society of Women Artists.
S.W.A.S.	Society of Women Artists of Scotland.

INDEX

David McClure **Black Studio – Interior**
1969, Scottish Art Council